EUROPEAN PHOTO GRAPHY 81

EUROPEAN PHOTO GRAPHY 81

EDITED BY EDWARD BOOTH-CLIBBORN

Edited by · Edité par · Herausgegeben von EDWARD BOOTH-CLIBBORN

The first annual of European editorial, book, poster, advertising, unpublished photography.

Premier annuaire européen de photographie de presse, du livre, de l'affiche, de publicité, d'oeuvres non publiées, du film d'animation et du design.

Der erste Band des Jahrbuches 'European Photography' über die Photographie auf redaktionellem Gebiet, im Buch, auf Plakat und Poster, in der Werbung, in unveröffentlichten Arbeiten, im Trickfilm und in der Gebrauchsgraphik.

EUROPEAN PHOTOGRAPHY 12 Carlton House Terrace, London

Book designed by David Hillman, Pentagram

Maquettiste du livre David Hillman, Pentagram

Buch gestaltet von David Hillman, Pentagram

The exhibition of the photography in this book
will be shown in:
L'Exposition d'oeuvres d'art de ce livre aura lieu à:
Die Originalarbeiten werden ausgestellt in:
THE NATIONAL FILM THEATRE, LONDON AND F.N.A.C. PARIS

European photography Call for Entries Copyright © 1981
The following companies hold the exclusive distribution rights
for European Photography 81:
Italy: Libreria Salto, Milan
Brazil: Paulo Gorodetchi & Cia Ltda, Sao Paulo
USA/Canada: Harry N Abrams Inc., New York
ISBN 0-8109-0855-7

UK and the rest of the world:
D&AD/European Illustration,
12 Carlton House Terrace, London SW1 5AH
Tel: 01-839 2464

Printed in Japan by Dai Nippon. Paper: 128GSM matt coated
Typeface: Garamond Light Condensed
Filmset by: Filmcomposition, London

Published by Polygon Editions S.A.R.L., Basel Copyright © 1981

European Photography wish to thank Charles Jourdan for the
use of Guy Bourdin photographs.

Photographie de la couverture:
Guy Bourdin, avec la permission de Charles Jourdan

Umschlag-Photo:
Guy Bourdin, mit freundlicher Genehmigung
von Charles Jourdan

CONTENTS

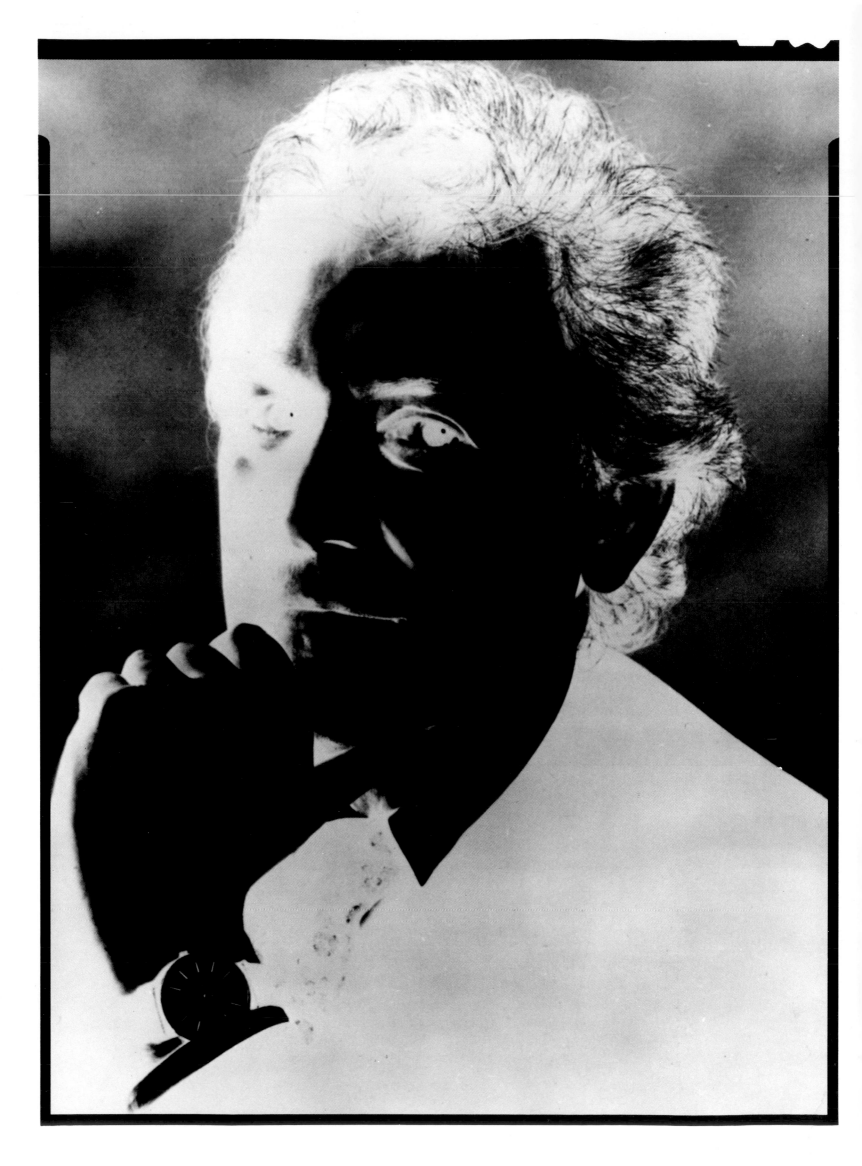

INTRODUCTION

EUROPEAN PHOTOGRAPHY TODAY

LA PHOTOGRAPHIE EUROPEENNE AUJOURD'HUI

EUROPÄISCHE PHOTOGRAPHIE HEUTE

To say that we live in a visual world is to state the obvious. The vast majority of us can see. But today to think about what we see and how we see is to begin to think about photography. For, in a way that painting never could, photography has become the great proletarian art device of the century. Its images are everywhere. In books and magazines, on posters and in galleries, the world through a lens is on show.

But is photography an art? Can photographs exist on their own? Must they have a purpose and are they really honest?

It is to offer an answer to some of these questions–and to provide a showcase for some rare and specialised photographic talents–EUROPEAN PHOTOGRAPHY has come into being.

To begin with, EUROPEAN PHOTOGRAPHY is out on its own among the photographic yearbooks. Unlike some other annuals, money can't buy a page in this book. Photographers have to submit their work to a rigorously selective jury before they can expect to see it reproduced here. How rigorously selective is borne out by the fact that we first started looking at work for publication as long ago as 1977. Then, despite the quantity, the jury rejected virtually every image set before them.

Secondly, all the work in this book was commissioned. Thus, the images here were created by photographers working either to a brief or to a deadline–if not to both. And by photographers who knew their work was going to have to work in the mass communications media. Not for them the hallowed sanctuary of the new photography galleries, those still, quiet rooms where photographs are viewed by devotees. Yet the people in this book were, when they made these images, engaged in the creative act of interpretation on the lightning process of observation. And they are all, as you will see, masters of the craft, as well as of the art, of photography.

Dire que nous vivons dans un monde visuel est d'affirmer l'évident. La plupart d'entre nous ont des yeux pour voir. Mais de penser aujourd'hui à ce que l'on voit et comment on le voit, est de commencer à penser au sujet de la photographie. Car la photographie est devenue le grand art prolétaire du siècle comme la peinture n'a jamais pu l'être. Des images photographiques se trouvent partout. Dans les livres et les revues, sur des affiches et dans les galéries le monde se manifeste à travers l'objectif.

Mais la photographie est-elle un art? Est-ce que les photographies peuvent exister toutes seules? Doivent-elles avoir une intention et est-ce qu'elles sont vraiment honnêtes?

C'est pour répondre à quelques unes de ces questions–et pour servir comme vitrine à quelques rares talents photographiques–que EUROPEAN PHOTOGRAPHY est né.

Premièrement, EUROPEAN PHOTOGRAPHY est unique parmi les annuaires photographiques. Contrairement à d'autres annuaires, l'argent ne peut acheter une page dans ce livre. Les photographes doivent présenter leur travail à un jury de sélection très rigoureux avant d'attendre à le voir reproduit sur ces pages. La rigueur du jury est telle que l'on a commencé à considérer du travail pour publication depuis aussi longtemps que 1977. Alors, malgré la quantité de travail, le jury a rejeté pratiquement toutes les images qu'on leur a présentés.

Deuxièmement, tout le travail dans ce livre a été fait sur commande. Donc, les images ici représentées ont été créées par des photographes qui travaillaient sous des instructions précises ou envers une date limite–même toutes deux; et créées par des photographes qui étaient conscients que leurs oeuvres devaient fonctionner dans le système du mass média. Pas pour eux le sanctuaire des nouvelles galeries photographiques, ces halles tranquilles où les photographies sont regardées par des

Zu sagen, daß wir in einer visuellen Welt leben, heißt Selbstverständliches feststellen. Die Mehrheit von uns kann sehen. Aber darüber nachzudenken, wie wir sehen und was wir sehen, bedeutet, über die Photographie nachzudenken. Denn in einer Weise, wie es der Malerei niemals gelang, wurde die Photographie zur großen, volksnahen Kunst, der Schlager des Jahrhunderts. Ihre Bilder sind überall. In Büchern und Zeitschriften, auf Plakaten und in Galerien, der Blick durch die Linse ist sehr gefragt.

Aber ist Photographie Kunst? Kann Photographie allein existieren? Muß sie einen Zweck erfüllen, und ist sie wirklich ehrlich?

EUROPÄISCHE PHOTOGRAPHIE möchte eine Antwort anbieten auf einige dieser Fragen und ein Forum schaffen für seltene und spezialisierte Photo-Talente. Das ist die Aufgabe, die sich EUROPÄISCHE PHOTOGRAPHIE gestellt hat.

Anders als bei einigen Jahr-Büchern, sind die Seiten in diesem Band nicht zu kaufen. Vielmehr müssen sich die Photographen einer strengen Jury stellen, bevor sie die Aussicht haben, hier reproduziert zu werden. Wie streng die Maßstäbe waren, zeigt sich darin, daß wir bei den Veröffentlichungen bis ins Jahr 1977 zurückgegangen sind. Und die Jury jedes einzelne Bild besprach, bevor sie sich entschied.

Außerdem sind alle hier abgebildeten Werke Auftragsarbeiten und somit unter Berücksichtigung von Texten und Terminen entstanden–wenn nicht gar von beiden. Und von Photographen, die wissen, daß ihre Arbeiten in Massenmedien wirken müssen. Denn für sie sind sie nicht gemacht, die heiligen Hallen der neuen Photo-Galerien, in denen Photo-Künstler von begeisterten Anhängern bewundert werden. Alle, die in diesem Buch vertreten sind, stehen vielmehr im kreativen Prozeß der Interpretation. Und sie alle, wie Sie

I say 'craft' and 'art' because photography is both. Just as a painter must develop his palette and learn how to handle colour and tone, a photographer must learn the camera's special way of seeing. It is only when he has done this that he can, by treating the camera as an extension of his own eye, use his craft to achieve art. But how do we recognise art? When you look at the work in this book you will see that most of it–though the images are as varied as the colours on a patchwork quilt–meets a simple set of criteria. These relate to content, composition and colour, the basic materials of art. Content relates the picture to life; good composition creates drama–and keeps the eye in the picture; colour lends greater vitality and enhances the image.

The content of a photograph is determined by the photographer's conception of the subject. It represents his idea about the subject or its message. It is his contribution to the life of the work which he, in conjunction with others, sets out to produce. In reportage work it is affected by events. It consists, in its combination of geometry, emotion and light, of what Cartier-Bresson calls 'the decisive moment', that instant–a fraction of a second–when the good photographer sees that all the elements of his story have fused together in a satisfactory composition.

It might be thought that composition was the preserve of the still-life photographer. In the quiet of a studio, shapes and forms can be arranged to create groups which, through their very organisation, lead the eye through the masses, keeping it always within the parameters of the work and directing it to some specific focal point. But in the highest forms of reportage photography the golden rules of composition still apply and the created, or observed, image needs no picture editor's cropping, no caption writer's explanation or expansion.

We've come to expect colour in a photograph. How many amateurs use black and white film to record their lives these days? But black and white has its own impact. It creates a different dynamic pattern, a sharper contrast between the solid forms of life and the empty spaces which give those forms their shape. It is, of course, the stuff of newspapers and, in the hands of photographers like Cartier-Bresson and McCullin, it can be the palette which most deeply affects our emotions.

When these rules are met–and when every cheap trick has been eliminated–photography can be said to be honest. And, if it can exist alone, without the help of words of explanation, then it may also be said to be art. Certainly, as a means of communication and as a method of recording the present, it meets all the demands made on art. The difference here, in this book, is that all the work was commissoned to work with words and yet can survive alone. Which means that, in Europe–and in this first edition of EUROPEAN PHOTOGRAPHY–we have some of the answers to some of the perennial questions posed about photography and art. You must judge for yourself whether or not the answers are right.

EDWARD BOOTH-CLIBBORN

dévoués. Pourtant, tous les gens concernés à créer ce livre s'engageaient, au moment de faire images, dans l'action créative d'interprétation ou dans le processus instantané d'observation. Et ils sont tous, comme vous le verrez, maîtres de leur métier et d'autant plus maîtres de l'art de la photographie.

Je dis 'métier' et 'art' parce que la photographie est les deux. Comme il faut à un peintre de développer sa palette et d'apprendre comment manipuler la couleur et les tons, ainsi faut-il qu'un photographe apprenne à comprendre la façon de voir spécial de l'appareil. Ce n'est qu'à ce point là que le photographe peut, en se servant de l'appareil comme une extension de ses propres yeux, exploiter son métier pour arriver à l'art. Mais comment reconnaît-on l'art? Quand vous regardez les oeuvres représentées dans ce livre vous verrez que la plupart d'entre elles– même que les images sont aussi variées que les couleurs d'une couverture de patchwork– conformant à une simple série de règles. Ceux-ci concernent le contenu, la composition et la couleur, les matériaux de base de l'art. Le contenu rattache l'image à la vie; la bonne composition crée l'action du drame–et maintien le regard; la couleur donne de l'animation et embellit l'image.

Le contenu d'une photographie est déterminé par la conception qu'à le photographe à son sujet. Cela représente son idée du sujet ou du message que comporte ce dernier. C'est sa contribution à la vie de l'oeuvre qu'il vise, en collaboration avec d'autres, à produire. Dans le reportage le contenu est influencé par les événements. Cela consiste, par sa combinaison de géométrie, d'émotion et de lumière, en ce que Cartier-Bresson appelle 'le moment decisif', cet instant–ce clin d'oeil–reconnu par le photographe, quand tous les éléments de son sujet sont réunis afin d'achever une composition satisfaisante.

On pourrait croire que la composition soit la réserve du photographe de nature-mortes. Dans la tranquillité du studio on peut arranger des formes afin de créer des groupes qui, dans leur organisation même, mène le regard à travers les masses le gardant toujours à l'intérieur des limites de l'oeuvre et le dirigeant vers quelque point spécifique. Mais dans la meilleure photographie de reportage les règles d'or de la composition s'appliquent toujours et l'image créée ou observée n'a besoin d'aucun coupage d'éditeur, d'aucune explication ni de dissertation.

On est venu à exiger de la couleur dans une photographie. Combien d'amateurs enrégistrent leur vie en noir et blanc aujourd'hui? Mais le noir et blanc a sa propre force. Cela crée un motif dynamique différent, un contraste plus aigu entre les formes solides de la vie et l'espace vide qui donne à ces formes leur silhouette. C'est, bien sûr, le matériel des journaux et, dans les mains des photographes comme Cartier-Bresson et McCullin, peut aussi être la palette qui affecte nos émotions le plus profondément.

Lorsque la photographie observe ces règles–et tous les petits trucs faciles sont eliminés–alors on peut dire qu'elle est honnête. Et puis, si elle peut tenir toute seule, sans l'assistance de mots d'explication, alors là on peut aussi dire qu'elle est un art. Certainement, comme moyen de communication et comme moyen d'enrégistrer le présent elle répond à tout ce qu'on exige de l'art. La différence c'est que, dans ce livre toutes les photographies ont été faites sur commande pour fonctionner ensemble avec des paroles et pourtant elles sont aussi fortes toutes seules. Qui fait que dans cette première édition de EUROPEAN PHOTOGRAPHY nous trouvons quelques solutions à quelques unes des questions éternelles qui se posent sur la photographie et l'art. Vous devez juger pour vous-mêmes si ces reponses sont justes ou non.

EDWARD BOOTH-CLIBBORN

sehen werden, sind Meister ihres Handwerks, in der Kunst wie in der Photographie.

Ich sage Handwerk und Kunst, denn Photographie ist beides. Gleich dem Maler, der lernen muß mit Palette, Farben und Formen umzugehen, muß der Photograph lernen, mit der Kamera zu sehen. Nur wenn es ihm gelingt, die Kamera als einen Teil seines Auges zu betrachten, kann sein Handwerk zur Kunst werden. Aber wie erkennen wir Kunst? Wenn Sie in dieses Buch schauen, werden Sie erkennen, daß die Bilder, so unterschiedlich sie auch sind, bestimmten Kriterien unterliegen. Komposition und Farbe bilden die Basis für Kunst. Sie zusammen erwecken ein Bild zum Leben, erzeugen Spannung und lassen das Auge beim Bild verweilen; Farbe unterstützt die Lebendigkeit und steigert den Eindruck.

Die Aussage eines Fotos wird bestimmt durch die Konzeption des Photographen. Es spiegelt seine Idee zu seinem Gegenstand oder einer Nachricht wieder. Es ist sein Beitrag zur Arbeit, die er zusammen mit anderen verwirklicht. Bei Reportagen wird er beeinflußt durch die Ereignisse. Ausschlaggebend ist dabei der 'entscheidende Augenblick,' wie Cartier-Bresson es nennt, in dem Geometrie, Gefühl und Licht zusammentreffen, und der Photograph im Bruchteil einer Sekunde erkennen muß, daß alle nötigen Elemente für seine Geschichte eine befriedigende Komposition ergeben.

Es mag allgemein angenommen werden, daß die Komposition Stilleben-Photographen vorbehalten ist. Denn in der Ruhe des Studios können Form und Farbe so zusammengestellt werden, daß sie das Auge führen und am wichtigsten Punkt festhalten. Doch in der Hohen Schule der Reportage-Photographie gelten die goldenen Regeln der Komposition ebenso. Und das gestaltete Bild bedarf weder der Unterstützung einer Bildunterschrift noch eines erklärenden Titels.

Wir erwarten heutzutage stets Farb-Photos. Wie viele Amateur-Photographen benutzen noch Schwarz-Weiß-Filme, um ihr Leben festzuhalten? Dabei hat Schwarz-Weiß seine eigene Ausdruckskraft. Es schafft ein diffrenzierteres, dynamischeres Abbild, schärfere Kontraste zwischen dem realen Leben und den Leer-Räumen, die seinen Ausdruck prägen. Schwarz-Weiß kann in den Händen solcher Photographen wie Cartier-Bresson oder McCullin ein sicheres Mittel sein, unsere Gefühle aufzurütteln.

Wenn all diese Regeln berücksichtigt werden–und alle billigen Tricks unterbleiben–dann kann man die Photographie ehrlich nennen. Und wenn sie allein existieren kann, ohne Worte und Erklärungen, dann kann man auch sagen, sie ist Kunst.

Das wesentliche an diesem Buch ist, daß alle Aufnahmen auf Text zugeschnitten waren und jetzt dennoch allein bestehen können. Das beweist, daß wir in Europa–und in der ersten Ausgabe der EUROPÄISCHEN PHOTOGRAPHIE–auf die immer wieder auftauchenden Fragen über den Zusammenhang von Photographie und Kunst einige Antworten haben. Urteilen Sie selbst, ob diese Antworten richtig sind.

EDWARD BOOTH-CLIBBORN

THE JURY

MICHAEL RAND

ALAN WALDIE

ROLF GILLHAUSEN

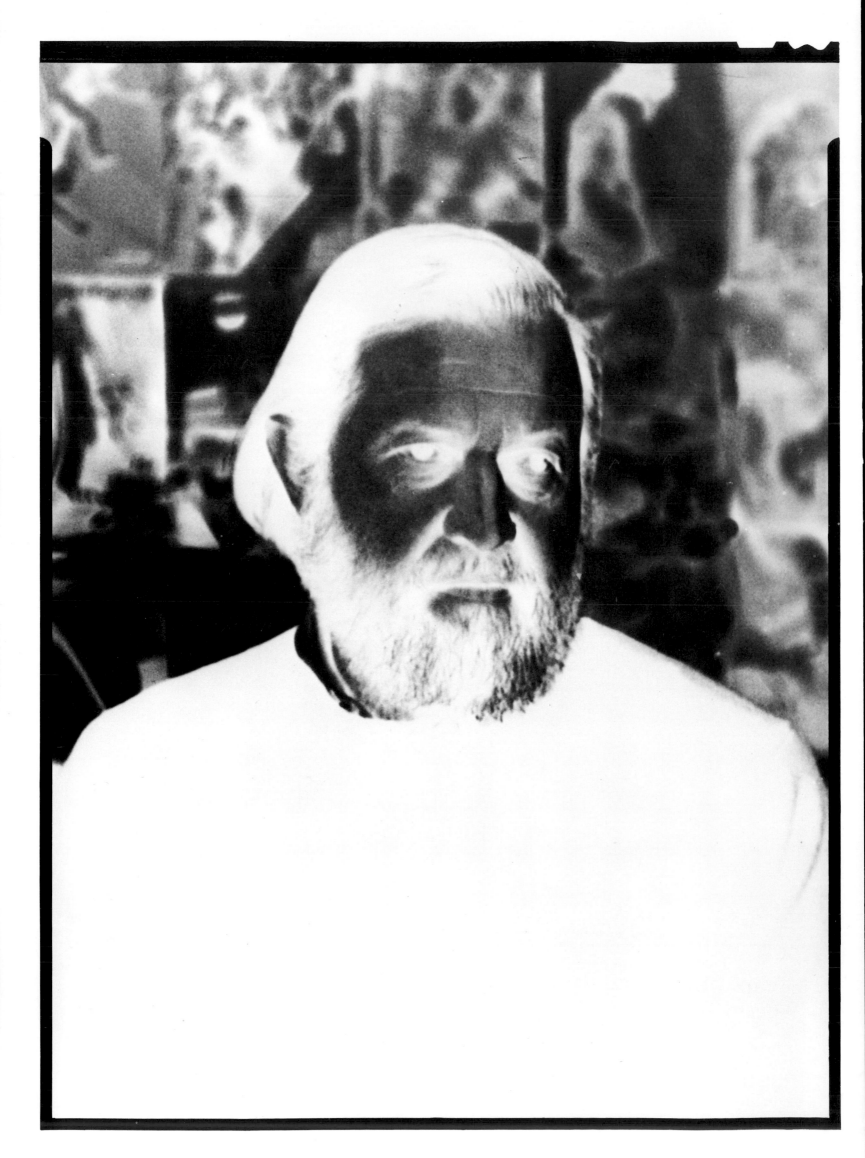

Michael Rand studied at London University and Goldsmiths' College School of Art. On leaving college he freelanced, mostly for advertising. In 1955 he joined the London 'Daily Express' as a consultant designer. There he developed the newspaper's coverage of the news by illustration with diagrams and charts.

In 1963 he joined 'The Sunday Times Magazine' as Art Editor. Apart from a year's break as Design Director of 'The Sunday Times', he has been on the Magazine ever since and is now Art Director and Managing Editor. During this time the Magazine has twice won the Designers' and Art Directors' Association Gold Award for the best designed item in the show, besides many Silver Awards. He has served for one year as President of the Designers' and Art Directors' Association and has worked as a Consultant Art director on other magazines in Britain and Germany.

He has designed and picture-edited a number of books including 'Homecoming' by Britain's distinguished war photographer, Donald McCullin, and 'The Great British' by America's foremost portrait photographer, Arnold Newman. In the autumn of 1981 he will have two more books published: 'Paris in the Third Reich' and 'Eyewitness: Pictures that Make News'.

He is an external examiner for the BA (Honours) degree in Graphic Design and Photography for a number of art schools, including The Royal College of Art, London.

Michael Rand a fait ses études à l'Université de Londres et à l'Ecole des Beaux-Arts de Goldsmiths' College. Ses études terminées il a travaillé indépendamment, principalement dans la publicité. En 1955 il est entré chez le London 'Daily Express' comme un designer consultant. Il a amplifié le reportage des nouvelles du journal par des illustrations, des dessins schématiques et des plans.

En 1963 il est entré chez 'The Sunday Times Magazine' comme éditeur artistique. A part une rupture d'un an, quand il a travaillé comme directeur du design chez 'The Sunday Times', il est toujours chez le Magazine et est maintenant directeur artistique et éditeur en chef. Sous sa direction le Magazine a deux fois gagné le prix d'or du Designers & Art Directors Association de Londres pour l'oeuvre la mieux dessinée dans l'exposition, à part avoir gagné plusieurs prix d'argent. Il a servi pendant un an comme Président du Designers & Art Directors Association de Londres et a travaillé comme directeur artistique consultant pour d'autres revues en Grand Bretagne et en Allemagne.

Il a été le designer et l'éditeur des images pour un nombre de livres, y compris 'Homecoming' par le photographe de guerre de Grande Bretagne, Donald McCullin, et 'The Great British' par le premier photographe de portraits en Amérique, Arnold Newman. En automne 1981 encore deux de ses livres seront publiés: 'Paris in the Third Reich' et 'Eyewitness: Pictures that Make News'.

Il est inspecteur externe pour l'examen 'BA Honours Degree' dans le dessin graphique et la photographie chez un nombre d'écoles des beaux-arts, y compris le Royal College of Art de Londres.

Michael Rand studierte an der Londoner Universität und an der Goldsmiths' College School of Art. Nach Beendigung des Studiums arbeitete er zunächst frei, hauptsächlich in der Werbung. 1955 übernahm er beim London 'Daily Express' die Beratung für die Gestaltung und verhalf dort der Illustration auf dem Gebiet der Zeitungsberichterstattung zu größerer Bedeutung.

1963 begann er beim 'Sunday Times Magazine' als Bildredakteur. Abgesehen von einem Jahr als Design-Direktor bei der 'Sunday Times', war er die ganze Zeit beim Magazin und ist dort nun Art Direktor und Managing Editor. In dieser Zeit hat das Magazin zweimal den Designers' and Art Directors' Association Preis in Gold und mehrmals in Sieber für die beste Gestaltung gewonnen. Michael Rand war für ein Jahr Präsident der Designers' and Art Directors' Association und als Berater für einige Magazine in England und Deutschland tätig.

Er gestaltete und verlegte eine Anzahl von Büchern, unter anderem 'Homecoming' von Englands bekanntestem Kriegs-Photographen, Donald McCullin, und 'The Great British' von Amerikas berühmtesten Portrait-Photographen Arnold Newman. Im Herbst 1981 werden zwei weitere Bücher von ihm herausgebracht: 'Paris in the Third Reich' und 'Eyewitness. Pictures that make News'.

Michael Rand ist Gastdozent an verschiedenen Kunstschulen, einschließlich dem Royal College of Art, London.

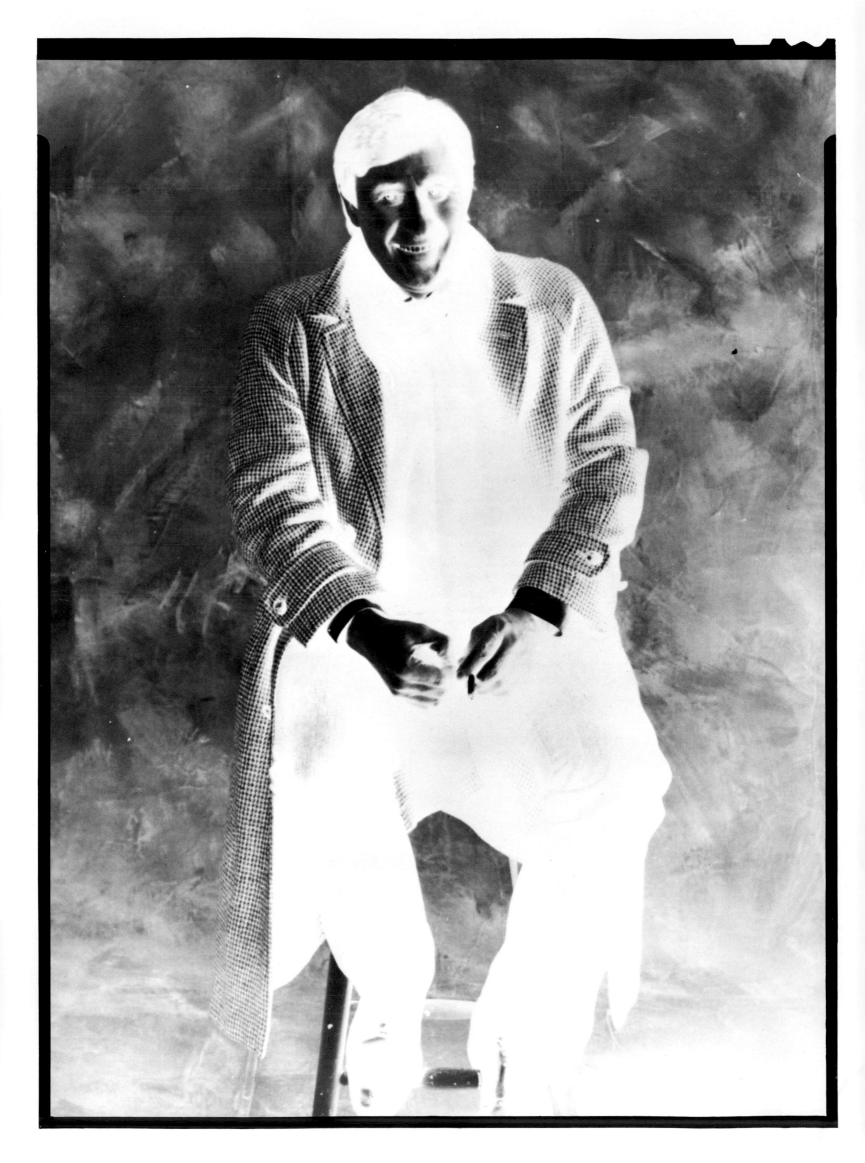

Born in 1940, Alan Waldie won a scholarship to Farnham School of Art in 1953. From 1958 he spent two years as a trainee with a Guildford advertising agency, then joined Roger Pryer Advertising, London, where he worked as Visualiser and Art Director. Following appointments as Art Director at Royds, London and Senior Art Director with Allen, Brady and Marsh, in 1969 he joined Collett, Dickenson, Pearce & Partners Ltd. He has won awards on many of the agency's accounts, notably Aer Lingus, Olympus Cameras, Pretty Polly, Heineken and Benson & Hedges. His work has been the topic of many magazine articles, and the basis of students' theses. During the past ten years he has given talks and lectures in this country and the USA.

Né en 1940 Alan Waldie a obtenu une bourse en 1953 de l'école des beaux arts à Farnham. Depuis 1958 il a passé deux années d'apprentissage chez une agence publicitaire à Guildford, ensuite il est entré chez Roger Pryer Advertising, Londres, ou il a travaillé comme 'visualiser' et directeur artistique. Après des postes comme directeur artistique chez Royds, Londres et directeur artistique en chef chez Allen, Brady and Marsh, en 1969 il est entré chez Collett, Dickenson, Pearce & Partners Ltd. Il a gagné des prix pour plusieurs des comptes de l'agence, notamment pour Aer Lingus, Olympus Cameras, Pretty Polly, Heineken et Benson & Hedges. Son travail a été le sujet de plusieurs articles dans des revues et le thème de thèses d'étudiants. Pendant les dix dernières années il a fait des discours et des conférences dans ce pays et aux USA.

1953, mit 13 Jahren, gewann Alan Waldie ein Stipendium der Farnham School of Art. 1958 volontierte er zwei Jahre in einer Guildforder Werbeagentur, dann wechselte er zur Roger Pryer Agentur, London, wo er bereits als Grafiker und Art Direktor arbeitete. Es folgten Aufgaben als Art Direktor bei Royds, London, und bei Allen, Brady and Marsh, sowie 1969 bei Collett, Dickenson, Pearce & Partners Ltd. Er gewann mehrer Preise mit Agentur-Aufträgen, zum Beispiel mit Aer Lingus, Olympus Kameras, Pretty Polly, Heineken und Benson & Hedges. Seine Arbeit war oft Anlaß zu Zeitschriften-Artikeln und Grundlage für Dissertationen. Während der letzten zehn Jahre hat er in England und den USA unterrichtet.

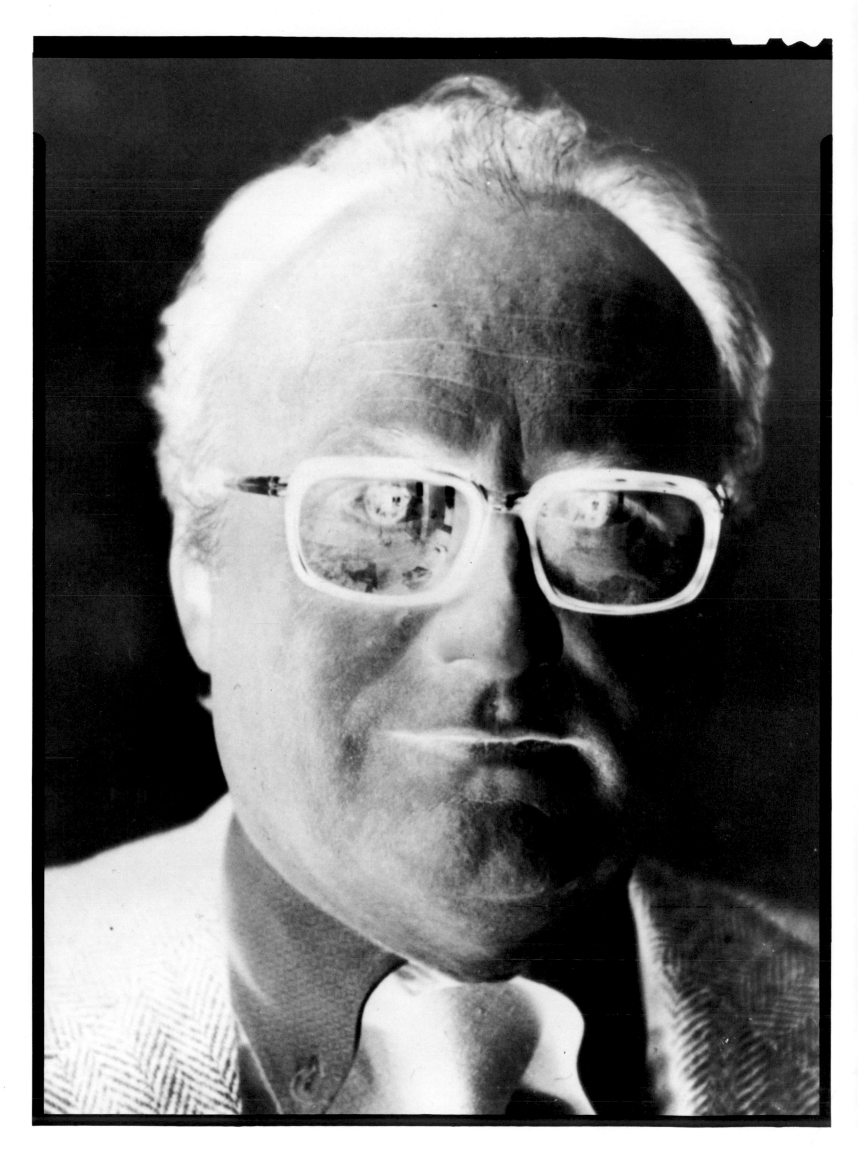

Rolf Gillhausen, a mechanical engineer, has worked all over the world since the end of world war two: for five years as a photographer for AP and for ten years as a reporter for Stern-magazine. He has produced award-winning TV-films in China, Russia, India and Africa. In 1965 Gillhausen became Deputy-Editor in Chief of Stern. Four years ago he started Geo-magazine. Since 1981 he has been Editor in Chief of Stern-magazine.

Rolf Gillhausen, un ingénieur mécanicien, travaille partout dans le monde depuis la fin de la deuxième guerre mondiale: pendant cinq ans comme photographe pour AP et pendant dix ans comme journaliste pour la revue Stern. Il a produit quelques films de télévision primés en Chine, en Russie, en Inde et en Afrique. En 1965 Gillhausen est devenu Sous-éditeur en Chef de Stern. Il y a quatre ans il a fondé la revue Geo. Depuis 1981 il est Editeur en Chef de la revue Stern.

Rolf Gillhausen, ein Ingenieur, hat seit dem Ende des zweiten Weltkrieges überall in der Welt gearbeitet: fünf Jahre als Photograph für AP und zehn Jahre als Reporter für die Zeitschrift Stern. Ausserdem hat er einige preisgekrönte Fernsehdokumentarfilme in China, Russland, Indien und Afrika produziert. 1965 wurde Gillhausen stellvertretender Chefredakteur des Stern. Vor vier Jahren etablierte er das Geo Magazin. Seit 1981 arbeitet er als Chefredakteur des Stern.

EDITORIAL

This section includes photography for newspapers, magazines and all forms of periodical publications.

MAGAZINES ET JOURNAUX

Cette section comprend des photographies pour des journaux, des magazines et des periodiques
de toutes sortes.

REDAKTIONELLE GRAPHIK

Dieser Abschnitt umfasst Photographie für Zeitungen, Zeitschriften und andere regelmässig erscheinende
Veröffentlichungen aller Art.

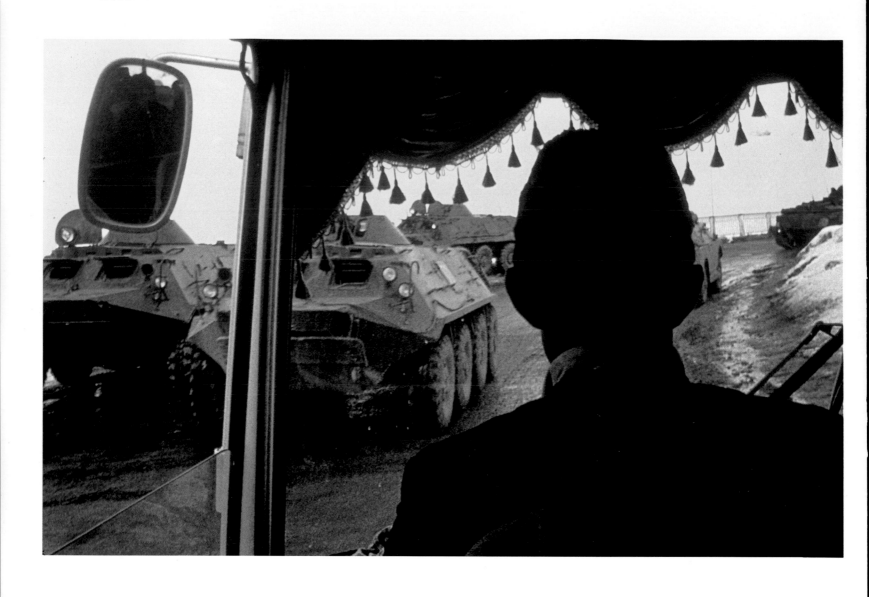

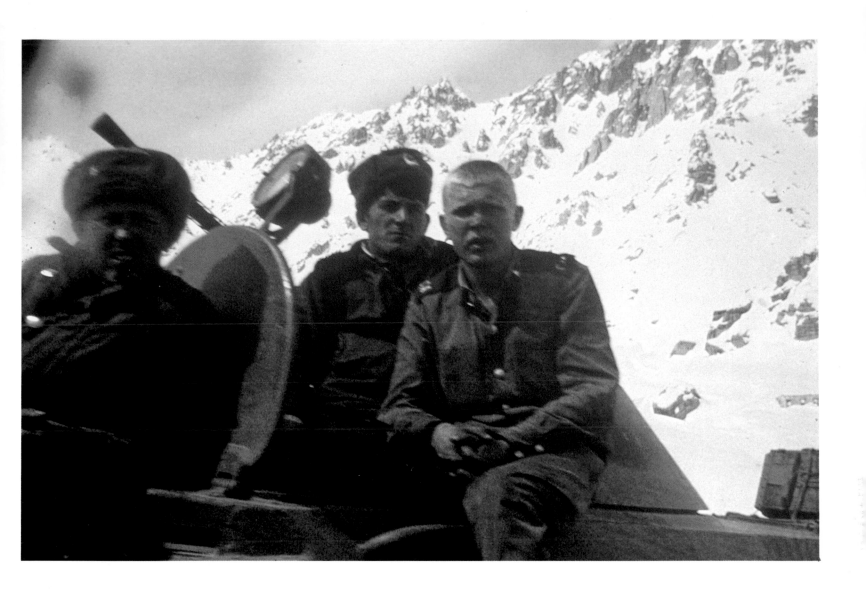

18, 19

Photographer · Photographe · Fotograph · ROMANO CAGNONI
Designer · Maquettiste · Gestalter · HERBERT SUHR
Art Director · Directeur Artistique · ROLF GILLHAUSEN
Publishing Company · Editeur · Verleger · GRUNER & JAHR AG & CO

Selection from the feature 'Afghanistan–Der rote Bruder ist überall' (Afghanistan–the Red Brother is everywhere) by Peter Hannes Lehmann, in 'Stern' April 1980.

Sélection du reportage 'Afghanistan–le Frère Rouge est partout' écrit par Peter Hannes Lehmann, publié dans 'Stern' avril 1980.

Auswahl zur Reportage 'Afghanistan–Der rote Bruder ist überall' von Peter Hannes Lehmann, im 'Stern' April 1980.

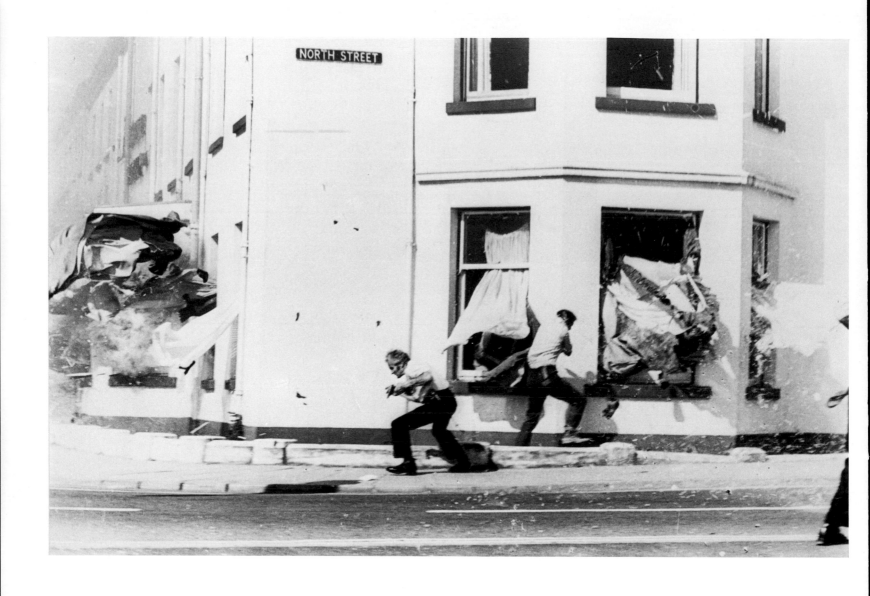

Photographer · Photographe · Fotograph · BRIGITTE DHAM

'Ulster: Moment of terror', taken on location outside the Marine Hotel, Ballycastle, Northern Ireland; reproduced throughout the world.

'Ulster: moment de terreur', prise sur place devant l'hôtel Marine, Ballycastle, Irelande du nord; reproduite partout dans le monde.

'Ulster: Augenblick des Terrors', aufgenommen am Marine Hotel, Ballycastle, Nord-Irland, weltweit veröffentlicht.

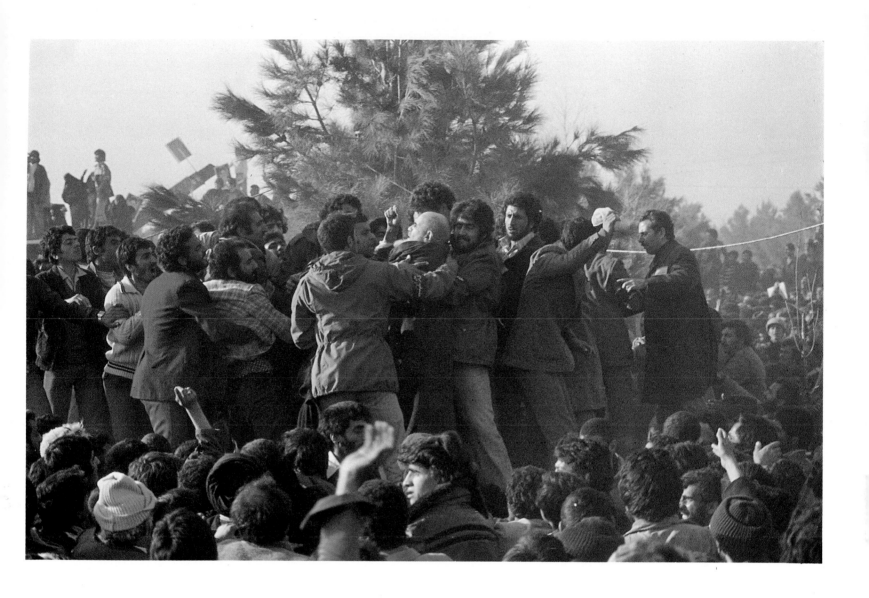

Photographer · Photographe · Fotograph · ALAIN MINGAM

'The return of the Ayatollah,' taken on location in Iran; first published in 'The Sunday Times Magazine' in February 1979 and later in other publications throughout the world.

Prise sur place en Iran, 'Le retour de l'Ayatollah' a été publiée pour la première fois en février 1979 dans 'The Sunday Times Magazine' et plus tard dans d'autres publications partout dans le monde.

'Die Rückkehr des Ayatollah,' photographiert in Iran. Zuerst erschienen im Februar 1979 in 'The Sunday Times Magazine,' später weltweit.

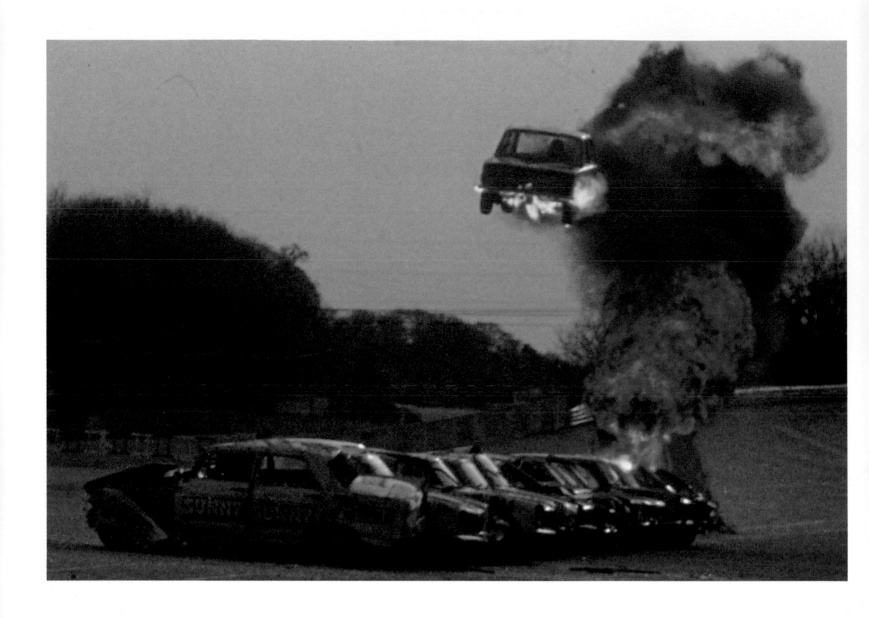

Photographer · Photographe · Fotograph · FRANCOLON
Designer · Maquettiste · Gestalter · WERNER DICK
Art Director · Directeur Artistique · ROLF GILLHAUSEN
Publishing Company · Editeur · Verleger · GRUNER & JAHR AG & CO

Double-page spread for the feature 'Die Tricks der Todesfahrer' (The deathdriver's tricks), in 'Stern' September 1980.

Double page sélectionnée du reportage 'Les trucs du conducteur de mort', publiée dans 'Stern' septembre 1980.

Doppelseite zur Reportage 'Die Tricks der Todesfahrer', im 'Stern' September 1980.

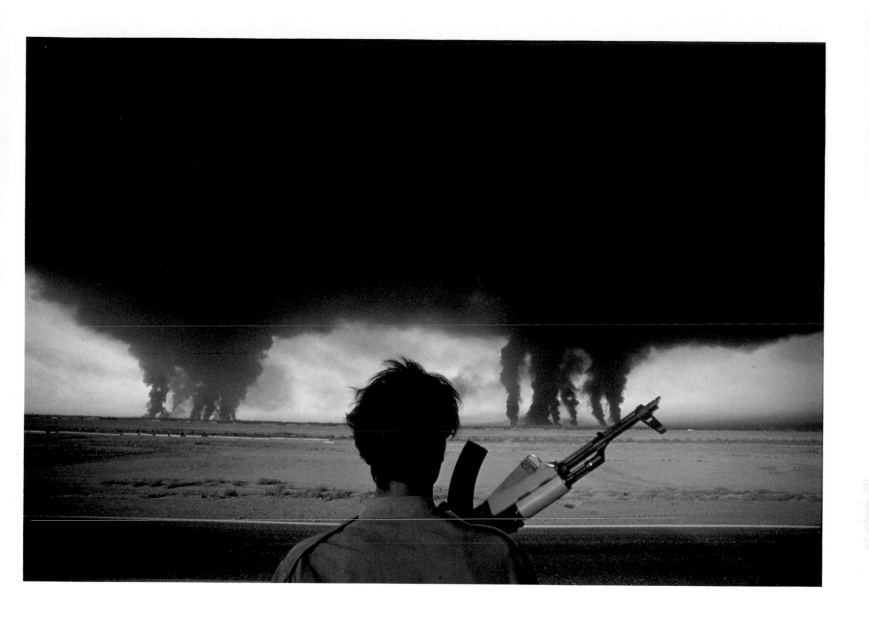

Photographer · Photographe · Fotograph · HENRI BUREAU

Taken on location with the Iraqi forces inside Iran. 'Abadan in flames' has been reproduced in 'Time', 'Now!' and 'The Sunday Times Magazine', September 1980.

Prise sur place avec l'armée iraquienne en Iran. 'Abadan en flammes' a été reproduite dans 'Time', 'Now!' et 'The Sunday Times Magazine', septembre 1980.

Aufgenommen unter den irakischen Truppen in Iran. 'Abadan in Flammen', veröffentlicht in 'Time', 'Now!' und 'The Sunday Times Magazine', September 1980.

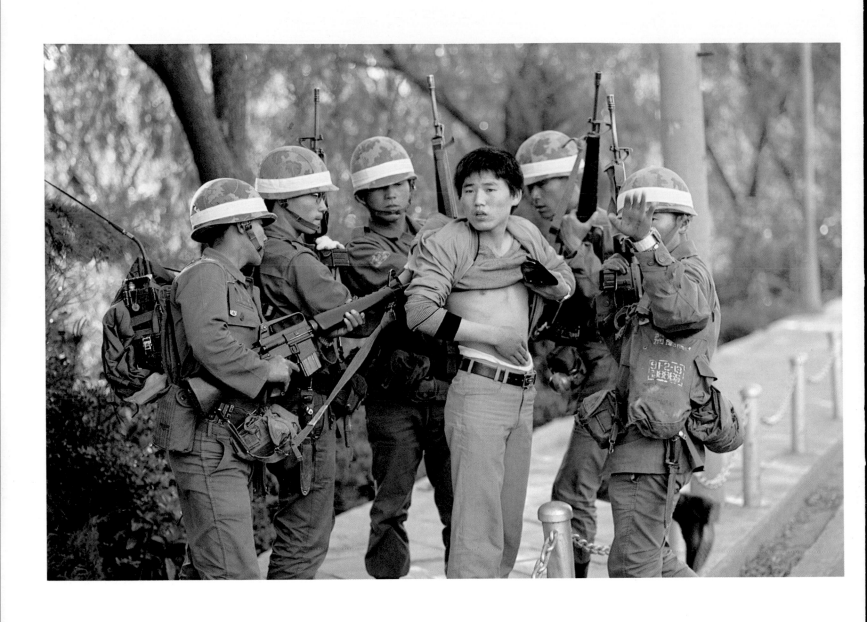

Photographer · Photographe · Fotograph · JAY ULLAL
Designer · Maquettiste · Gestalter · WOLF DAMMANN
Art Director · Directeur Artistique · ROLF GILLHAUSEN
Publishing Company · Editeur · Verleger · GRUNER & JAHR AG & CO

'Jagd auf die Zivilisten' (Hunting the civilians), double-page spread from the feature 'Ein Volk hat Angst vor der eigenen Armee' (A nation afraid of its own army) by Bernd Dörler, in 'Stern' September 1980.

'La Chasse aux Civils', double page sélectionnée du reportage 'Une nation qui a peur de sa propre armée' par Bernd Dörler, publié dans 'Stern' septembre 1980.

'Jagd auf die Zivilisten', Doppelseite aus der Reportage 'Ein Volk hat Angst vor der eigenen Armee' von Bernd Dörler, im 'Stern' September 1980.

Photographer · Photographe · Fotograph · JOHN GRIFFITH
Designer · Maquettiste · Gestalter · WOLF DAMMANN
Art Director · Directeur Artistique · ROLF GILLHAUSEN
Publishing Company · Editeur · Verleger · GRUNER & JAHR AG & CO

'Onkel Sam ist immer dabei' (Uncle Sam is always nearby), double-page spread from the feature 'Ein Volk hat Angst vor der eigenen Armee' (A nation afraid of its own army) by Bernd Dörler, in 'Stern' September 1980.

'L'Oncle Sam est toujours tout près', double page sélectionnée du reportage 'Une nation qui a peur de sa propre armée' par Bernd Dörler, publié dans 'Stern' septembre 1980.

'Onkel Sam ist immer dabei', Doppelseite aus der Reportage 'Ein Volk hat Angst vor der eigenen Armee' von Bernd Dörler, im 'Stern' September 1980.

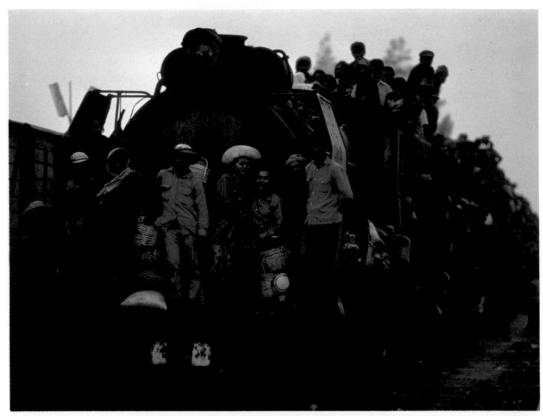

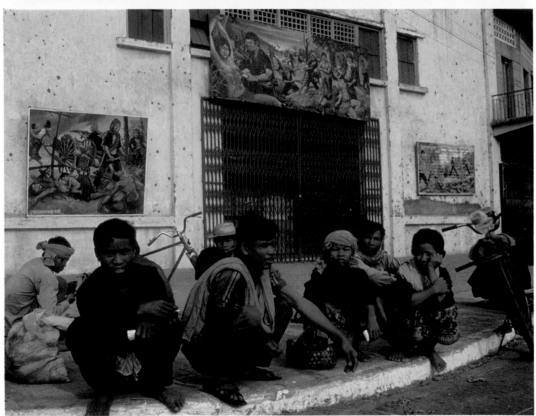

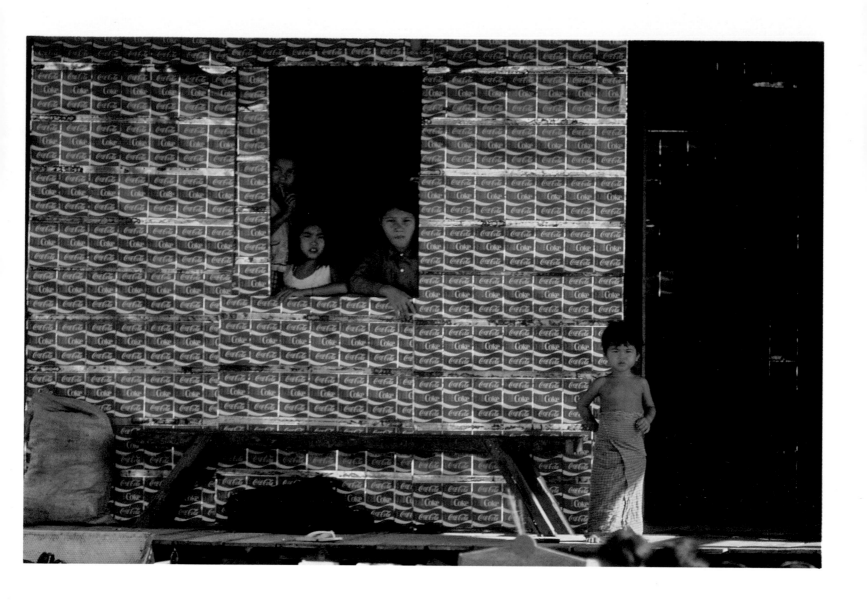

26, 27

Photographer · Photographe · Fotograph · JOHN GRIFFITH
Designer · Maquettiste · Gestalter · GÜNTHER MEYER
Art Director · Directeur Artistique · ROLF GILLHAUSEN
Publishing Company · Editeur · Verleger · GRUNER & JAHR AG & CO

Taken on location in Cambodia for the feature 'Rückkehr in die tote Stadt' (Return of the city of death) by Bernd Dörler, in 'Stern' May 1980.

Prise sur place au Cambodge pour le reportage 'Retour à la ville de la mort' par Bernd Dörler, publié dans 'Stern' mai 1980.

Aufgenommen in Kambodscha für die Reportage 'Rückkehr in die tote Stadt' von Bernd Dörler, im 'Stern' Mai 1980.

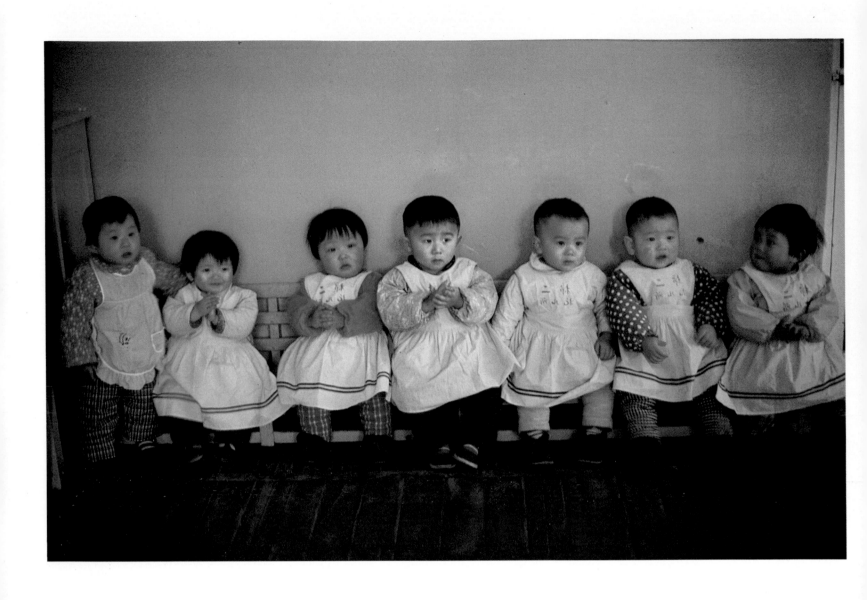

Photographer · Photographe · Fotograph · EVE ARNOLD
Art Director · Directeur Artistique · MICHAEL RAND
Publishing Company · Editeur · Verleger · TIMES NEWSPAPERS LIMITED

Chinese children in a Peking nursery selected from Eve Arnold's photojournalist report on China, 1980.

Des enfants chinois dans une garde d'enfants à Pekin sélectionée du reportage photojournaliste de Eve Arnold sur la Chine, 1980.

Chinesische Kinder in einem Kindergarten in Peking ausgewält aus dem Photo-Report über China von Eve Arnold, 1980.

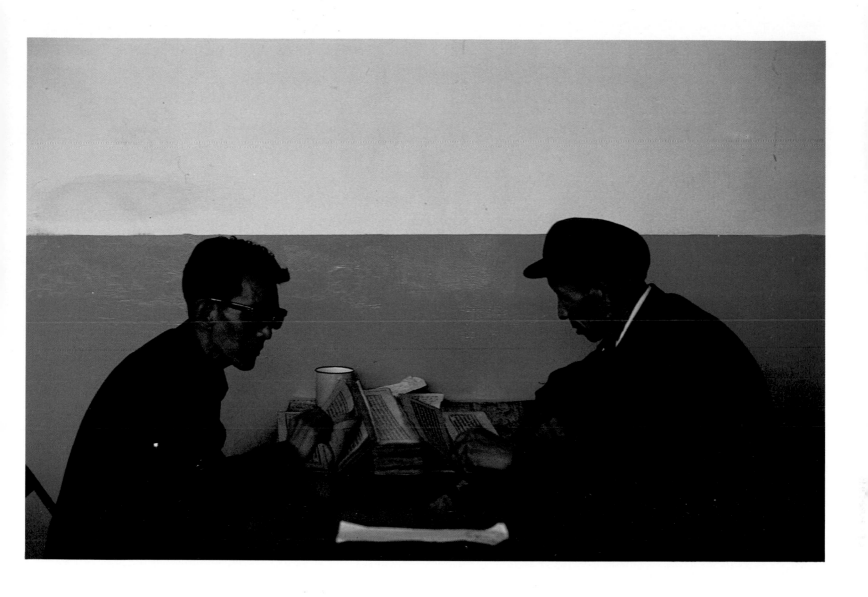

Photographer · Photographe · Fotograph · EVE ARNOLD
Art Director · Directeur Artistique · MICHAEL RAND
Publishing Company · Editeur · Verleger · TIMES NEWSPAPERS LIMITED

Peking doctors studying ancient texts of Tibetian medicine selected from Eve Arnold's photojournalist report on China, 1980.

Des médecins pékinois étudiant des textes anciens de la médicine tibétaine sélectionée du reportage photo-journaliste de Eve Arnold sur la Chine, 1980.

Ärzte aus Peking beim Studium alter Schriften der tibetanischen Heilkunst, ausgewält aus dem Photo-Report über China von Eve Arnold, 1980.

Photographer · Photographe · Fotograph · DON MCCULLIN
Art Director · Directeur Artistique · MICHAEL RAND
Publishing Company · Editeur · Verleger · TIMES NEWSPAPERS LIMITED

Photograph of monks flinching in a dust storm whilst greeting the Dalai Lama on his visit to the valley of Zanskar in the Himalayas, for the article 'The Hidden Valley' by Brian Moynahan, in 'The Sunday Times Magazine', December 1980.

Photographie de moines se réfugiant d'un orage de poussière pendant l'accueil du Dalai Lama à la vallée de Zanskar dans les Himalayas, pour l'article 'La vallée secrète' par Brian Moynahan, dans 'The Sunday Times Magazine', décembre 1980.

Ein Photo von Mönchen welche in einem Sandsturm zurückweichen während sie den Dalai Lama bei seinem besuch im Zanskartal, Himalaya begrüssen Dies für den Bericht 'Das Verstecktetal' von Brian Moynahan in 'The Sunday Times Magazine' Dezember 1980.

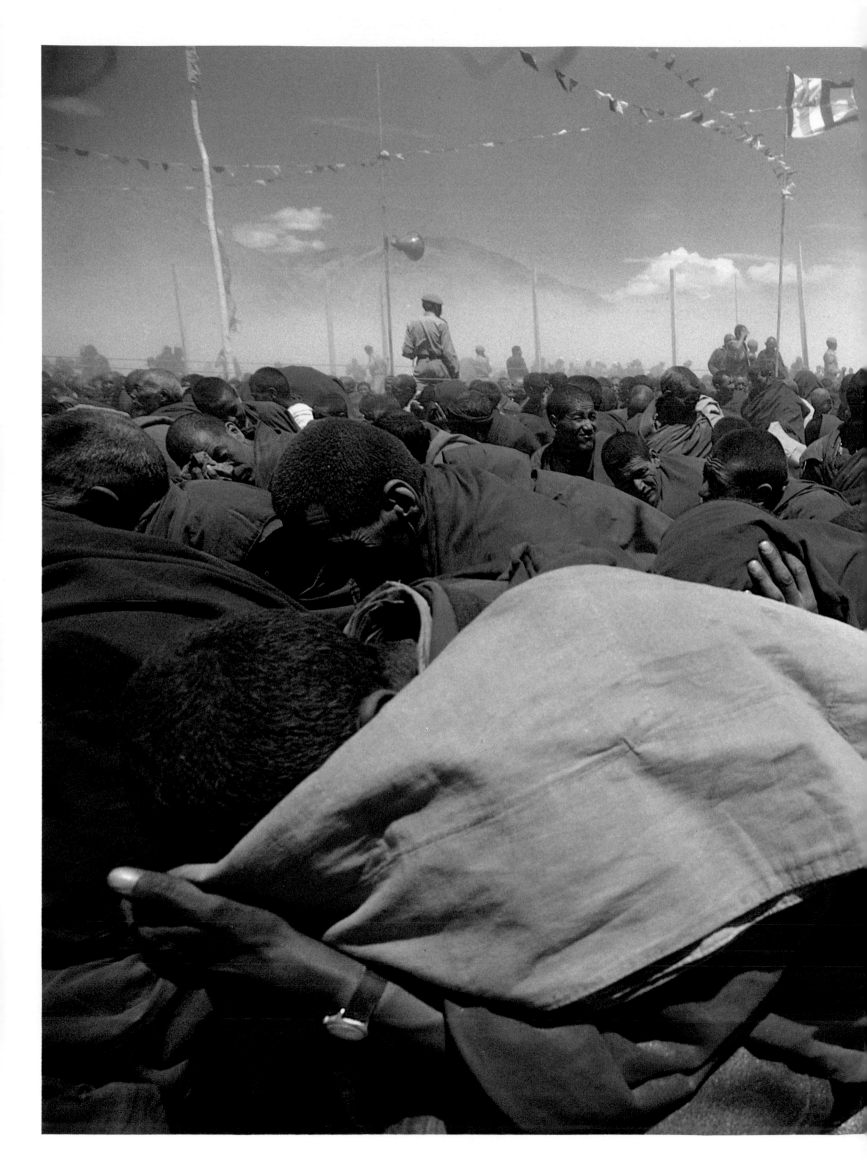

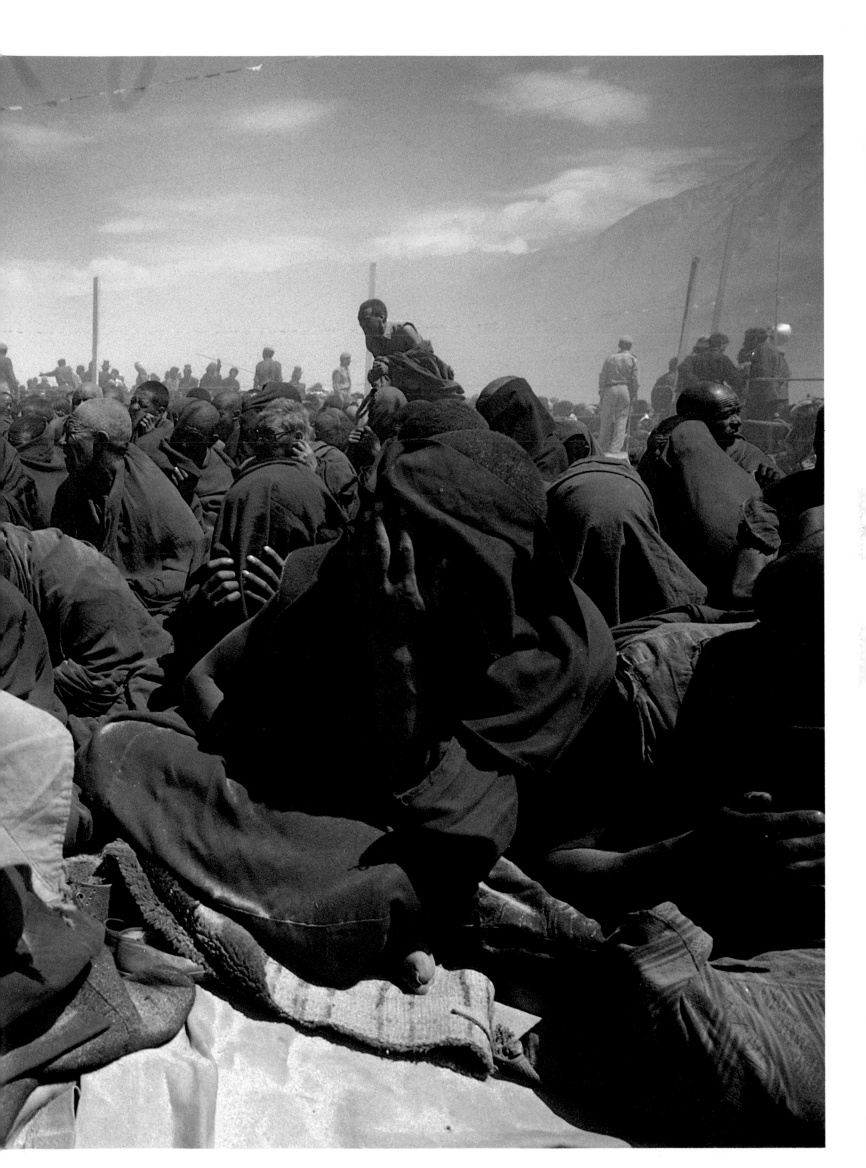

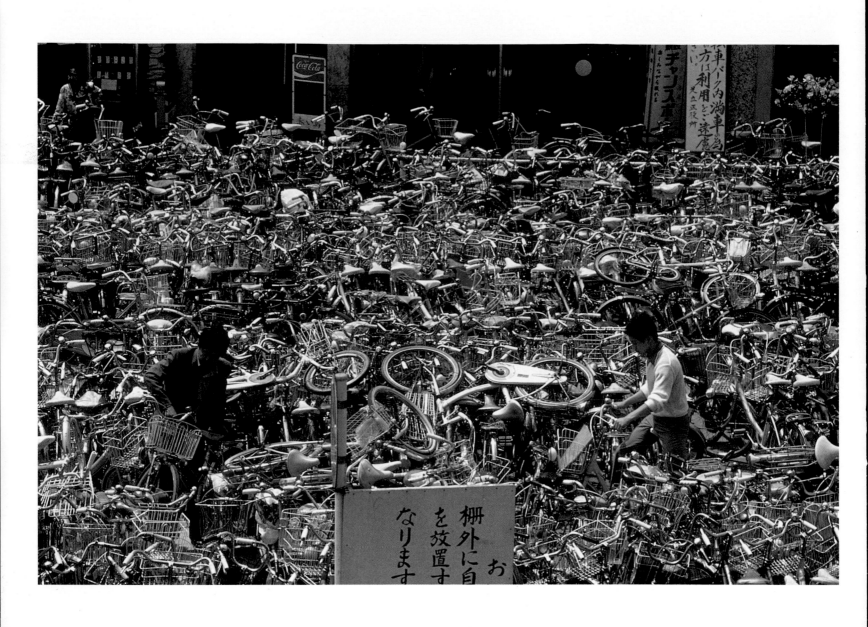

Photographer · Photographe · Fotograph · TADANORI SAITO

Designer · Maquettiste · Gestalter · GILVRIE MISSTEAR

Art Director · Directeur Artistique · MICHAEL RAND

Publishing Company · Editeur · Verleger · TIMES NEWSPAPERS LIMITED

Taken on location at Kita-Senju station, Tokyo, for the feature 'Japan Style versus Tokyo Style' by Murray Sayle, in 'The Sunday Times Magazine' March 1980.

Prise sur place à la gare de Kita-Senju, Tokyo, pour le reportage 'Le style japonais contre le style de Tokyo' écrit par Murray Sayle, publié dans 'The Sunday Times Magazine' mars 1980.

Aufgenommen auf dem Kita-Senju-Bahnhof, Tokio, für die Reportage 'Japans Stil contra Tokios Stil' von Murray Sayle, in 'The Sunday Times Magazine' März 1980.

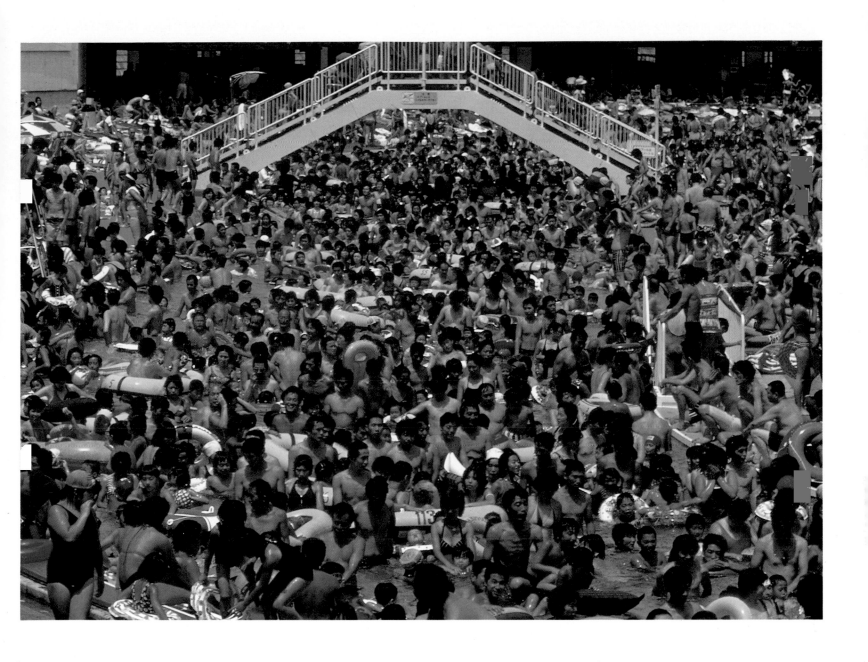

Photographer · Photographe · Fotograph · TADANORI SAITO
Designer · Maquettiste · Gestalter · GILVRIE MISSTEAR
Art Director · Directeur Artistique · MICHAEL RAND
Publishing Company · Editeur · Verleger · TIMES NEWSPAPERS LIMITED

Taken on location at Korakuen swimming pool, Tokyo, for the feature 'Japan Style versus Tokyo Style' by Murray Sayle, in 'The Sunday Times Magazine' March 1980.

Prise sur place à la piscine de Korakuen, Tokyo, pour le reportage 'Le style japonais contre le style de Tokyo' écrit par Murray Sayle, publié dans 'The Sunday Times Magazine' mars 1980.

Aufgenommen im Korakuen-Schwimmbad, Tokyo, für die Reportage 'Japans Stil contra Tokios Stil' von Murray Sayle, in 'The Sunday Times Magazine' März 1980.

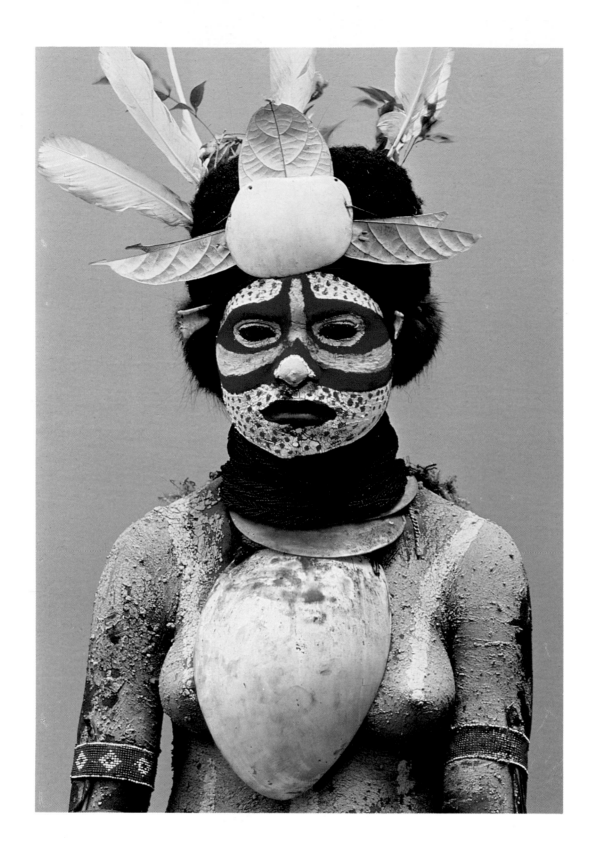

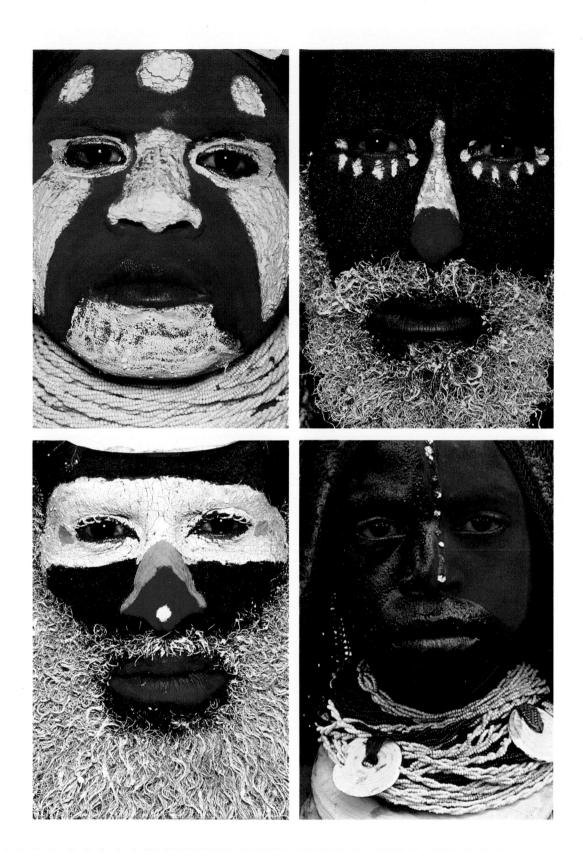

34, 35

Photographer · Photographe · Fotograph · MALCOLM KIRK
Designer · Maquettiste · Gestalter · PETER VOIGT
Art Directors · Directeurs Artistiques · ERWIN EHRET/FRANZ BRAUN
Publishing Company · Editeur · Verleger · GRUNER & JAHR AG & CO

'Mit den Masken sprechen sie eine Sprache, für die es keine Wörter gibt' (With masks they speak without words), double-page spread from the feature 'Menschen zum Lachen?' (People to make you laugh), in 'Geo' November 1980.

'En masques ils parlent sans paroles', double page sélectionnée du reportage de revue 'Les hommes qui font rire', dans 'Geo' novembre 1980.

'Mit den Masken sprechen sie eine Sprache, für die es keine Wörter gibt', Doppelseite aus der Reportage 'Menschen zum Lachen?', in 'Geo' November 1980.

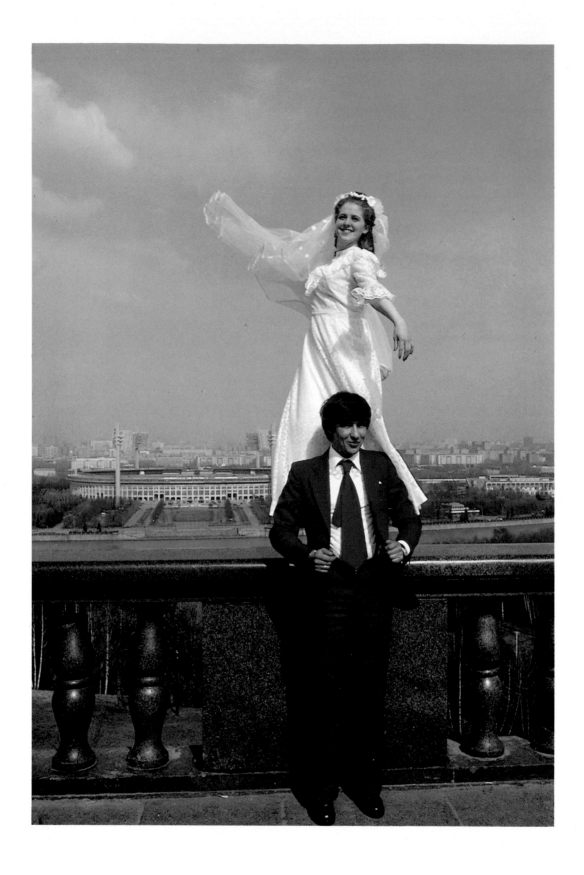

Photographer · Photographe · Fotograph · ALAIN LE GARSMEUR
Art Editor · Rédacteur Artistique · Kunstredakteur · GRAEME MURDOCH
Publishing Company · Editeur · Verleger · THE OBSERVER MAGAZINE LIMITED

Full-page photograph taken on location in Moscow for an article 'The people and the System' by Robert Chesshyre and Mark Frankland, in 'The Observer Magazine' July 1980.

Photographie de pleine page prise sur place à Moscou pour l'article 'Le Peuple et le système' écrit par Robert Chesshyre et Mark Frankland; 'The Observer Magazine', juillet 1980.

Ganzseitiges Photo, aufgenommen in Moskau, zur Geschichte 'Das Volk und das System' von Robert Chesshyre und Mark Frankland, in 'The Observer Magazine', Juli 1980.

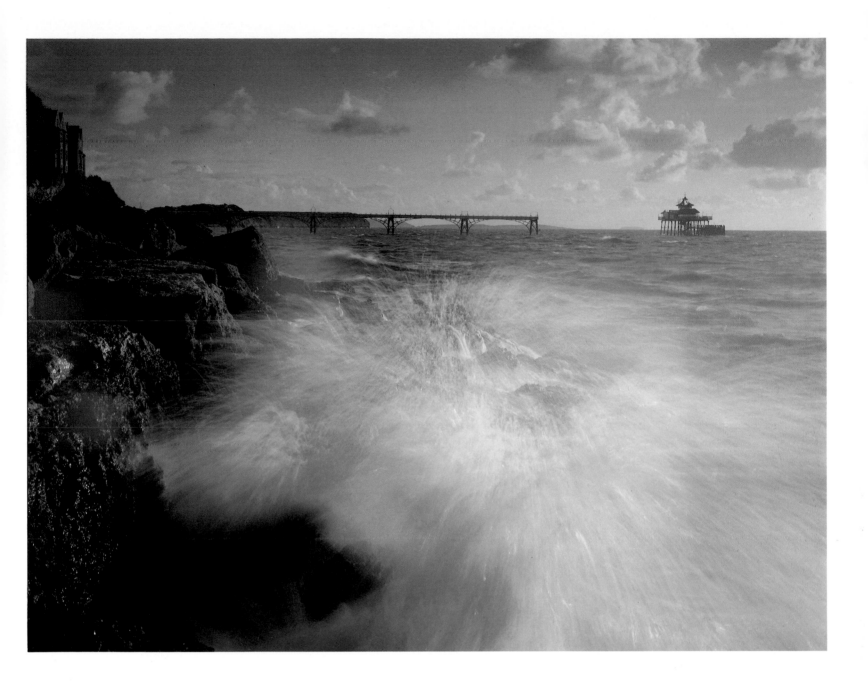

37, 38, 39

Photographer · Photographe · Fotograph · DENIS WAUGH
Designer · Maquettiste · Gestalter · JOHN TENNANT
Art Director · Directeur Artistique · MICHAEL RAND
Publishing Company · Editeur · Verleger · TIMES NEWSPAPERS LIMITED

Taken on location at Clevedon Pier and Brighton's Palace Pier for the feature 'Piers in Peril' by Roland Adburgham, in 'The Sunday Times Magazine'.

Prises sur place à la Jetée de Clevedon et à la Jetée du Palais à Brighton pour le reportage 'Les jetées promenades en péril' par Roland Adburgham, dans 'The Sunday Times Magazine'.

Photographiert auf den Landungsbrücken in Clevedon und Brighton für die Reportage 'Landungsbrücken in Gefahr' von Roland Adburgham, in 'The Sunday Times Magazine'.

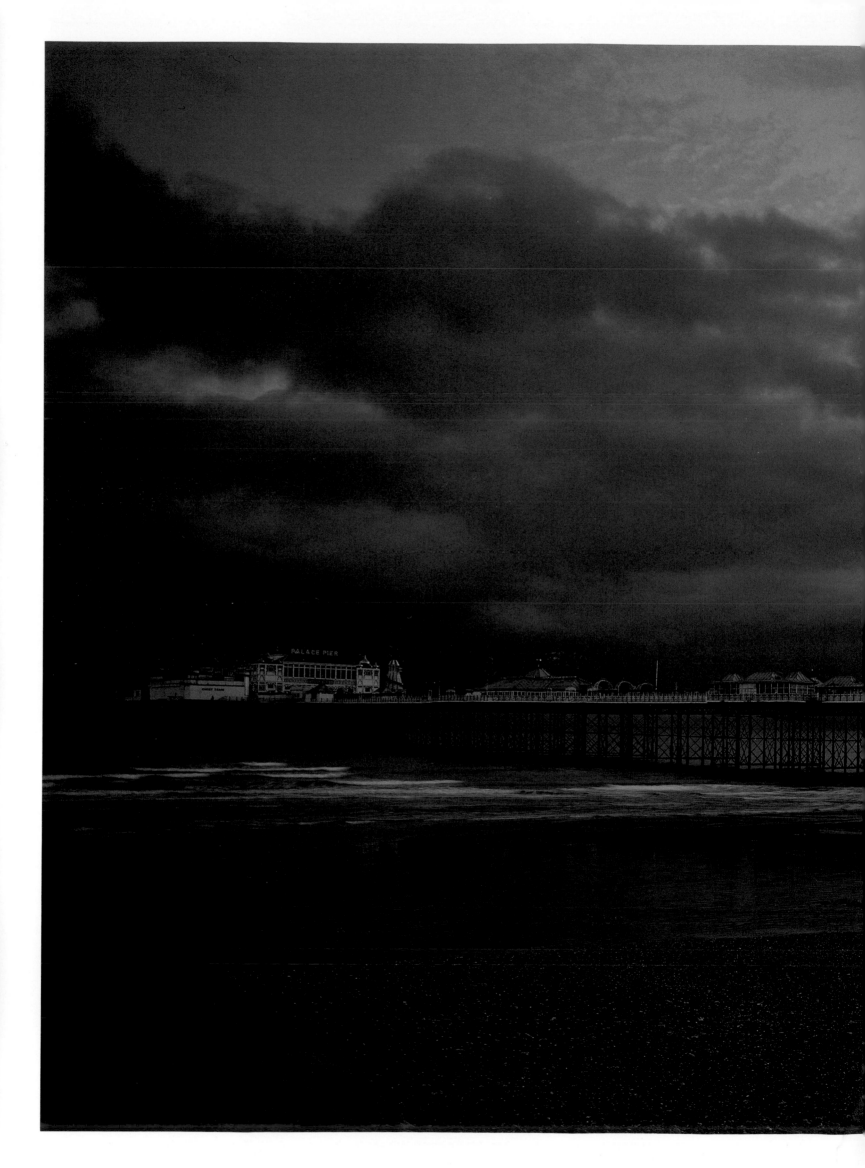

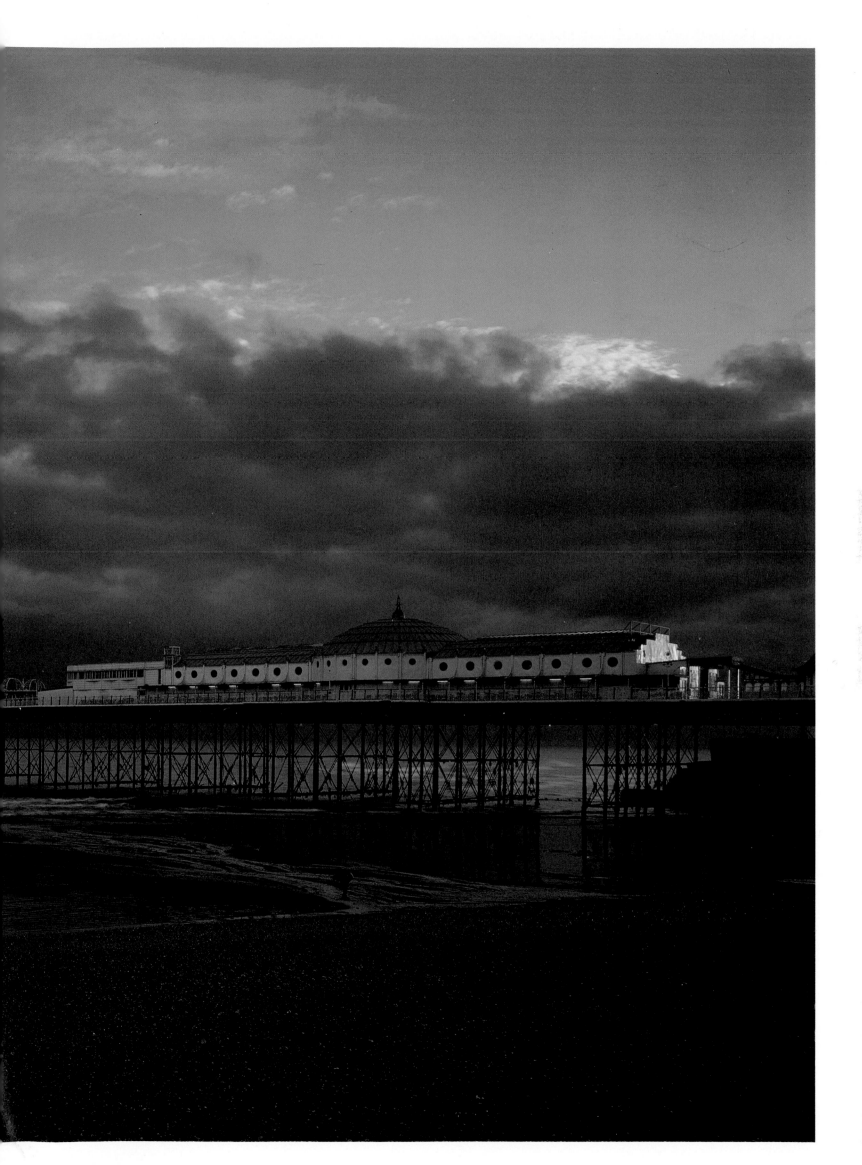

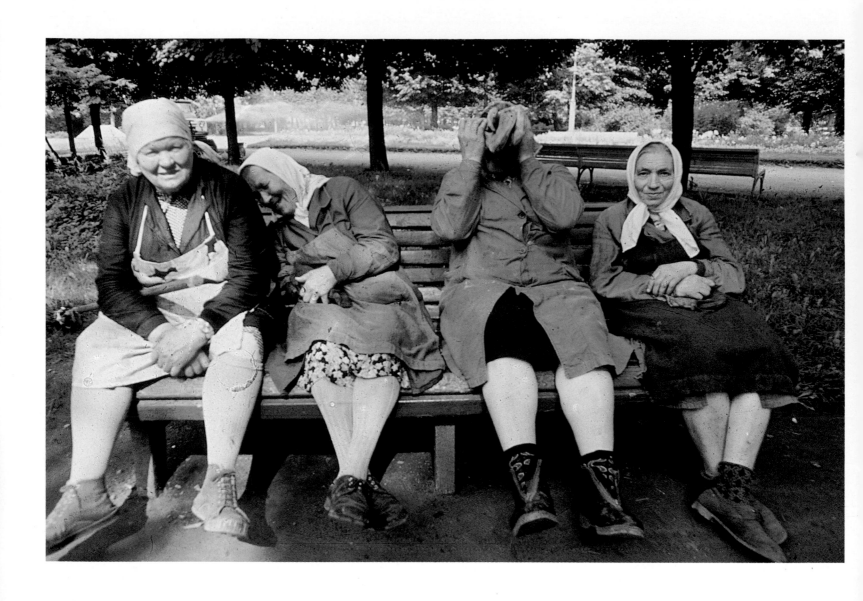

40

Photographer · Photographe · Fotograph · WILFRIED BAUER
Designer · Maquettiste · Gestalter · ANDREAS KRELL
Art Directors · Directeurs Artistiques · ERWIN EHRET/FRANZ BRAUN
Publishing Company · Editeur · Verleger · GRUNER & JAHR AG & CO

Double-page spread, taken on location in Gorki Park for the feature 'Der Garten an der Moskwa' (The gardens in Moscow) by Juri Trifonov, in 'Geo' October 1979.

Prises sur place au parc Gorki, les photographies sur cette double page ont été sélectionnées du reportage de magazine, 'Les Jardins de Moscou' écrit par Juri Trifonov, publié dans 'Geo' octobre 1979.

Doppelseite, aufgenommen im Gorki Park für die Geschichte 'Der Garten an der Moskwa' von Juri Trifonov, in 'Geo' Oktober 1979.

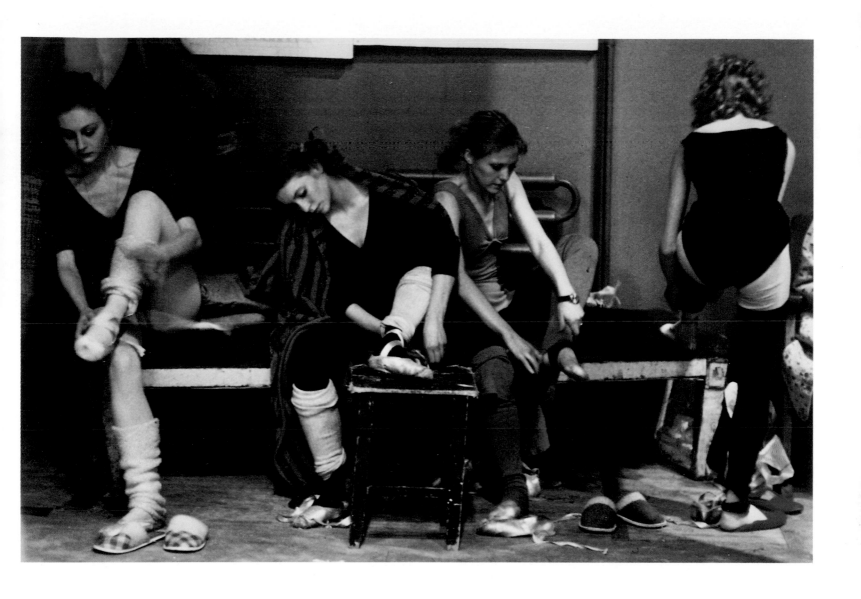

Photographer · Photographe · Fotograph · ROBERT LEBECK
Designer · Maquettiste · Gestalter · MAX LENGWENUS
Art Director · Directeur Artistique · ROLF GILLHAUSEN
Publishing Company · Editeur · Verleger · GRUNER & JAHR AG CO

Double-page spread for the feature 'Bolschoi', about the daily routine of the members of the Bolschoi Ballet Company, by Jürgen Kesting; in 'Stern'.

Une double page de l'article 'Bolschoi', un récit par Jürgen Kesting de la routine quotidienne des membres du Bolshoi; publié dans 'Stern'.

Doppelseite zur Reportage 'Bolschoi'. Ein Bericht von Jürgen Kesting über den Alltag der Mitglieder des Bolschoi-Balletts, im 'Stern'.

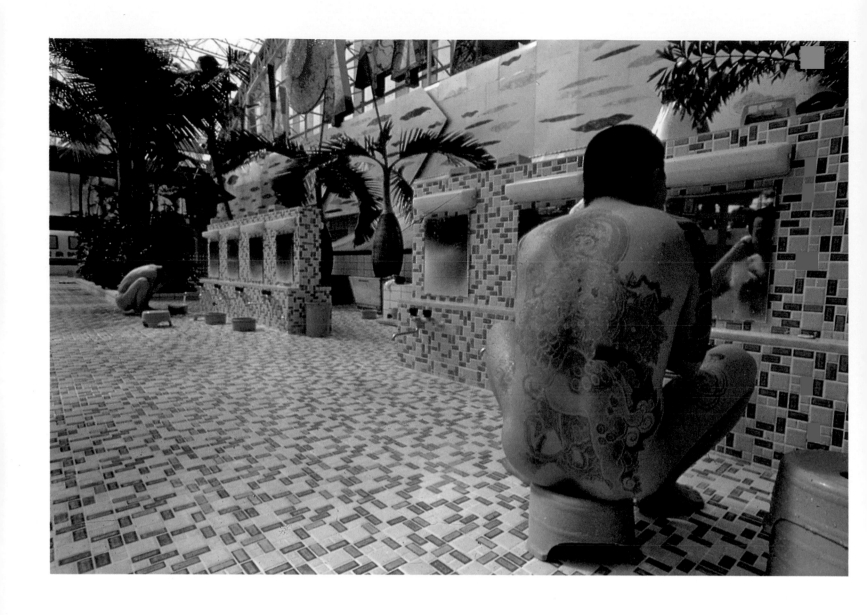

Photographer · Photographe · Fotograph · PAUL CHESLEY
Designer · Maquettiste · Gestalter · ANDREAS KRELL
Art Director · Directeur Artistique · ERWIN EHRET
Publishing Company · Editeur · Verleger · GRUNER & JAHR AG & CO

Taken on location in Beppu, Japan for the feature 'Ein Volk unter Dampf' (A nation under steam) by Constance Brown, showing a rare example of the dying tradition of tattooing; 'Geo' January 1980.

Prise sur place à Beppu, Japon pour un reportage par Constance Brown, cette photographie montre un rare exemple du tatouage, une tradition qui est en train de disparaître; publiée dans 'Geo' Janvier 1980.

Photographiert in Beppu, Japan, für die Reportage 'Ein Volk unter Dampf' von Constance Brown. Die Aufnahme zeigt ein ausgefallenes Beispiel der aussterbenden Tradition des Tatöwierens; in 'Geo' Januar 1980.

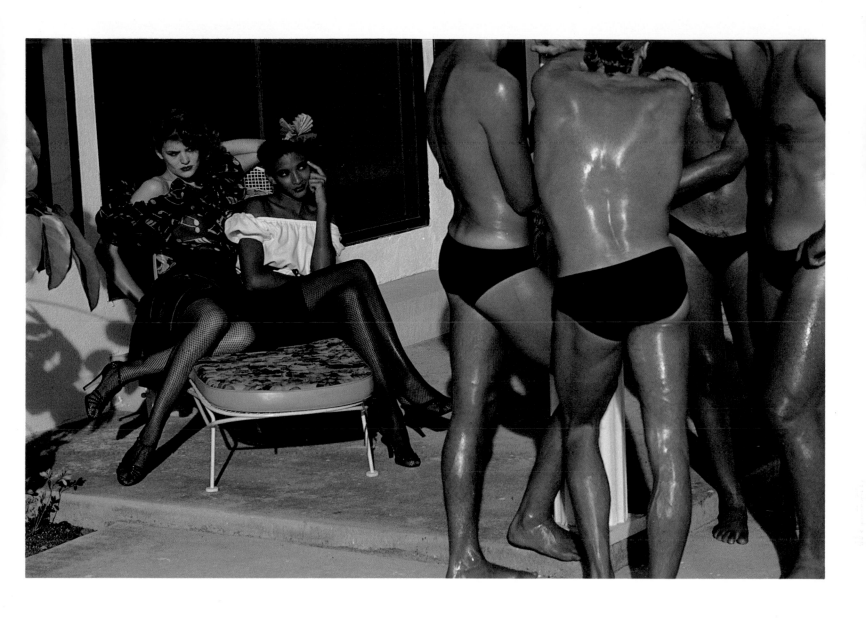

Photographer · Photographe · Fotograph · HELMUT NEWTON
Designer · Maquettiste · Gestalter · MAX LENGWENUS
Art Director · Directeur Artistique · ROLF GILLHAUSEN
Publishing Company · Editeur · Verleger · GRUNER & JAHR AG & CO

Double-page spread from a fashion feature by Barbara Larcher about black and white clothes, in 'Stern' 1980.

Double page sélectionnée d'un reportage sur la mode au sujet du noir et du blanc comme les couleurs en vogue, publiée dans 'Stern' 1980.

Doppelseite aus einem Mode-Bericht von Barbara Larcher über schwarze und weiße Kleidung, im 'Stern' 1980.

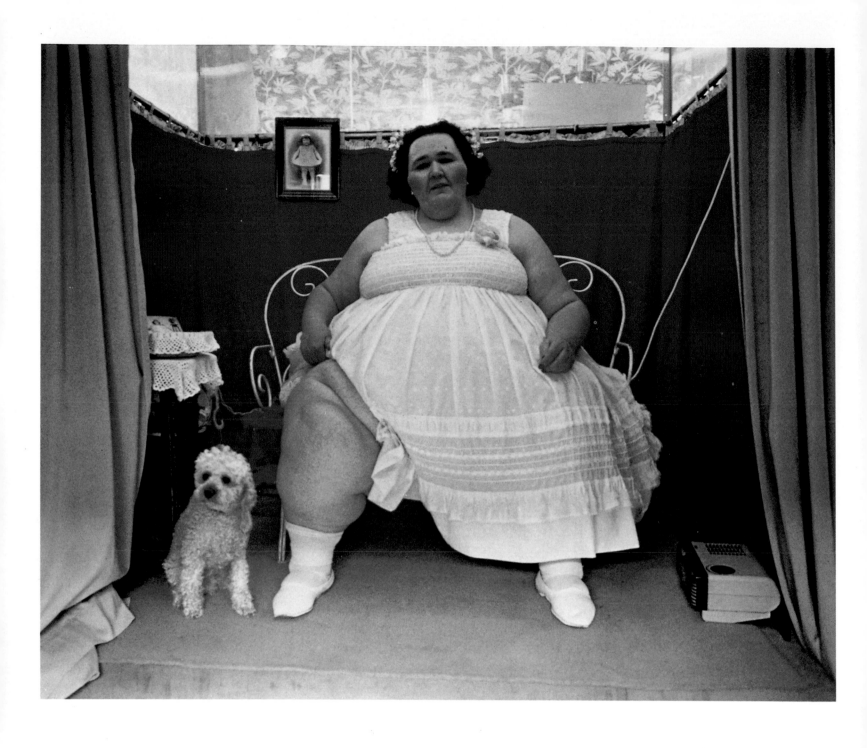

Photographer · Photographe · Fotograph · PETER THOMANN
Designer · Maquettiste · Gestalter · WALTER STRENGE
Art Director · Directeur Artistique · ROLF GILLHAUSEN
Publishing Company · Editeur · Verleger · GRUNER & JAHR AG & CO

'Der Floh zieht nicht mehr' (The flea has lost its attraction), from an article about travelling showmen by Birgit Lahann, in 'Stern' July 1980.

'Les puces n'attirent plus', double page d'un reportage au sujet de forains, écrit par Birgit Lahann; dans 'Stern' juillet 1980.

'Der Floh zieht nicht mehr', Doppelseite aus einem Artikel über Schausteller von Birgit Lahann, im 'Stern' Juli 1980.

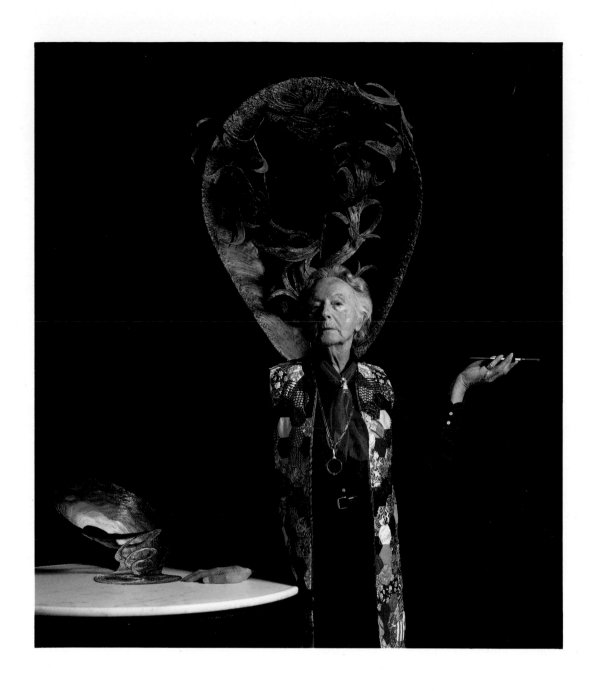

Photographer · Photographe · Fotograph · SNOWDON

Publishing Company · Editeur · Verleger · CONDÉ NAST PUBLICATIONS LIMITED

Portrait of Erté for the 'Spotlight' column in 'Vogue',
June 1980.

Portrait d'Erté pour la rubrique 'Spotlight' dans
'Vogue', juin 1980.

Portrait von Erté für die 'Spotlight' Spalte in 'Vogue',
Juni 1980.

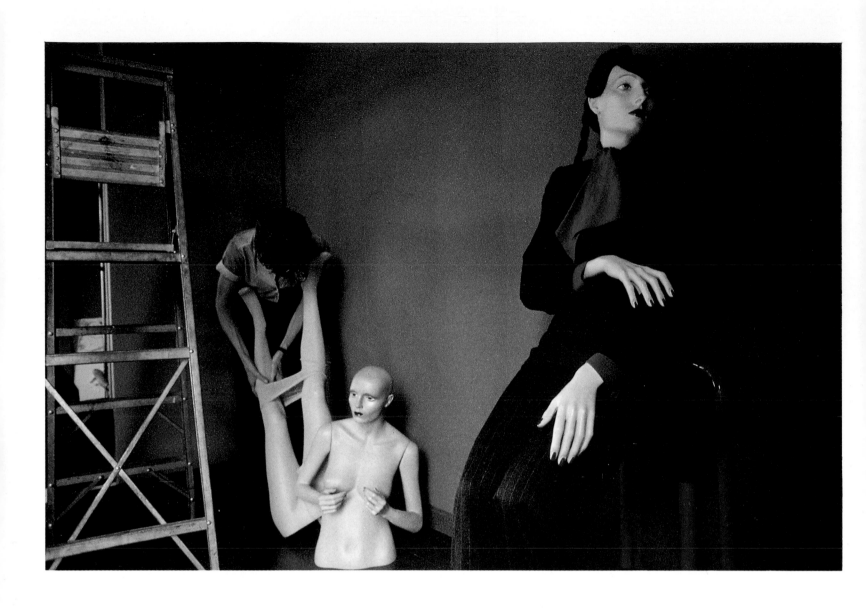

Photographer · Photographe · Fotograph · GUIDO MANGOLD

Designer · Maquettiste · Gestalter · PETER VOIGT

Art Directors · Directeurs Artistiques · ERWIN EHRET/FRANZ BRAUN

Publishing Company · Editeur · Verleger · GRUNER & JAHR AG & CO

Double-page spread for the feature 'Bloomies' (sobriquet of New York's famous department store Bloomingdales) by Annaliese Friedmann, in 'Geo' December 1980.

Double page du reportage 'Bloomies' (le sobriquet pour Bloomingdales, le grand magasin célèbre à New York) écrit par Annaliese Friedmann; dans 'Geo' décembre 1980.

Doppelseite zur Reportage 'Bloomies' (Kosename für New Yorks berühmtestes Kaufhaus Bloomingdale) von Annaliese Friedmann, in 'Geo' Dezember 1980.

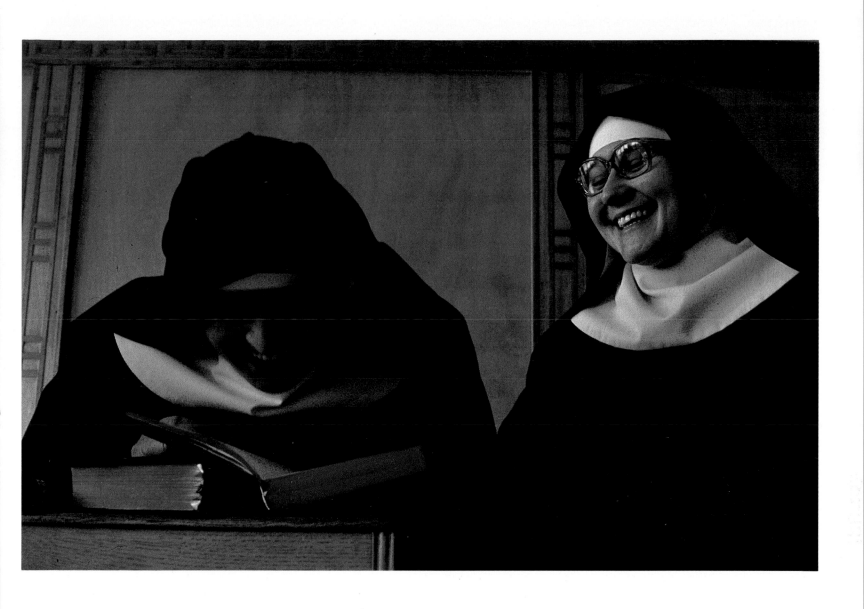

Photographer · Photographe · Fotograph · ANNE-MARIE GROBET
Designer · Maquettiste · Gestalter · PETER DASSE
Art Directors · Directeurs Artistiques · ERWIN EHRET/FRANZ BRAUN
Publishing Company · Editeur · Verleger · GRUNER & JAHR AG & CO

'Zusammen schweigen und zusammen lachen' (Silence together and laughter together), double-page spread from the feature 'Die Freiheit hinter Mauern' (Freedom behind walls) by Barbara Franck, in 'Geo' December 1980.

'Etre silent ensemble et rire ensemble', double page sélectionnée du reportage 'La liberté derrière les murs' écrit par Barbara Franck, dans 'Geo' décembre 1980.

'Zusammen schweigen und zusammen lachen', Doppelseite aus der Reportage 'Die Freiheit hinter Mauern' von Barbara Franck, in 'Geo' Dezember 1980.

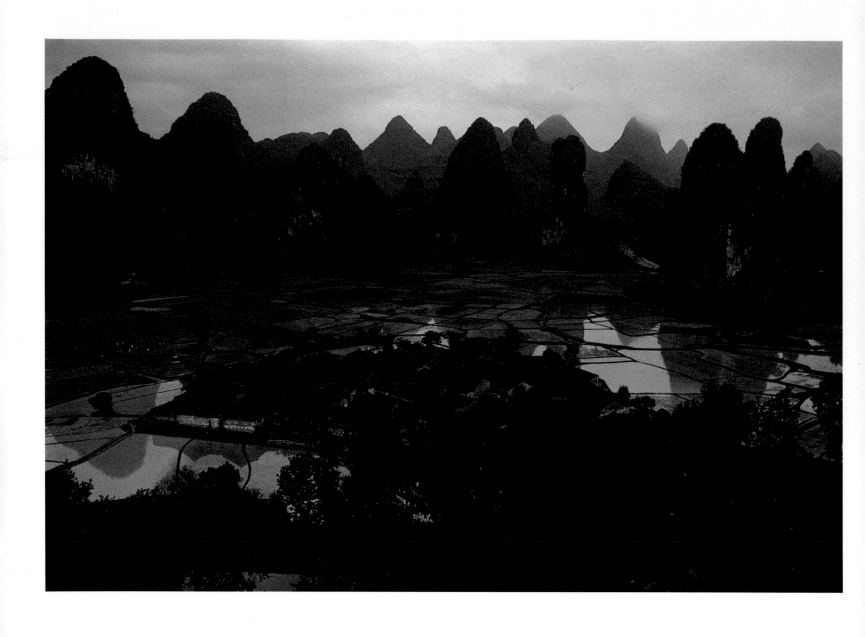

Photographer · Photographe · Fotograph · BRUNO BARBEY
Designer · Maquettiste · Gestalter · DIETMAR SCHULZE
Art Director · Directeur Artistique · ROLF GILLHAUSEN
Publishing Company · Editeur · Verleger · GRUNER & JAHR AG & CO

'Beim Reisanbau lernt man Rücksicht üben' (At the rice planting you learn to be careful), double-page spread from the feature 'Zu neuen Ufern' (Towards new frontiers) by Erwin Wickert, in 'Stern' September 1980.

'A la plantation du riz vous apprenez à faire attention', double page sélectionnée du reportage 'Envers de nouvelles frontières' par Erwin Wickert, publié dans 'Stern' septembre 1980.

'Beim Reisanbau lernt man Rücksicht üben', Doppelseite aus der Reportage 'Zu neuen Ufern' von Erwin Wickert, im 'Stern' September 1980.

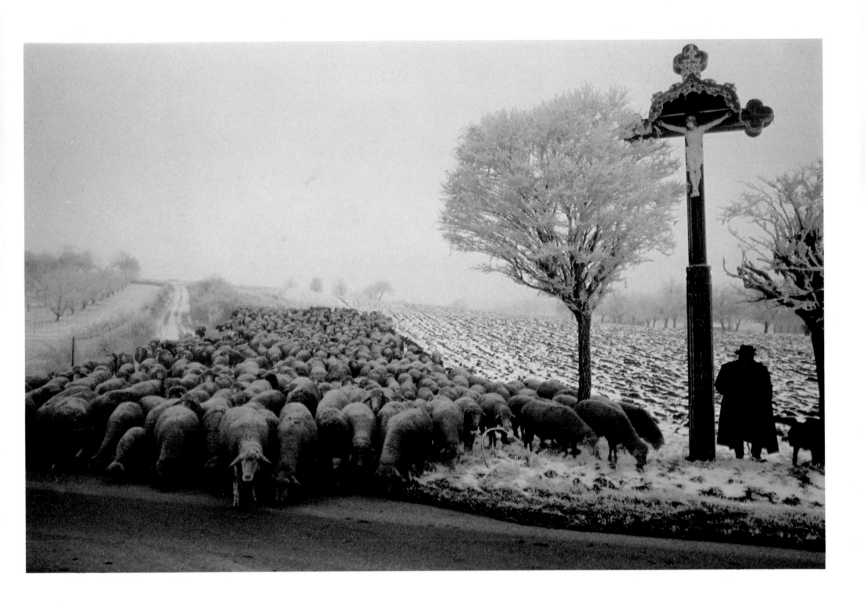

Photographer · Photographe · Fotograph · WOLFGANG STAIGER

Designer · Maquettiste · Gestalter · DETLEF SCHLOTTMANN

Art Director · Directeur Artistique · ROLF GILLHAUSEN

Publishing Company · Editeur · Verleger · GRUNER & JAHR AG & CO

Double-page spread from the feature 'Das romantische Risiko' (The romantic risk) by Leo Sievers, in 'Stern' January 1980.

Une double page du reportage 'Le risque romantique' par Leo Sievers, publié dans 'Stern' janvier 1980.

Doppelseite zur Reportage 'Das romantische Risiko' von Leo Sievers, im 'Stern' Januar 1980.

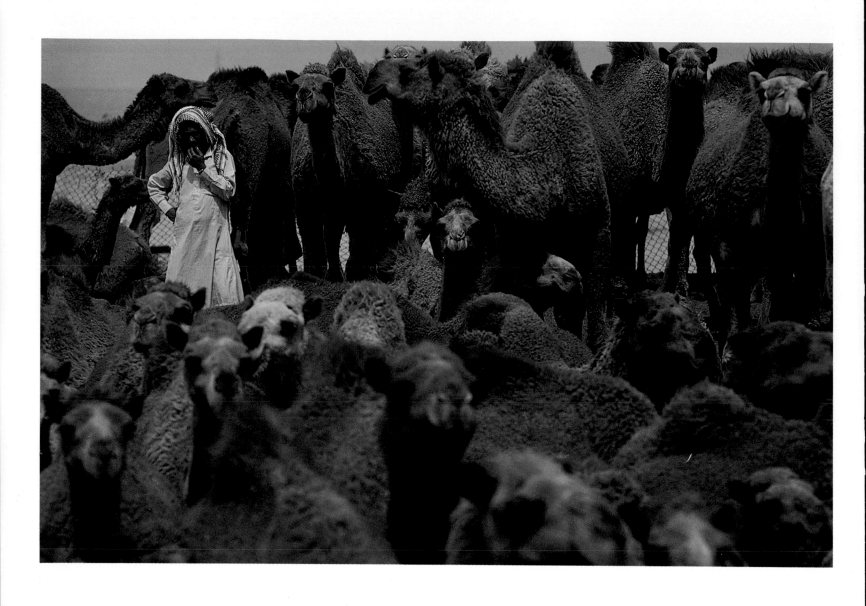

Photographer · Photographe · Fotograph · PHIL SAYER
Designers · Maquettistes · Gestalter · NANCY WILLIAMS/DAVID HILLMAN
Art Director · Directeur Artistique · DAVID HILLMAN
Publishing Company · Editeur · Verleger · THE COMMERCIAL BANK OF KUWAIT
Design Group · Equipe de Graphistes · Design Gruppe · PENTAGRAM

Taken on location in the camel market at Al-Jahara; double-page spread for the feature 'Kuwait is a Market' by David Gibbs and Phil Sayer, in 'Dinar' 1980.

Double page sélectionnée du reportage 'Koweit est un marché' écrit par David Gibbs et Phil Sayer; prise sur place au marché aux chameaux a Al-Jahara et publiée dans 'Dinar' 1980.

Doppelseite photographiert auf dem Kamelmarket von Al-Jahara zu dem Bericht 'Kuweit ist ein Markt', von David Gibbs und Phil Sayer, in 'Dinar' 1980.

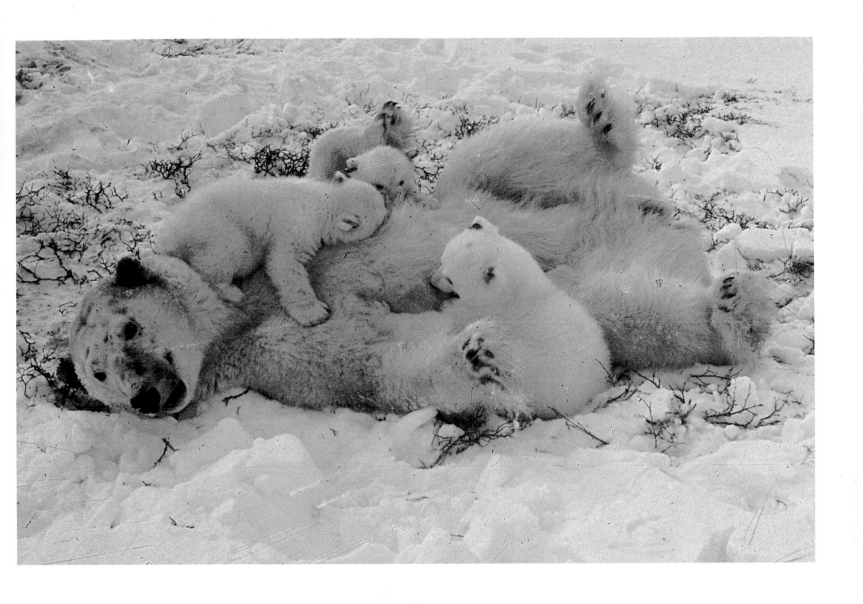

Photographer · Photographe · Fotograph · IVARS SILIS
Designer · Maquettiste · Gestalter · JOHANNES DÖNGES
Art Directors · Directeurs Artistiques · ERWIN EHRET/ FRANZ BRAUN
Publishing Company · Editeur · Verleger · GRUNER & JAHR AG & CO

'Erst drei Monate nach der Geburt erblicken sie das Licht der Welt' (At three months they can see for the first time), double-page spread from the feature 'Die Stadtstreicher von Churchill Town' (The tramps of Churchill Town) by Ivars Silis, in 'Geo' August 1980. The blood on the bear's face is the result of its having been tagged for research. The photographer has worked closely over the years with polar bears, as a scientist as well as a photographer.

'A l'âge de trois mois ils voient pour la première fois', double page du reportage 'Les vagabonds de Churchill Town' écrit par Ivars Silis, publié dans 'Geo' août 1980. Le visage de l'ours est ensanglanté parce que l'ours a été marqué pour la recherche. Le photographe travaille de près depuis des années auprès des ours blancs en tant que scientifique aussi bien que photographe.

'Erst drei Monate nach der Geburt erblicken sie das Licht der Welt', Doppelseite zur Reportage 'Die Stadtstreicher von Churchill Town' von Ivars Silis, in 'Geo' August 1980. Das Blut ist auf den Bären-Gesichtern, weil sie zu Forschungszwecken gefangen worden sind. Der Photograph arbeitete jahrelang mit den Polar-Bären, als Wissenschaftler und als Photograph.

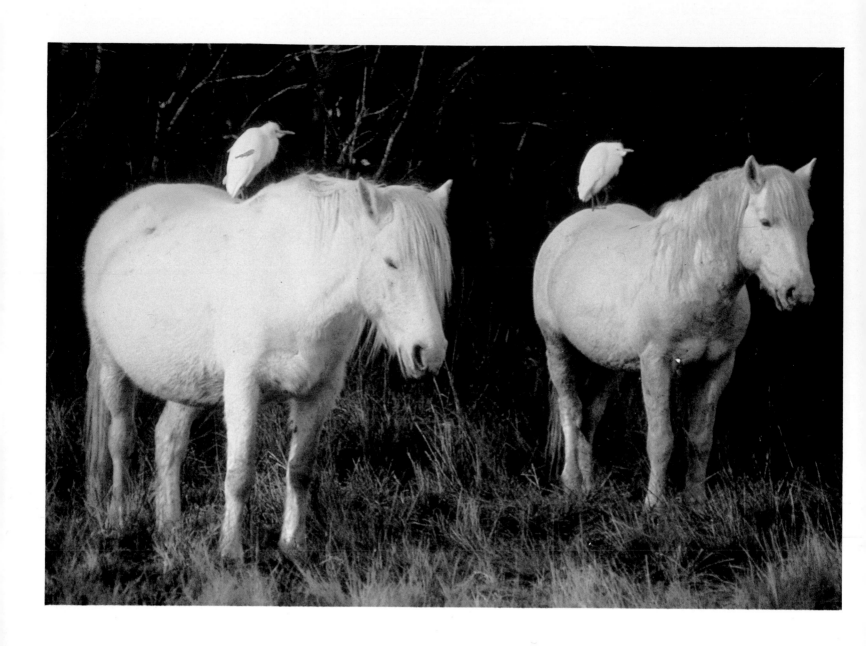

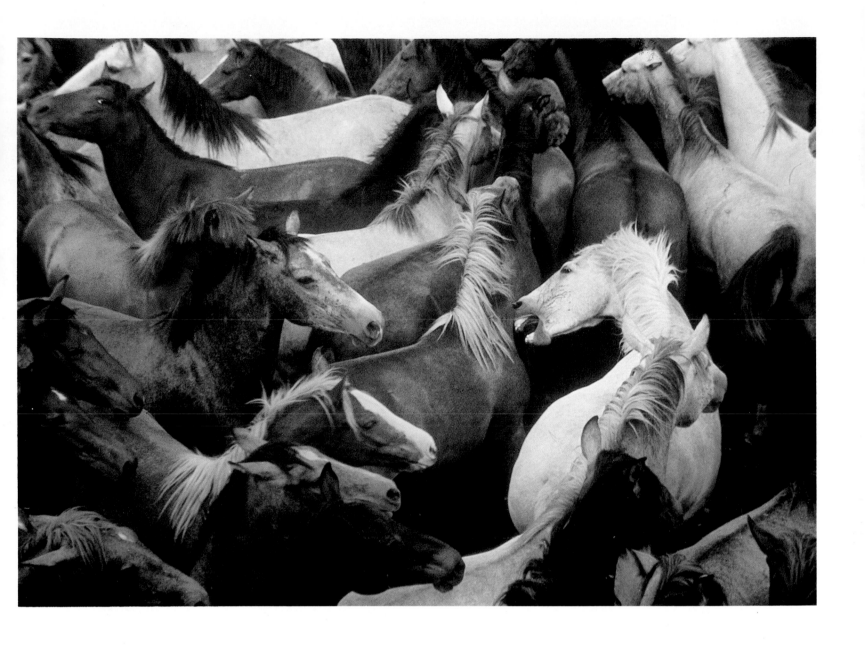

52, 53, 54, 55

Photographer · Photographe · Fotograph · ROBERT VAVRA
Designer · Maquettiste · Gestalter · DETLEF CONRATH
Art Director · Directeur Artistique · ROLF GILLHAUSEN
Publishing Company · Editeur · Verleger · GRUNER & JAHR AG & CO

'Die Hackordnung der Herde' (The rule of the herd), from the feature 'Die Sprache der Pferde' (Horse-language) by Klaus Thews, in 'Stern' March 1980.

'La loi du troupeau', selectionée du reportage 'La langue des chevaux' par Klaus Thews, publiée dans 'Stern' mars 1980.

'Die Hackordnung der Herde', ausgewählt aus der Reportage 'Die Sprache der Pferde' von Klaus Thews, im 'Stern' März 1980.

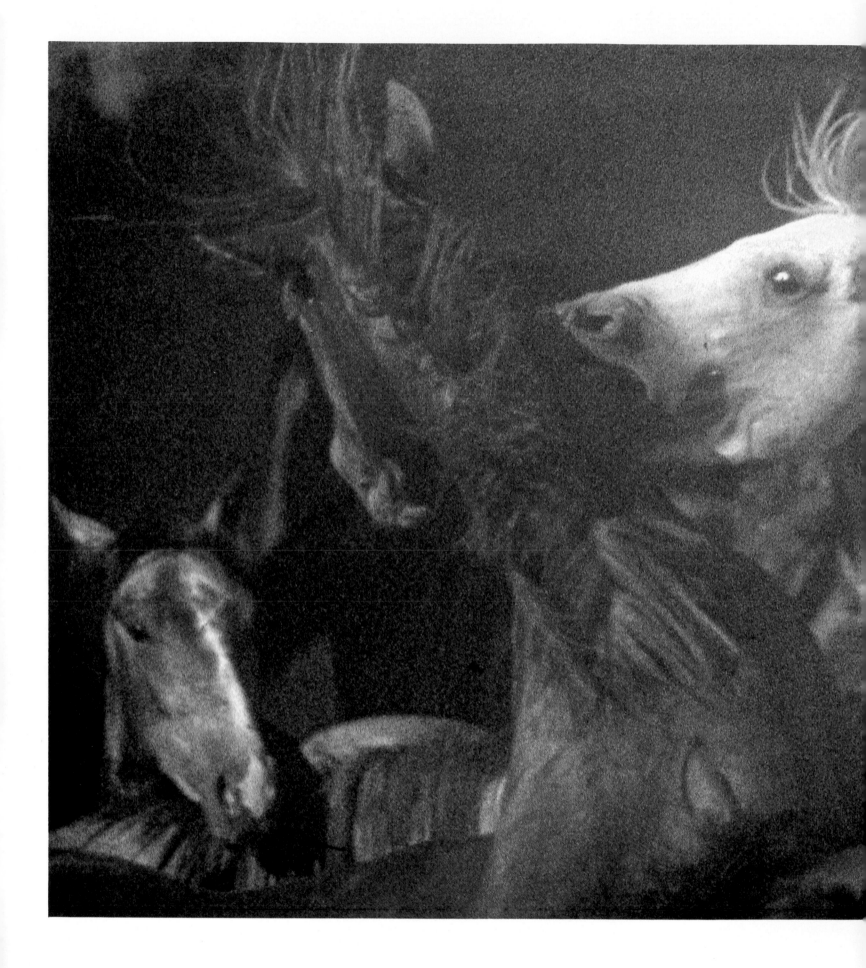

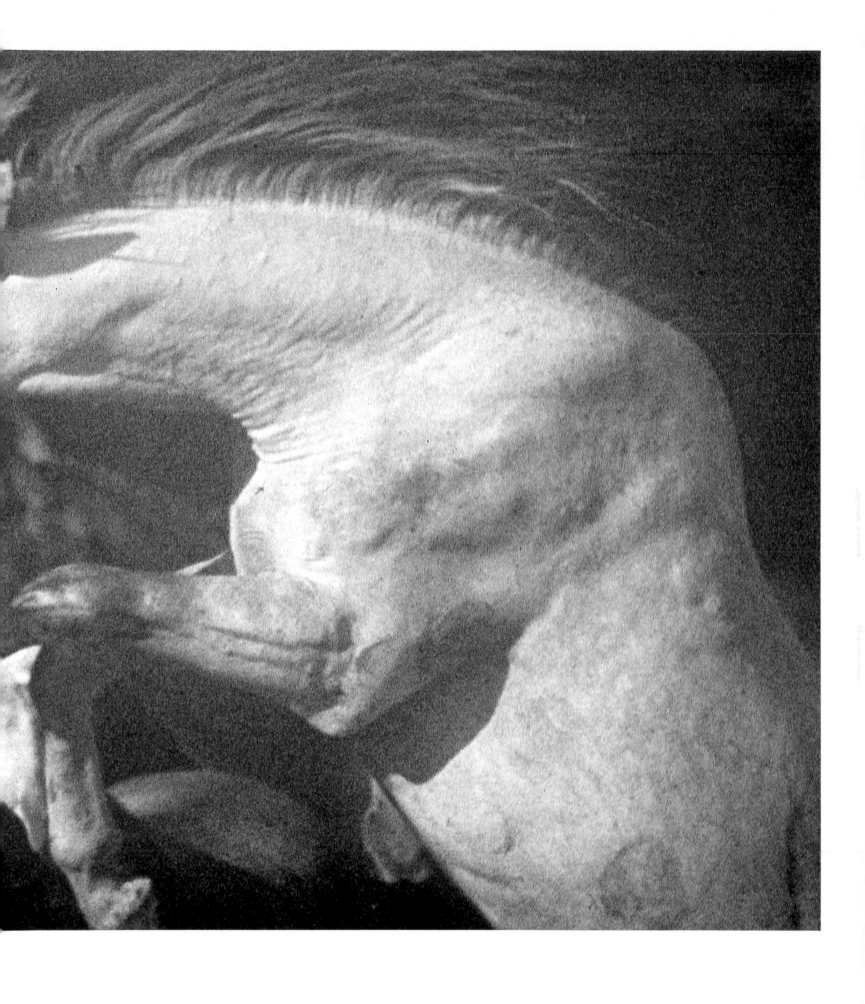

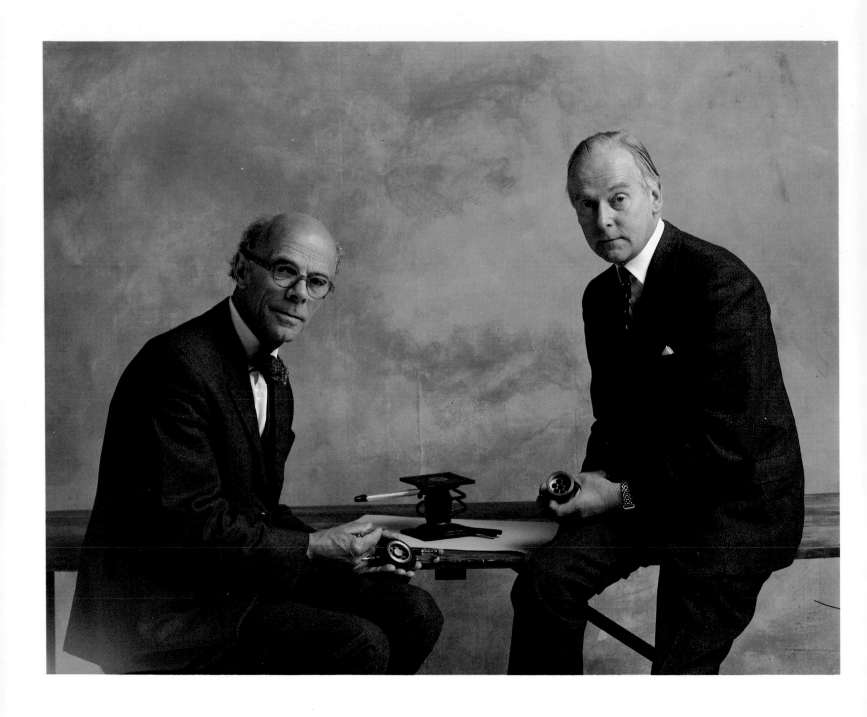

Photographer · Photographe · Fotograph · DUFFY
Art Director · Directeur Artistique · MICHAEL RAND
Publishing Company · Editeur · Verleger · TIMES NEWSPAPERS LIMITED

Portrait of the two scientists John Randall and Henry Boot for the article 'Secret Weapons' by Russell Miller, discussing the development of submarine detection equipment in World War II; in 'The Sunday Times Magazine'.

Portrait des deux scientifiques John Randall et Henry Boot pour l'article 'Les armes secrets', écrit par Russell Miller, qui traite le développement de l'équipment pour la détection des sous-marins pendant la deuxième guerre mondiale; publié dans 'The Sunday Times Magazine'.

Portrait der Wissenschaftler John Randall und Henry Boot während der Diskussion über die Entwicklung der U-Boot-Peilung im Zweiten Weltkrieg. Aus der Reportage 'Geheim-Waffen' von Russell Miller, in 'The Sunday Times Magazine'.

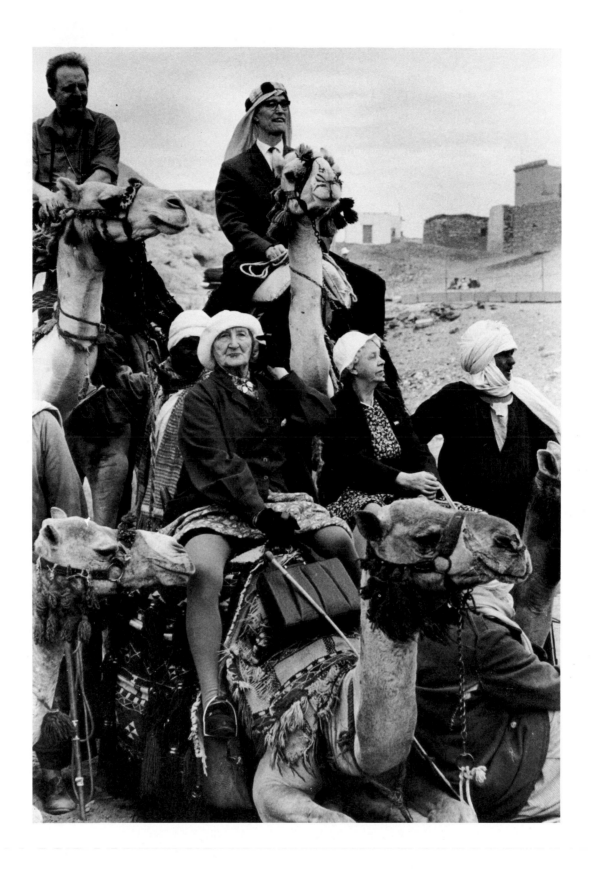

Photographer · Photographe · Fotograph · THOMAS HOPKER

Taken on location, 'Tourists in Cairo' won the third prize in the 1976 Nikon competiton.

Prise sur place, 'Touristes à Caire' a gagné le troisième prix du concours Nikon en 1976.

'Touristen in Kairo' gewann 1976 den dritten Preis beim Nikon-Wettbewerb.

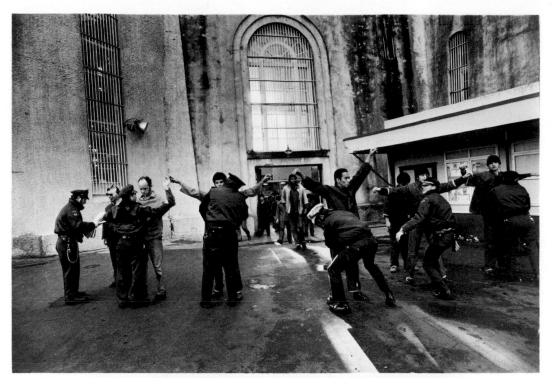

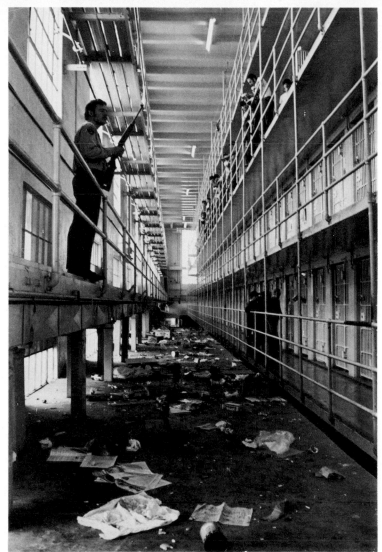

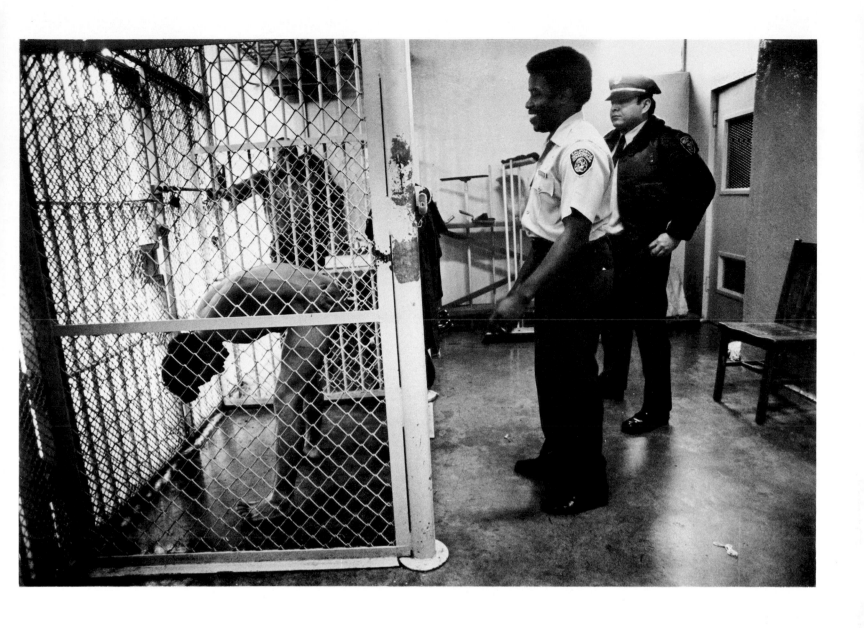

Photographer · Photographe · Fotograph · PERRY KRETZ
Designer · Maquettiste · Gestalter · ERWIN EHRET
Art Director · Directeur Artistique · ROLF GILLHAUSEN
Publishing Company · Editeur · Verleger · GRUNER & JAHR AG & CO

A selection of photographs taken on location for the feature 'Die Hölle von San Quentin' (The hell of San Quentin) by Klaus Liedtke, in 'Stern'.

Une sélection de photographies prises sur place pour le reportage 'L'Enfer de San Quentin' écrit par Klaus Liedtke et publié dans 'Stern'.

Eine Auswahl von Photos zur Reportage 'Die Hölle von San Quentin' von Klaus Liedtke, im 'Stern'.

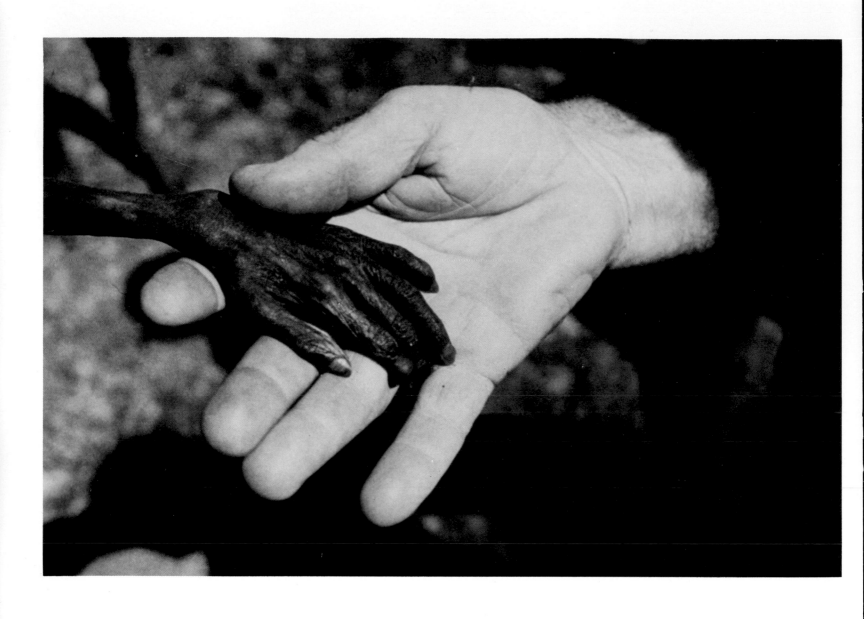

Photographer · Photographe · Fotograph · MIKE WELLS
Designer · Maquettiste · Gestalter · HERBERT SUHR
Art Director · Directeur Artistique · ROLF GILLHAUSEN
Publishing Company · Editeur · Verleger · GRUNER & JAHR AG & CO

Double-page spread from the feature 'Hilfe' (Help) on hunger in Africa by Wibke Bruhns, in 'Stern' June 1980.

Double page du reportage 'Au secours' qui traite la faim en Afrique, écrit par Wibke Bruhns et publié dans 'Stern' June 1980.

Doppelseite zur Reportage 'Hilfe' über den Hunger in Afrika, von Wibke Bruhns, im 'Stern' Juni 1980.

Photographer · Photographe · Fotograph · HANNS-JORG ANDERS
Art Director · Directeur Artistique · ROLF GILLHAUSEN
Publishing Company · Editeur · Verleger · GRUNER & JAHR AG & CO

Double-page spread for the feature 'Nur die Prothesen bezahlt der Staat – Adoptionsfamilie de Bolt in den USA' (Only the artificial limbs are paid for by the state – the adopting family de Bolt in the USA), by Erich Kuby, in 'Stern'.

Une double page du reportage de magazine 'Seulement les prothèses orthopédiques sont payées par l'état – la famille adoptante 'de Bolt' au USA' par Erich Kuby, dans 'Stern'.

Doppelseite für die Reportage 'Nur die Prothesen bezahlt der Staat – Adoptionsfamilie de Bolt in den USA', von Erich Kuby, im 'Stern'.

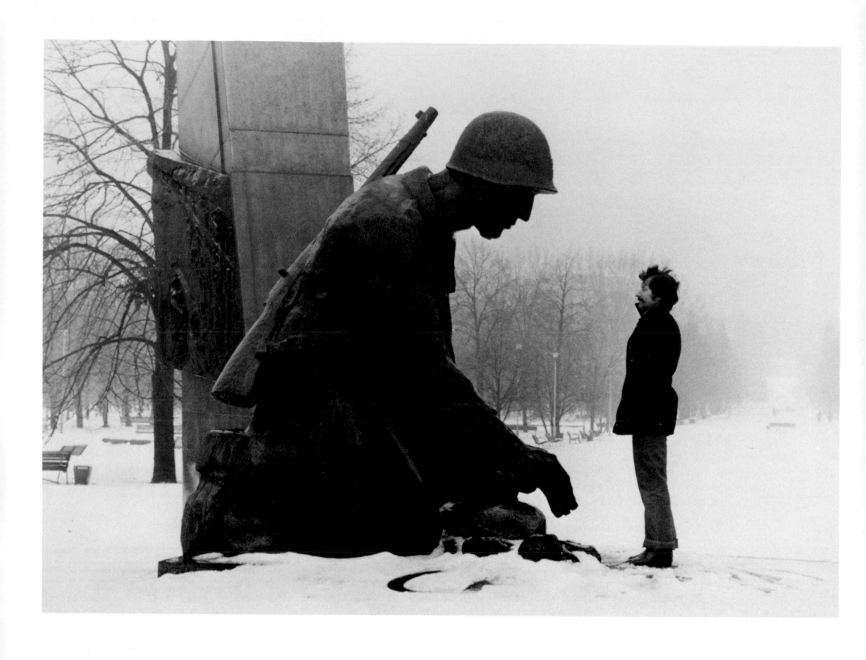

Photographers · Photographes · Fotographen · MARC BULKA/ARNAUD DE WILDENBERG

Publishing Company · Editeur · Verleger · THE OBSERVER LTD

Lech Walesa visiting a monument to Polish soldiers who died in World War II used to illustrate the article 'Hero of the Lenin Shipyard' by Mark Frankland, describing the rise from apparent obscurity of the leader of Solidarity and 8 million Polish workers, in 'The Observer', 28 December 1980.

La visite de Lech Walesa au monument aux soldats polonais morts dans la deuxième guerre mondiale pour illustrer l'article 'Le héro du chantier naval Lenin' par Mark Frankland qui décrit l'émergence d'une obscurité apparante du chef de Solidarity et de 8 million ouvriers polonais, dans le 'Observer,' 28 décembre 1980.

Lech Walesa am Denkmal der polnischen Soldaten. die im 2. Weltkrieg starben, zur Illustration des Artikels 'Held der Lenin Werft' von Mark Frankland. über den Aufstieg aus der Unscheinbarkeit des Solidarity Führers und Sprechers für 8 Millionen polnische Arbeiter, im 'Observer, 28. Dezember 1980

Photographer · Photographe · Fotograph · SNOWDON
Publishing Company · Editeur · Verleger · CONDÉ NAST PUBLICATIONS LIMITED

Portrait of Sir Hugh Casson for the 'Spotlight' column in 'Vogue', September 1980.

Portrait de Sir Hugh Casson pour la rubrique 'Spotlight' dans 'Vogue', septembre 1980.

Portrait von Sir Hugh Casson für die 'Spotlight' Spalte in 'Vogue', September 1980.

Photographer · Photographe · Fotograph · HANNS-JORG ANDERS
Designer · Maquettiste · Gestalter · ROLF GILLHAUSEN
Art Director · Directeur Artistique · ROLF GILLHAUSEN
Publishing Company · Editeur · Verleger · GRUNER & JAHR AG & CO

Selection from the feature 'Gelobtes Land im Busch' (The Holy Land in the Bush) by Hero Buss, in 'Stern'.

Sélectionnée du reportage de revue 'La Terre Sainte dans la brousse' par Hero Buss, dans 'Stern'.

Auswahl aus der Reportage 'Gelobtes Land im Busch' von Hero Buss, im 'Stern'.

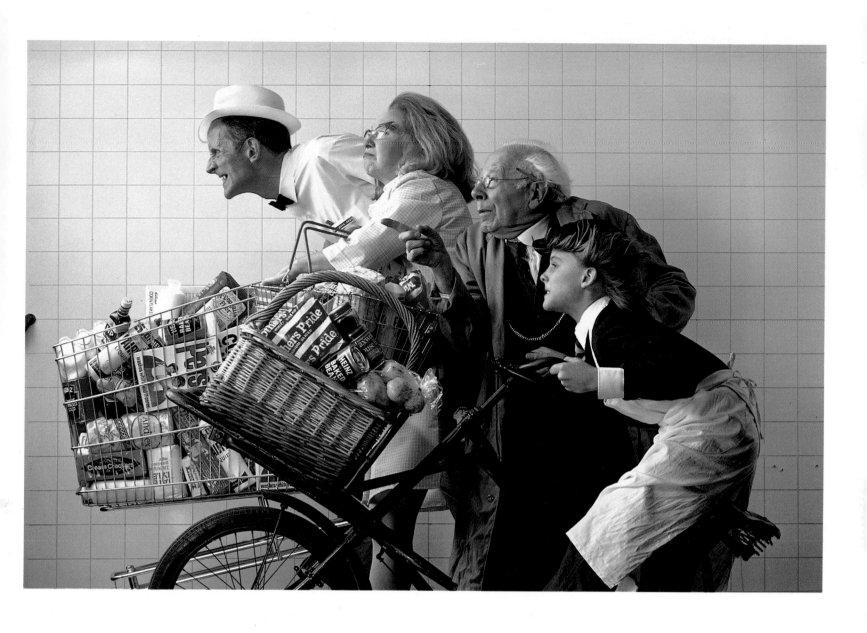

Photographer · Photographe · Fotograph · RED SAUNDERS
Art Director · Directeur Artistique · MICHAEL RAND
Publishing Company · Editeur · Verleger · TIMES NEWSPAPERS LIMITED

Double-page spread for the feature 'The great shopping race', a survey of the changing shopping habits in Britain, by Victoria Irving; in 'The Sunday Times Magazine'.

Une double page du reportage 'La Grande Course des Acheteurs', une étude des moeurs changeants des acheteurs en Grande Bretagne, par Victoria Irving; dans 'The Sunday Times Magazine'.

Doppelseite für die Reportage 'Das große Einkaufsrennen', ein Bericht über die sich ändernden Einkaufsgewohnheiten in Großbritannien, von Victoria Irving, in 'The Sunday Times Magazine'.

Photographer · Photographe · Fotograph · DENIS WAUGH
Designer · Maquettiste · Gestalter · JOHN TENNANT
Art Director · Directeur Artistique · MICHAEL RAND
Publishing Company · Editeur · Verleger · TIMES NEWSPAPERS LIMITED

Portrait of Anthony Burgess for a biographical feature in 'The Sunday Times Magazine'.	Portrait de Anthony Burgess pour un article biographique publié dans 'The Sunday Times Magazine'.	Porträt von Anthony Burgess für einen biographischen Artikel in 'The Sunday Times Magazine'.

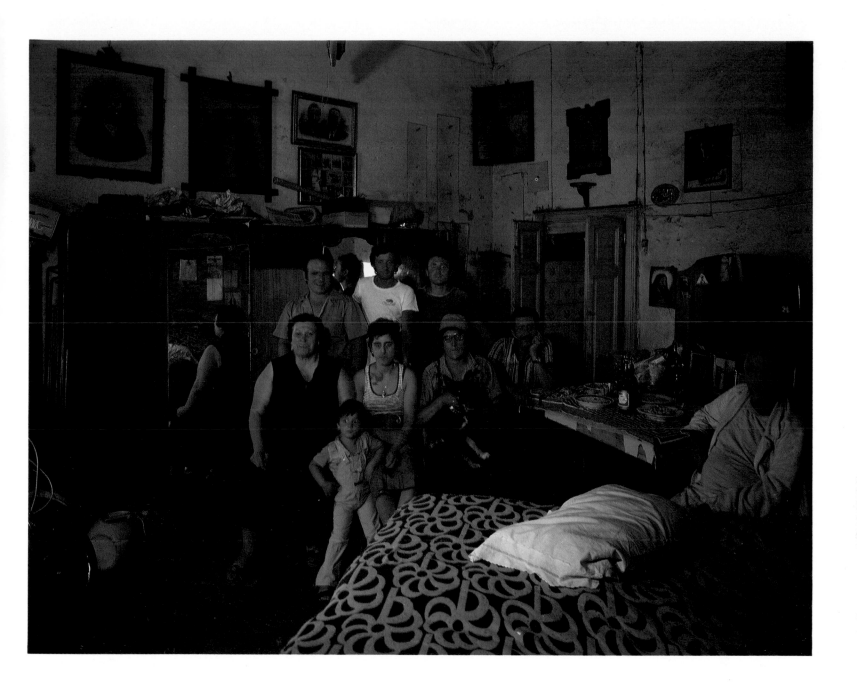

67, 68, 69

Photographer · Photographe · Fotograph · KENNETH GRIFFITHS
Designer · Maquettiste · Gestalter · GILVRIE MISSTEAR
Art Director · Directeur Artistique · MICHAEL RAND
Publishing Company · Editeur · Verleger · TIMES NEWSPAPERS LIMITED

Selection from the feature 'Essential Cities: Naples' by Norman Lewis, one of an occasional series about provincial cities in Europe, in 'The Sunday Times Magazine' April 1980.

Sélection du reportage 'Les grandes villes essentielles: Naples' par Norman Lewis, qui fait partie d'une série épisodique sur les villes de province européennes, dans 'The Sunday Times Magazine' avril 1980.

Auswahl aus der Reportage 'Wichtige Städte: Neapel' von Norman Lewis. Beitrag zu einer losen Reihe über Provinz-Städte in Europa, in 'The Sunday Times Magazine', April 1980.

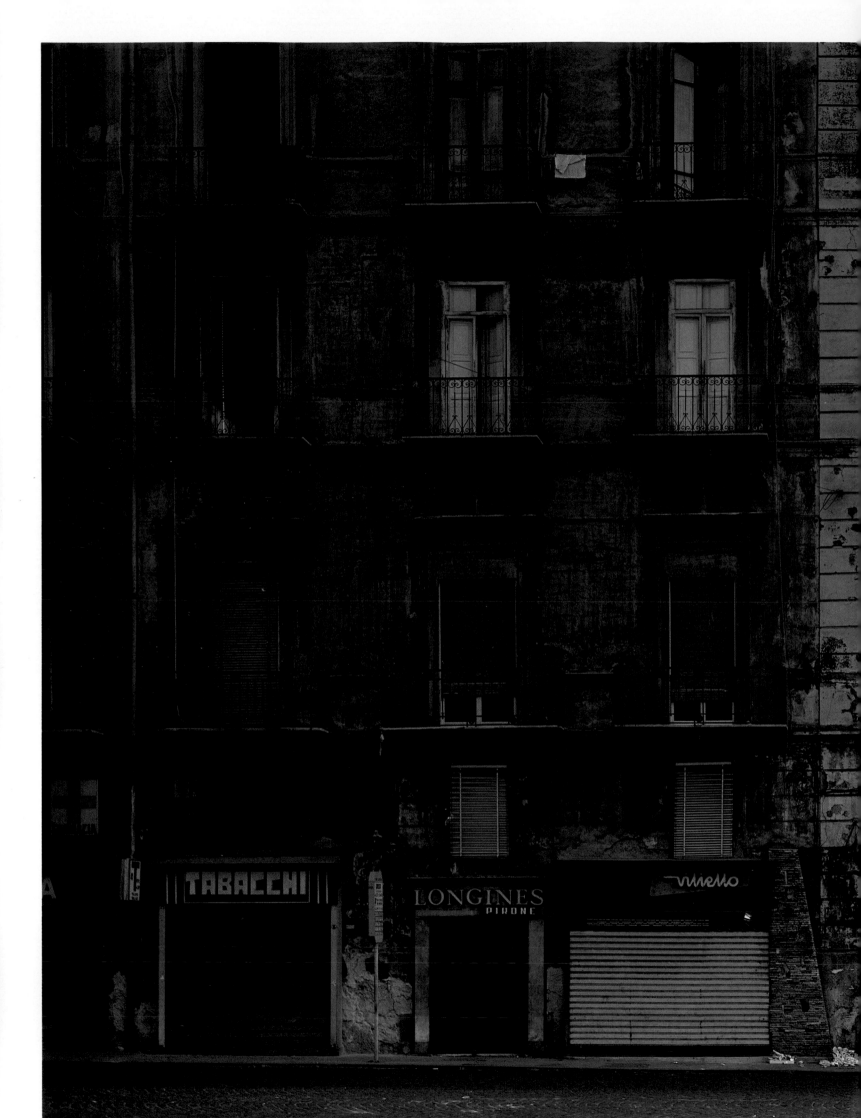

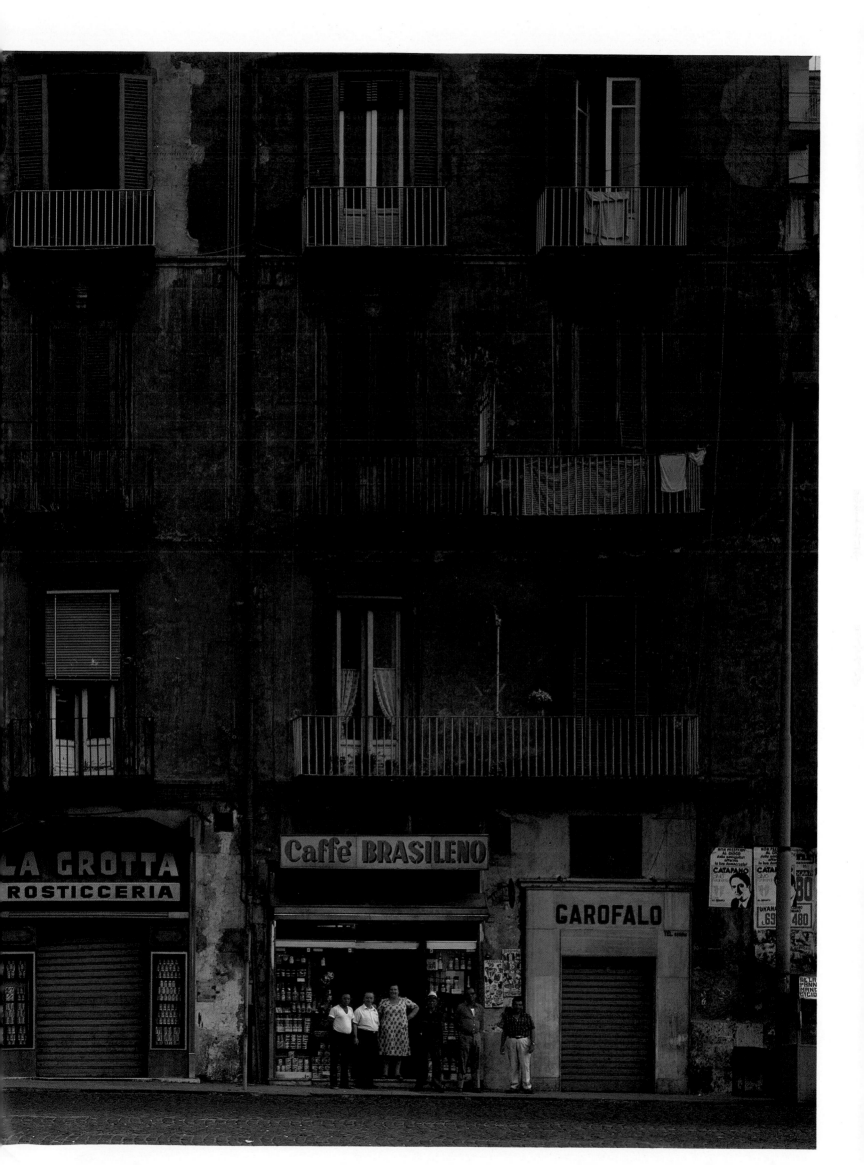

70, 71

Photographer · Photographe · Fotograph · PHIL SAYER
Designer · Maquettiste · Gestalter · ROBERT PRIEST
Art Director · Directeur Artistique · ROBERT PRIEST
Publishing Company · Editeur · Verleger · WEEKEND MAGAZINE

Taken on location in Kweilin and Hangchow for the feature 'China, the Waking Giant' by Adrienne Clarkson and Charles Taylor, in 'Weekend' magazine September 1979.

Prises sur place à Kweilin et Hangchow pour le reportage 'La Chine, la géante se réveille' écrit par Adrienne Clarkson et Charles Taylor, dans 'Weekend' magazine septembre 1979.

Aufgenommen in Kweilin und Hangchow für die Reportage 'China, der erwachende Gigant' von Adrienne Clarkson und Charles Taylor, in 'Weekend' magazine September 1979.

Photographer · Photographe · Fotograph · PETER COLEMAN
Designer · Maquettiste · Gestalter · DIETMAR SCHULZE
Art Director · Directeur Artistique · WOLFGANG BEHNKEN
Publishing Company · Editeur · Verleger · GRUNER & JAHR AG & CO

Double-page spread from the feature 'Der sechste Sinn der Tiere' (Sixth sense in animals) by Guenter Karweina, in 'Stern' April 1980.

Double page du reportage 'Le sixième sens des animaux' écrit par Guenter Karweina, publié dans 'Stern' avril 1980.

Doppelseite zur Reportage 'Der sechste Sinn der Tiere' von Guenter Karweina, im 'Stern' April 1980.

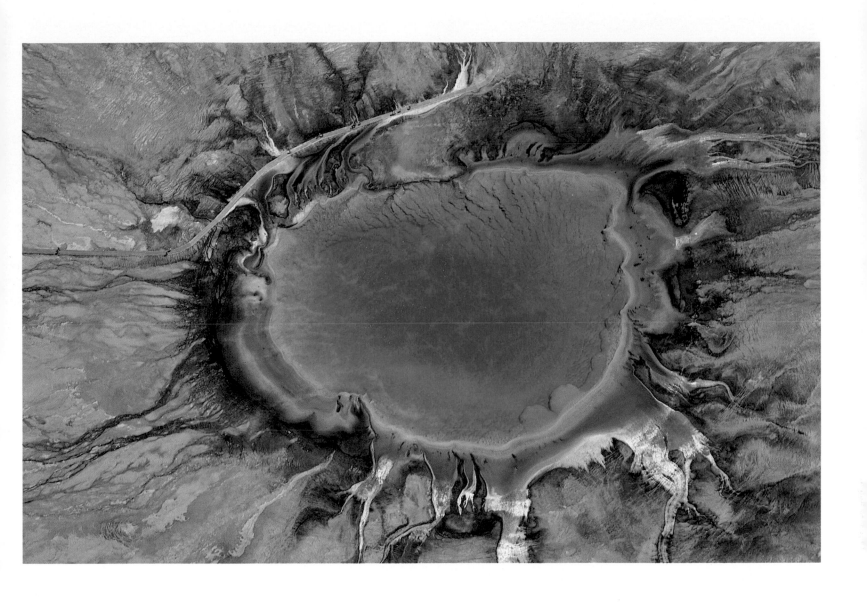

Photographer · Photographe · Fotograph · MICHAEL FREEMAN
Art Director · Directeur Artistique · FRANK DEVIN
Publishing Company · Editeur · Verleger · PENTHOUSE PUBLICATIONS (USA)

Aerial view of the Grand Prisamatic Spring in National Park, for the article 'Phenomena', in 'Omni' November 1978.

Une vue aérienne de la source 'Grand Prisamatic' à Yellowstone National Park pour l'article 'Phenomena', publié dans 'Omni' novembre 1978.

Luftaufnahmenvon der Grand Prisamatic Quelle im National Park für den Artikel 'Phenomena', in 'Omni' November 1978.

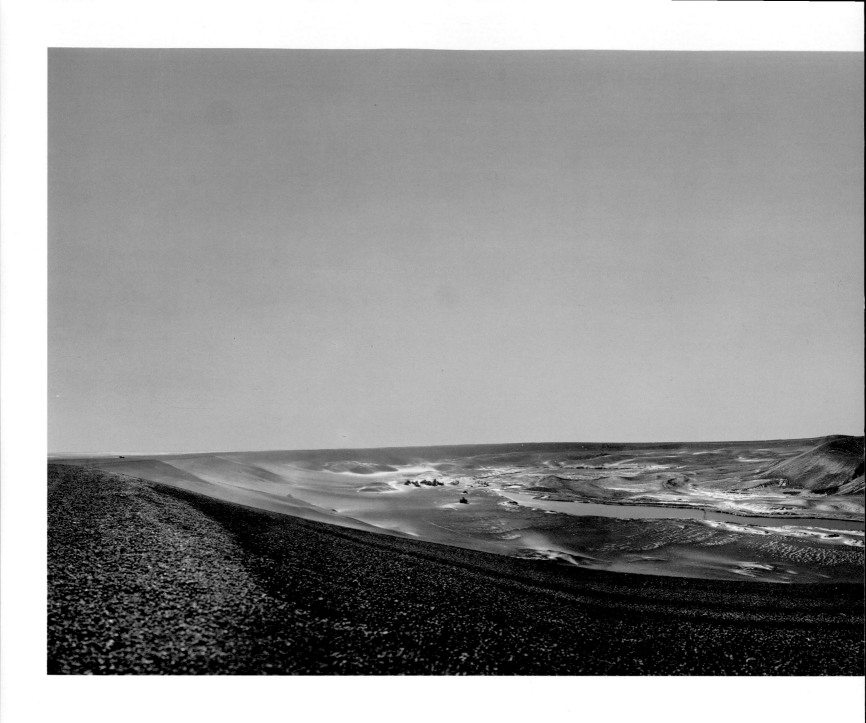

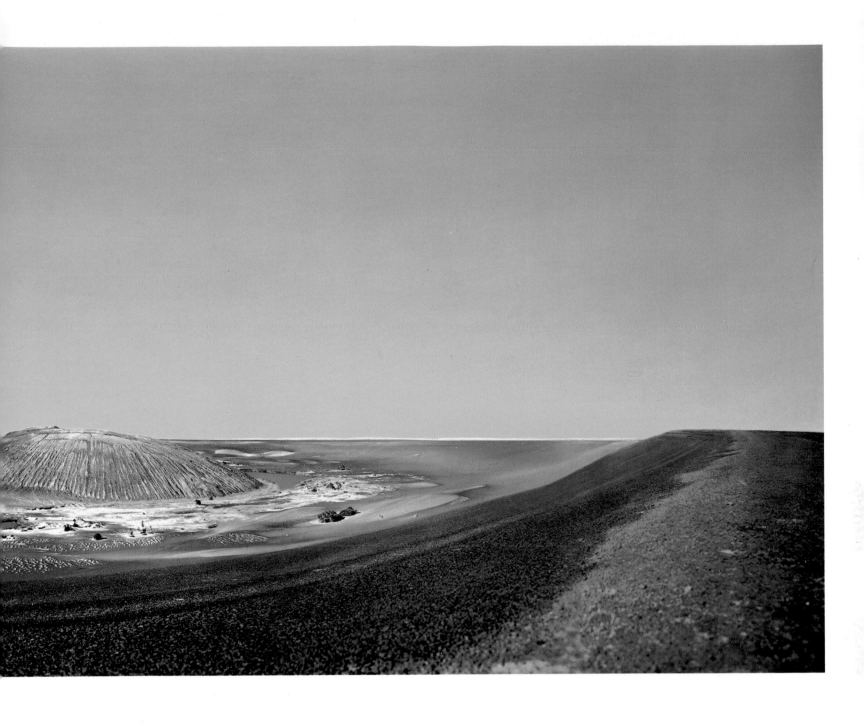

Photographer · Photographe · Fotograph · UWE GEORGE
Designer · Maquettiste · Gestalter · ANDREAS KRELL
Art Directors · Directeurs Artistiques · ERWIN EHRET/FRANZ BRAUN
Publishing Company · Editeur · Verleger · GRUNER & JAHR AG & CO

Four-page spread from the feature 'Sahara: Das verschollene Meer' (The Sahara: the sunken sea) by Uwe George, in 'Geo' January 1980.

Quatres pages pour le reportage 'Sahara: la mer engloutie' par Uwe George, dans 'Geo' janvier 1980.

Vier Seiten zur Reportage 'Sahara: Das verschollene Meer' von Uwe George, in 'Geo' Januar 1980.

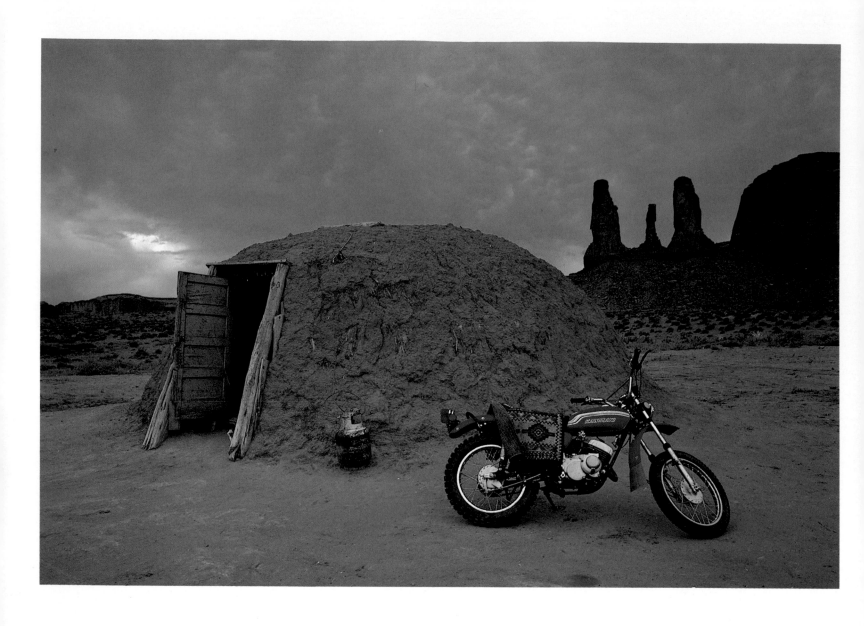

Photographer · Photographe · Fotograph · EBERHARD GRAMES
Designer · Maquettiste · Gestalter · GÜNTHER MEYER
Art Director · Directeur Artistique · WOLFGANG BEHNKEN
Publishing Company · Editeur · Verleger · GRUNER & JAHR AG & CO

'Vom Mustang bleibt nur die Satteldecke' (Only the saddle-cloth is left of the Mustang), double-page spread for a feature on the Navajos by Friedrich Abel, in 'Stern' November 1980.

'Il ne reste du mustang que la housse de cheval', double page sélectionée d'un reportage sur les Navajos par Friedrich Abel, publié dans 'Stern' novembre 1980.

'Vom Mustang bleibt nur die Satteldecke', Doppelseite aus der Reportage über Navajo-Indianer von Friedrich Abel; im 'Stern' November 1980.

Photographer · Photographe · Fotograph · WILFRIED BAUER
Designer · Maquettiste · Gestalter · PETER DASSE
Art Directors · Directeurs Artistiques · ERWIN EHRET/FRANZ BRAUN
Publishing Company · Editeur · Verleger · GRUNER & JAHR AG & CO

Two double page spreads for the feature 'Die grunen Patriarchen' (The green partriarchs) by Wilfried Bauer, in 'Geo' May 1980. Above: 'Kein Baum in Deutschland ist so alt wie die zweigeteilte Eibe von Balderschwang' (No tree in Germany is as old as the forked yew of Balderschwang). Below: 'Die Hute-Eichen im Reinhardswald sind trotz der Rinder, Schafe und Schweine alt geworden' (The oaks in the Reinhards-Forest have survived into old age in spite of the cows, sheep and pigs).

Deux double-pages du reportage 'Les Patriarches verts' par Wilfried Bauer, dans 'Geo' mai 1980. Dessus: 'Aucun arbre en Allemagne est aussi vieux que l'if fourché de Balderschwang'. Dessous: 'Les chênes de la forêt de Reinhards ont survecu malgré les vaches, les moutons et les cochons'.

Zwei Doppelseiten des Artikels 'Die grunen Partriarchen' von Wilfried Bauer, im 'Geo' Mai 1980. Oben: 'Kein Baum in Deutschland ist so alt wie die zweigeteilte Eibe von Balderschwang'. Unten: 'Die Hute-Eichen im Reinhardswald sind trotz der Rinder, Schafe und Schweine alt geworden'.

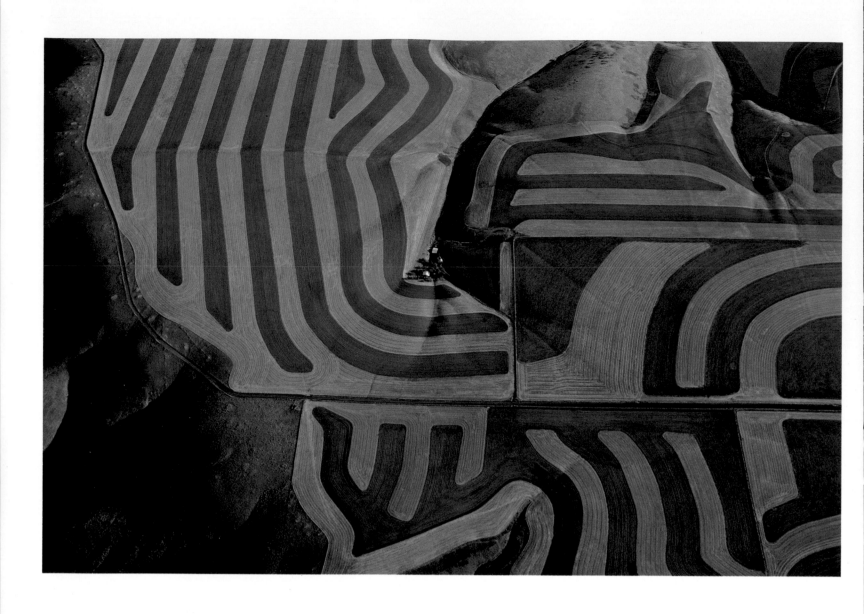

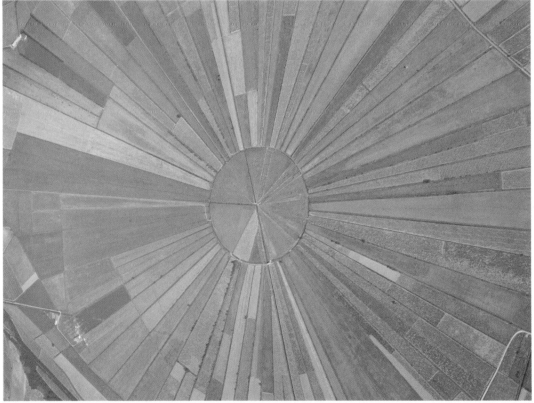

78, 79

Photographer · Photographe · Fotograph · DR GEORG GERSTER
Designer · Maquettiste · Gestalter · ERWIN EHRET
Art Directors · Directeurs Artistiques · ERWIN EHRET/FRANZ BRAUN
Publishing Company · Editeur · Verleger · GRUNER & JAHR AG & CO

Series of aerial views of rural landscapes for the feature 'Brot und Salz' (Bread and salt), written by the photographer, in 'Geo' September 1980.

Une série de vues aériennes de paysages rurales pour le reportage 'Pain et Sel', aussi écrit par le photographe; publié dans 'Geo' septembre 1980.

Landschaftsaufnahmen aus der Luft für die Reportage 'Brot und Salz' photografiert und geschrieben von Dr Georg Gerster, in 'Geo' September 1980.

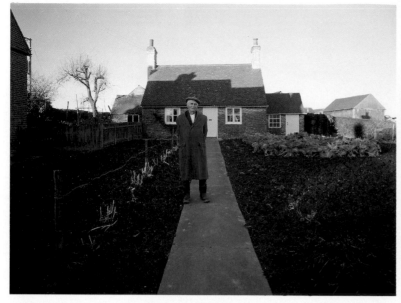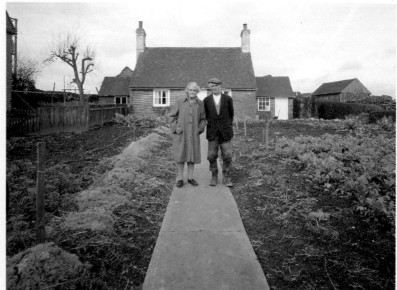
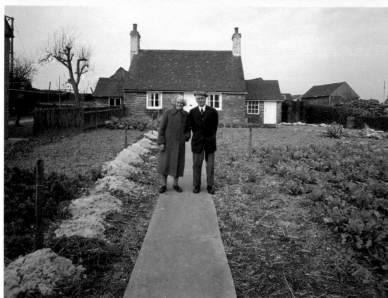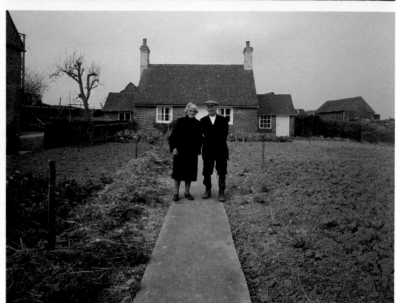

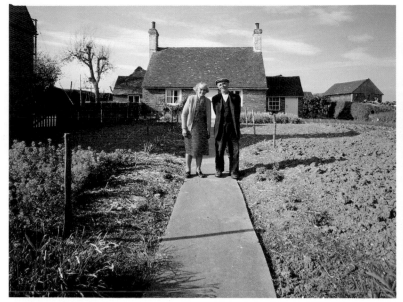 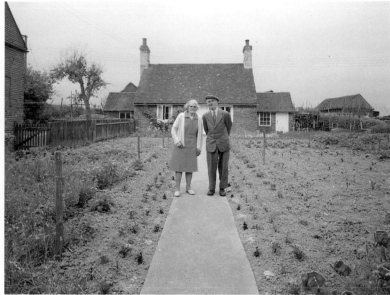

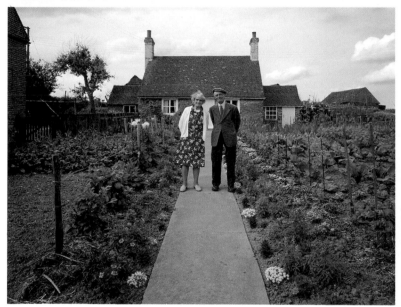 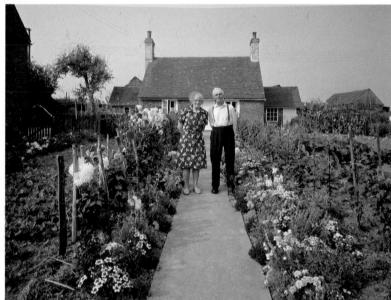

80, 81, 82

Photographer · Photographe · Fotograph · KENNETH GRIFFITHS
Art Directeur · Directeur Artistique · MICHAEL RAND
Publishing Company · Editeur · Verleger · TIMES NEWSPAPERS LIMITED

A series of twelve photographs for the feature 'A Country Cottage Calendar' by Francis Wyndham, showing a year in the life of Mr Sweetman's Sussex garden (in January Mrs Sweetman was too ill to stand outside but she can just be seen peering from the window); in 'The Sunday Times Magazine'.

Une série de douze photographies pour le reportage 'Un calendrier de cottage', écrit par Francis Wyndham, qui montrent une année dans la vie du jardin de M. Sweetman (en janvier Mme Sweetman était trop malade pour sortir dehors mais elle se laisse juste entrevoir à la fenêtre); publiée dans 'The Sunday Times Magazine'.

Zwölf Photos zur Geschichte 'Ein Landhaus Kalender' von Francis Wyndham. Sie zeigen den Verlauf eines Jahres in Mr Sweetmans Garten (im Januar war Mrs Sweetman krank und ist deshalb nur am Fenster zu sehen), in 'The Sunday Times Magazine'.

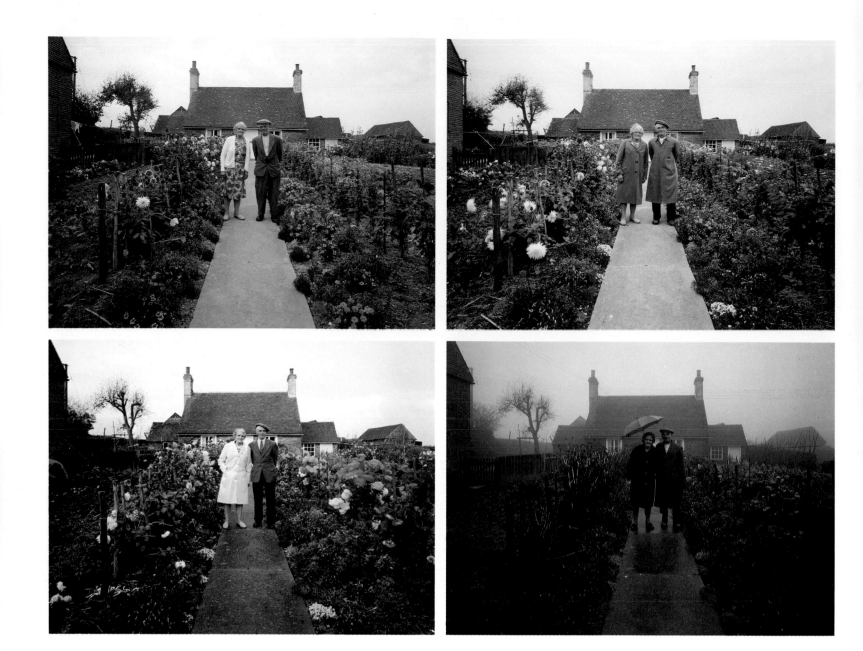

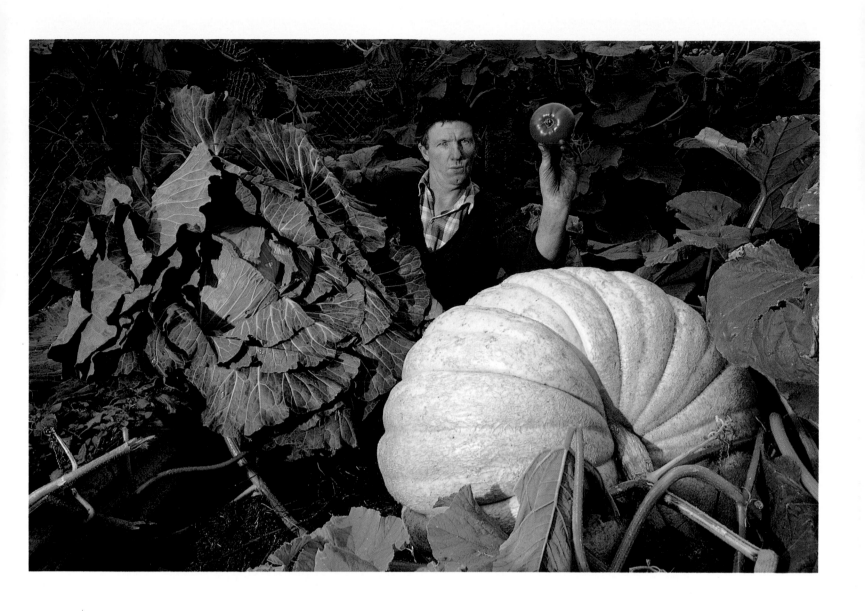

Photographer · Photographe · Fotograph · RED SAUNDERS
Designer · Maquettiste · Gestalter · GILVRIE MISSTEAR
Art Director · Directeur Artistique · EDWIN TAYLOR
Publishing Company · Editeur · Verleger · TIMES NEWSPAPERS LIMITED

Double-page spread for the article 'The Green Giant' by Peter Laurie, about a man who grows outsize vegetables, in 'The Sunday Times Magazine'.

Une double page de l'article 'Le Géant vert' écrit par Peter Laurie, au sujet d'un homme qui cultive des légumes gigantesques, publié dans 'The Sunday Times Magazine'.

Doppelseitige Aufmachung zur Geschichte 'Der grüne Gigant' von Peter Laurie über einen Mann, der, supergroßes Gemüse züchtet, in 'The Sunday Times Magazine'.

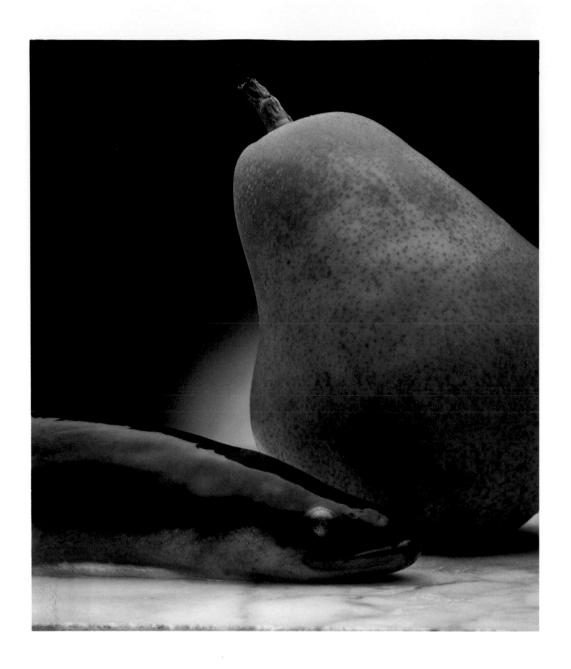

Photographer · Photographe · Fotograph · HANS KROESKAMP
Designer · Maquettiste · Gestalter · YOKE WESTERMAN
Art Director · Directeur Artistique · DICK DE MOEI
Publishing Company · Editeur · Verleger · DE GEILLUSTREERDE PERS B.V.

Full-page still life for a cookery feature, 'Bizarre combinatens' (Bizarre combinations) by Wina Born, in 'Avenue' February 1979.

Une nature morte de pleine page pour un reportage de cuisine, 'Combinaisons bizarres' par Wina Born, dans 'Avenue' février 1979.

Ganzseitiges Stilleben zu einem Kochrezept 'Aussergewöhnliche Kombinationen' von Wina Born, in 'Avenue' Februar 1979.

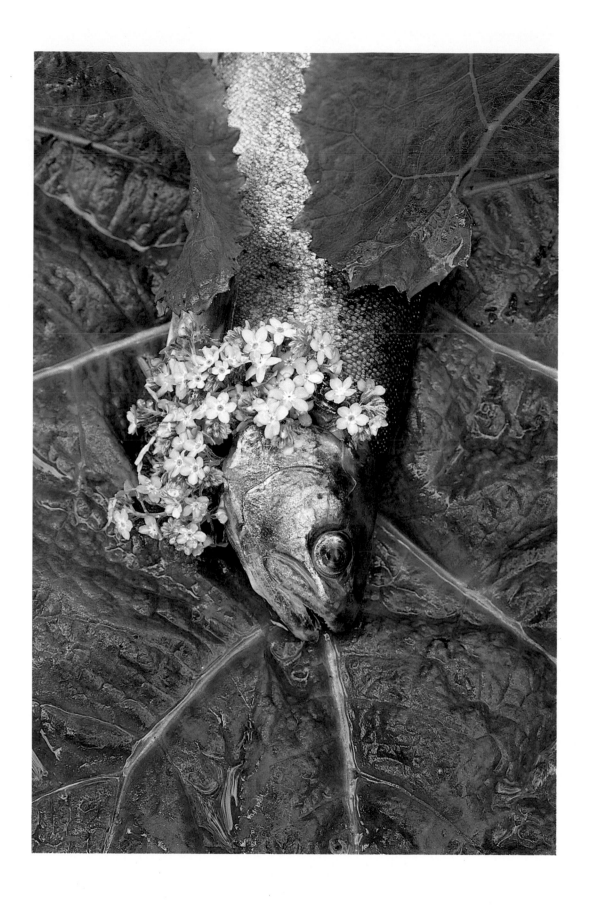

Photographer · Photographe · Fotograph · PIET VAN LEEUWEN

Designer · Maquettiste · Gestalter · HANS VAN BLOMMESTEIN

Art Director · Directeur Artistique · DICK DE MOEI

Publishing Company · Editeur · Verleger · DE GEILLUSTREERDE PERS B.V.

Full-page still life for a cookery feature, 'Zoetwatervis' (Fresh water fish) by Wina Born, in 'Avenue' August 1979.	Une nature morte de pleine page pour un reportage de cuisine, 'Poissons d'eau douce' par Wina Born, dans 'Avenue' août 1979.	Ganzseitiges Stilleben zu einem Kochrezept 'Süsswasserfisch' von Wina Born, in Avenue' August 1979.

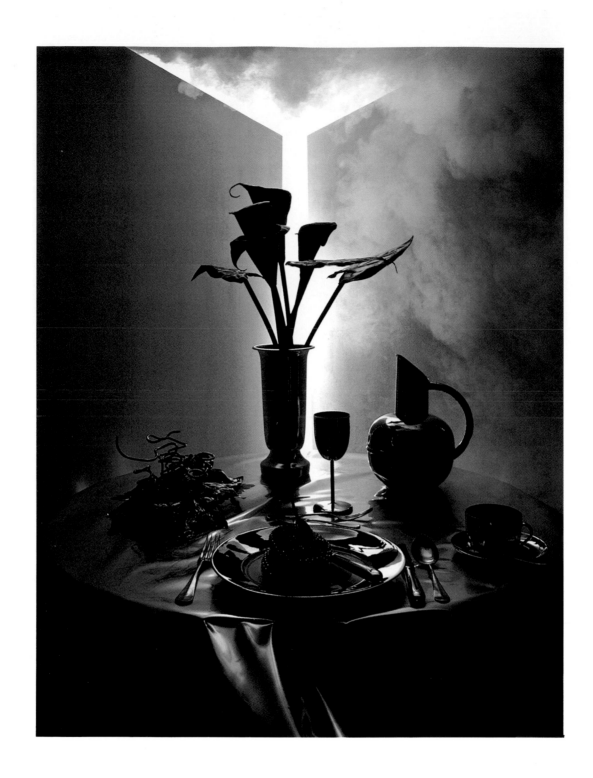

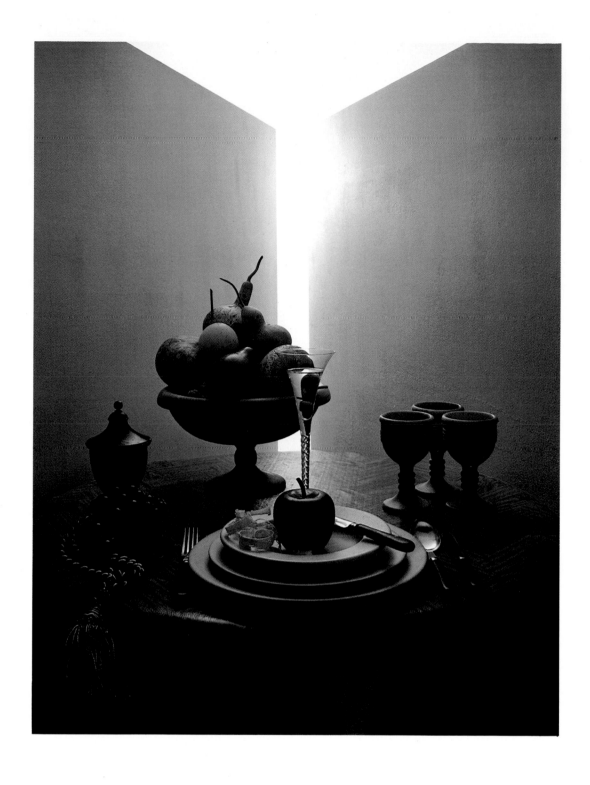

Photographer · Photographe · Fotograph · ALAN GINSBURG

Art Director · Directeur Artistique · MANUEL ORTZ

Publishing Company · Editeur · Verleger · JAHRESZEITEN VERLAG

A selection of still-life photographs for the feature 'Gedeckt für's herbstliche Mahl' (Setting for an autumnal meal) by Gerriet E. Ulrich in 'Architektur & Wohnen', 1977.

Une sélection de nature-mortes pour l'article, 'La scene pour un repas d'automne' par Gerriet E. Ulrich dans 'Architektur & Wohnen', 1977.

Eine Reihe von Stilleben-Photos für den Artikel 'Gedeckt für's herbstliche Mahl', von Gerriet E. Ulrich. in 'Architektur & Wohnen', 1977.

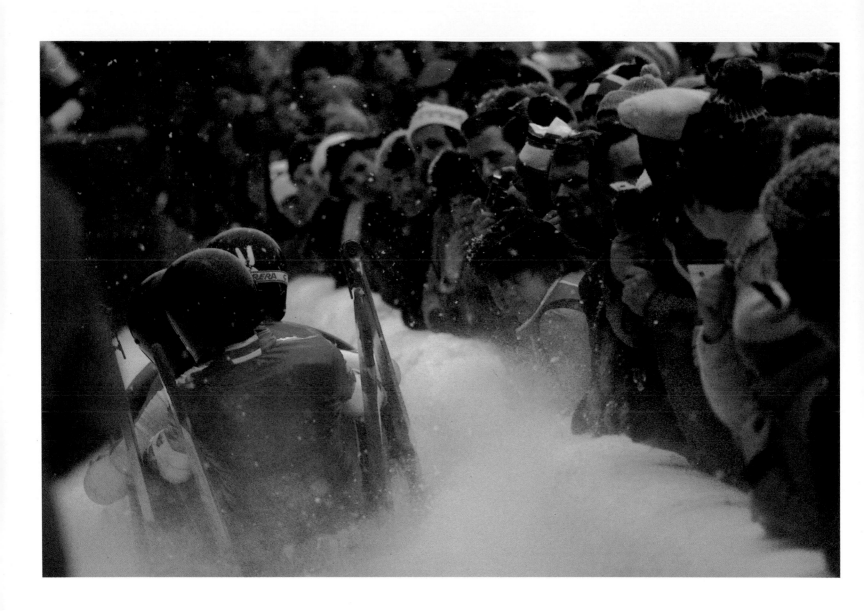

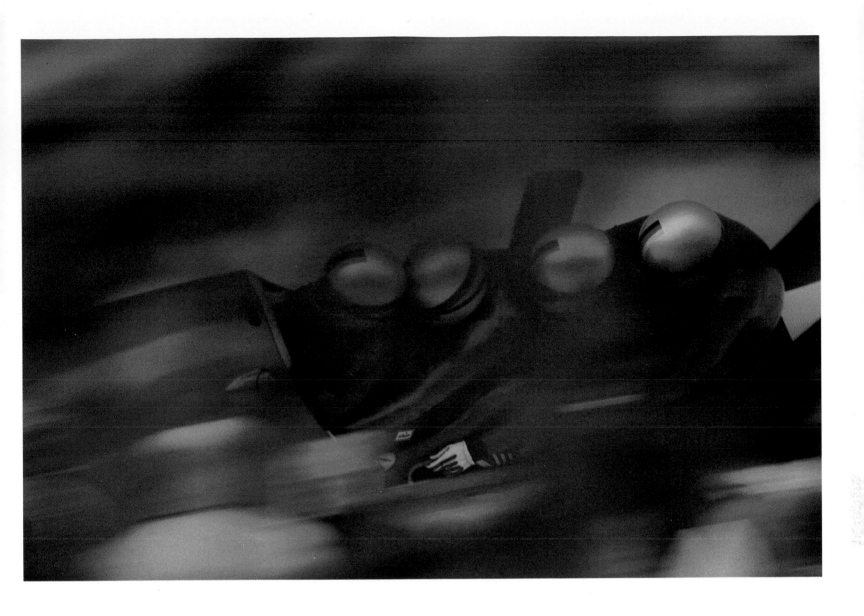

88, 89, 90, 91

Photographer · Photographe · Fotograph · WALTER SCHMIR
Designer · Maquettiste · Gestalter · HERBERT SUHR
Art Director · Directeur Artistique · ROLF GILLHAUSEN
Publishing Company · Editeur · Verleger · GRUNER & JAHR AG & CO

Selection from the feature 'Bob-Medaillenjagd im Todeskanal von Lake Placid' (Going for the Bobsleigh Gold in Lake Placid's death run) by Peter Bizer, in 'Stern' February 1980.

Une sélection du reportage 'Le Bob-chasse des medailles dans la piste de la mort à Lake Placid" écrit par Peter Bizer, publié dans 'Stern' février 1980.

Auswahl aus einer Reportage mit dem Titel 'Bob-Medaillenjagd im Todeskanal von Lake Placid' von Peter Bizer, im 'Stern' Februar 1980.

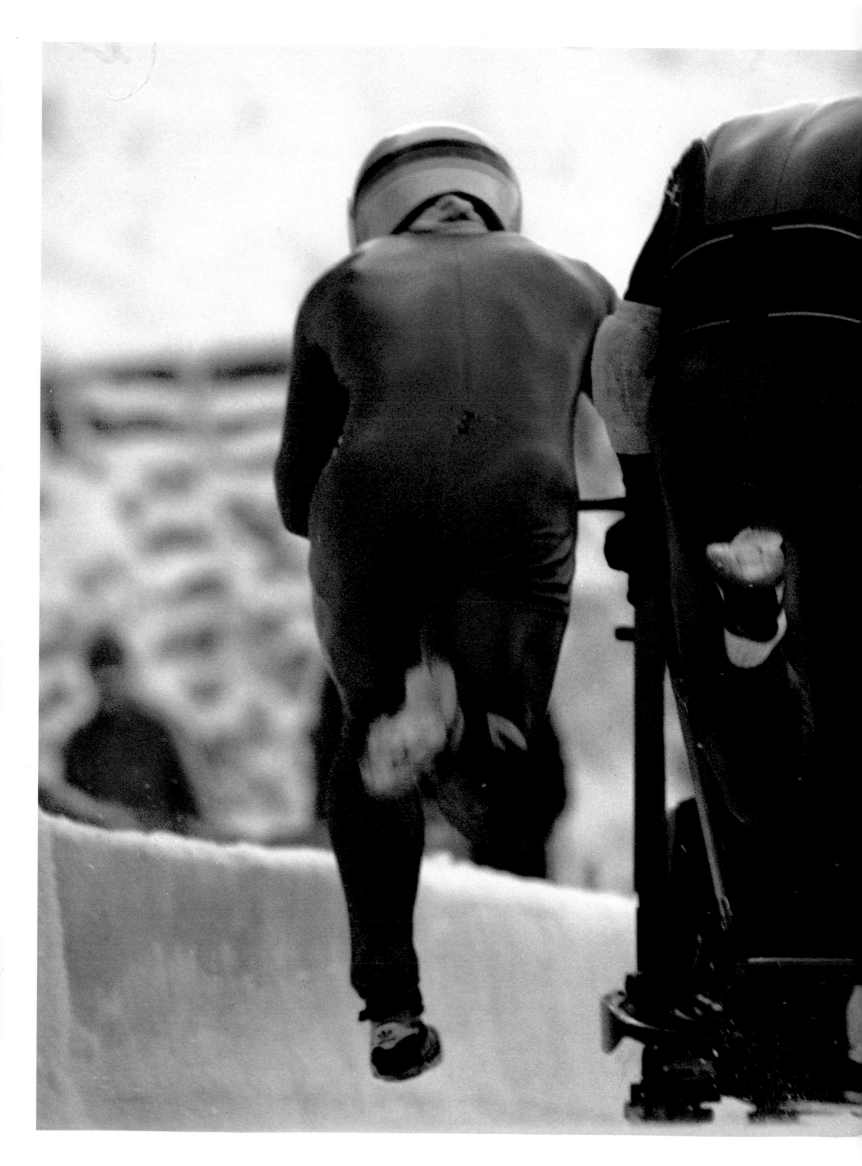

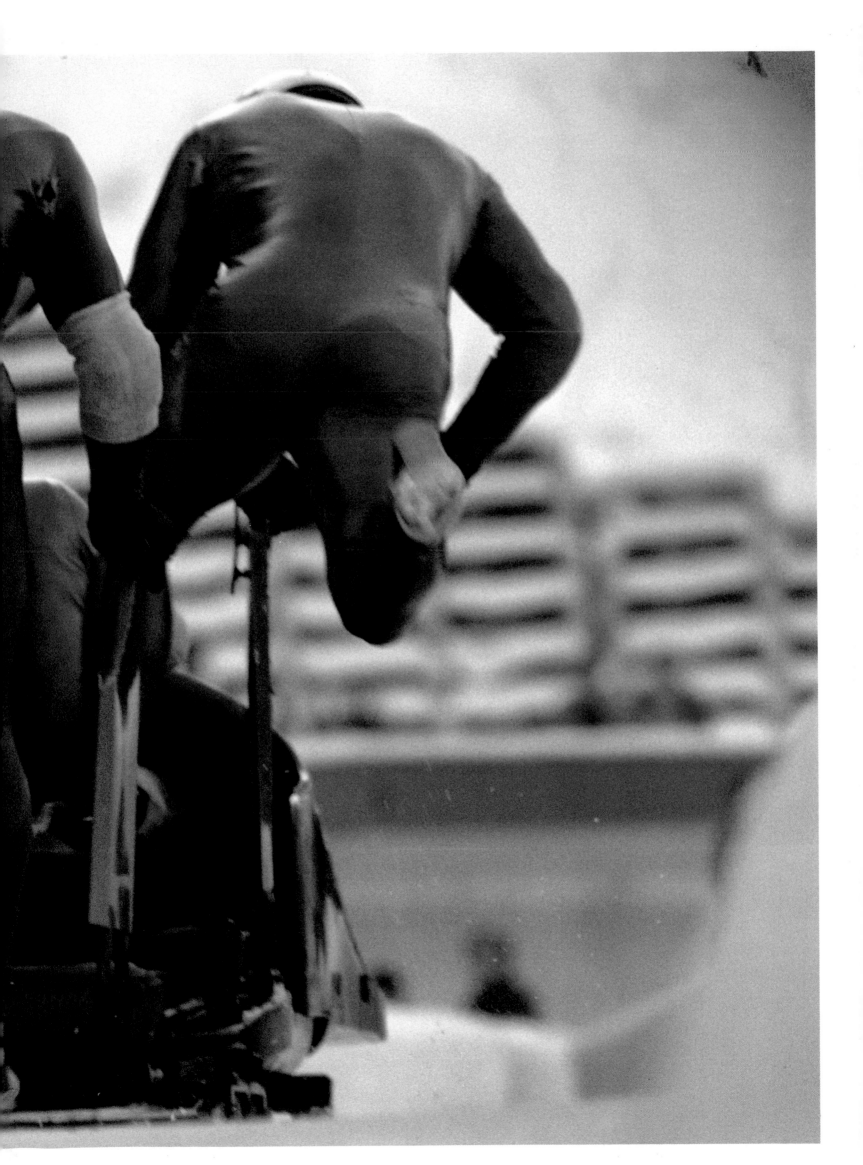

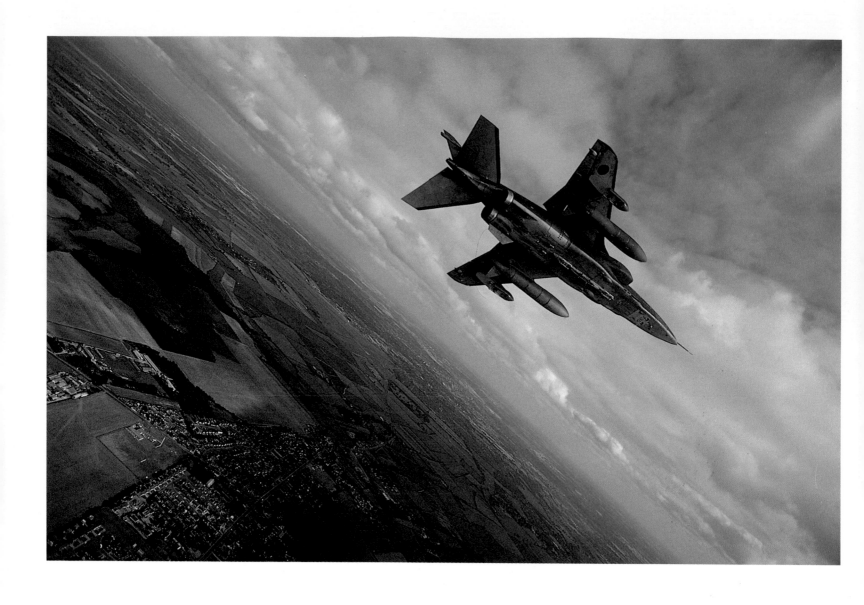

Photographer · Photographe · Fotograph · RICHARD COOKE
Designer · Maquettiste · Gestalter · ADRIANNE LEMAN
Art Director · Directeur Artistique · ADRIANNE LEMAN
Publishing Company · Editeur · Verleger · THE ILLUSTRATED LONDON NEWS

Taken for an article by Anthony Grey, during a two-Jaguar aircraft sortie while at three times gravity, so that the camera weighed about 15 instead of 5 pounds; in 'The Illustrated London News'.

Prise pour un article par Anthony Grey, au cours d'une sortie à bord un avion Jaguar 2 moteurs pendant qu'il était a 3 fois gravité, donc l'appareil photo pesait environ 15 au lieu de 5 livres, publiée dans 'The Illustrated London News'.

Photographiert für eine Reportage von Anthony Grey über einen Feindflug mit der Jaguar II - Maschine. Während des Fluges veränderte sich die Schwerkraft (über 3 G) dreimal und veränderte das Gewicht der Kamera von fünf auf 15 Pfund; in 'The Illustrated London News'.

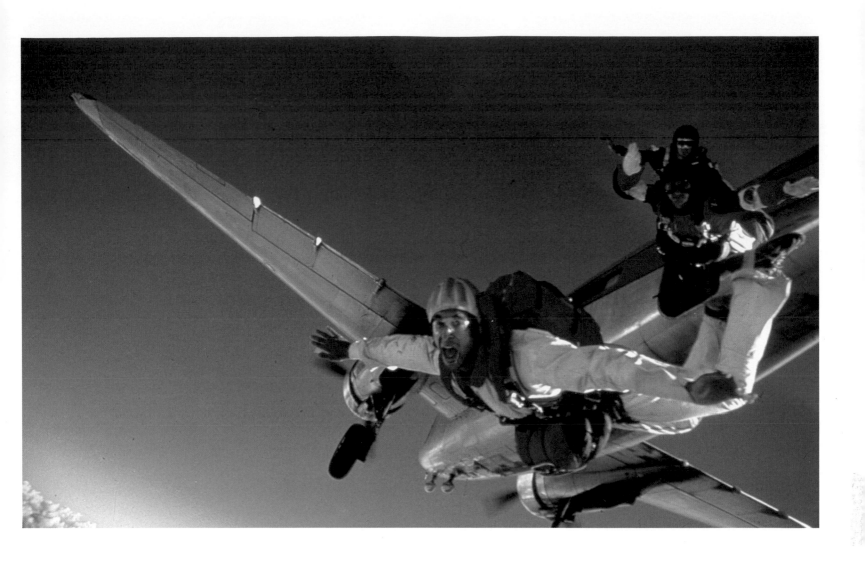

Photographers · Photographes · Fotographen · TOM DUNN/JERRY IRWIN

Art Directors · Directeurs Artistiques · ERWIN EHRET/FRANZ BRAUN

Publishing Company · Editeur · Verleger · GRUNER & JAHR AG & COMPANY

A sky dive from a plane to illustrate the feature 'Dem Himmel verfallen' (Fallen for the skies), by Judi Tobias, in 'Geo', April 1980.

Une chute libre d'un avion pour illustrer l'article 'Tombé amoureux des cieux', par Judi Tobias, dans 'Geo', avril 1980.

Fallschirmabsprung aus einem Flugzeug für den Artikel 'Dem Himmel verfallen' von Judi Tobias, in 'Geo', April 1980.

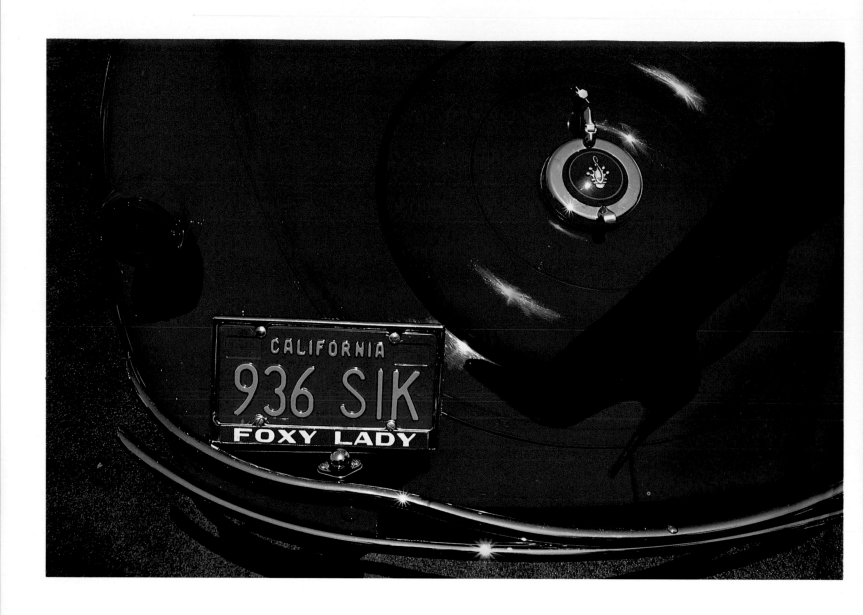

Photographer · Photographe · Fotograph · CHEYCO LEIDMANN
Publishing Company · Editeur · Verleger · VERKERKE REPRODUKTIES

Taken on location in Los Angeles in September 1979 and selected from 'Foxy Lady' which exists in the form of a book, a calendar and a film.

Prise sur place à Los Angeles en septembre 1979 et sélectionée de 'Foxy Lady,' qui existe en forme de livre, de calendrier et de film.

Aufgenommen in Los Angeles im September 1979 und ausgewählt aus 'Foxy Lady', erschienen als Buch, Kalender und Film.

Photographer · Photographe · Fotograph · CHRISTIAN VON ALVENSLEBEN
Designer · Maquettiste · Gestalter · NORBERT KLEINER
Art Director · Directeur Artistique · WOLFGANG BEHNKEN
Publishing company · Editeur · Verleger · GRUNER & JAHR AG & CO

Double-page spread for a fashion feature, 'Die Bunten kommen' (Colours are coming) by Ursula Harprecht, in 'Stern' April 1980.

Double page du reportage 'Les couleurs arrivent' écrit par Ursula Harprecht, publié dans 'Stern' avril 1980.

Doppelseite für einen Mode-Bericht mit dem Titel 'Die Bunten kommen' von Ursula Harprecht, im 'Stern' April 1980.

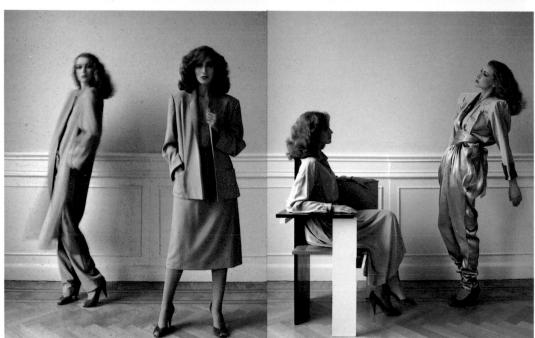

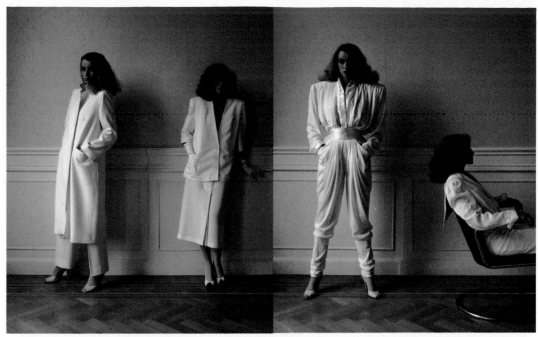

Photographer · Photographe · Fotograph · ROLPH GOBITS
Art Director · Directeur Artistique · DICK DE MOEI
Publishing Company · Editeur · Verleger · DE GEILLUSTREERDE PERS B.V.

Four double-page spreads from a fashion feature, 'Coup de Chic' (A touch of chic) by Marie-Louise Terwindt, in 'Avenue'. | Quatre double pages extraites d'un reportage de mode, 'Coup de Chic' par Marie-Louise Terwindt, dans 'Avenue'. | Vier Doppelseiten zum Mode-Bericht 'Ein Hauch von Chic' von Marie-Louise Terwindt, in 'Avenue'.

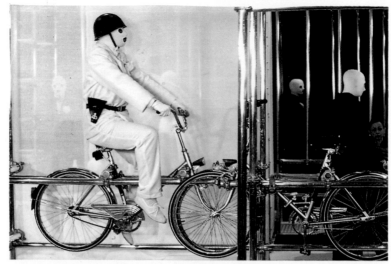

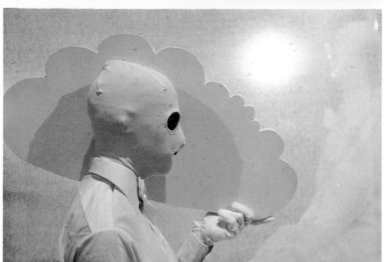

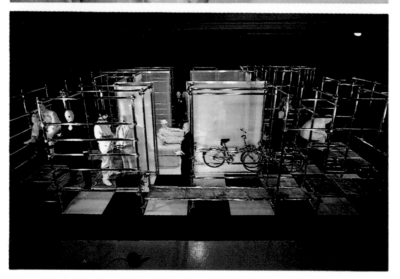

Photographer · Photographe · Fotograph · BOUDEWIJN NEUTEBOOM
Designer · Maquettiste · Gestalter · MARIANNE VOS
Art Director · Directeur Artistique · DICK DE MOEI
Publishing Company · Editeur · Verleger · DE GEILLUSTREERDE PERS B.V.

Photographs for a feature, 'Transparante Samenleving' (Transparent Society) by Marielle Ruskauff and Emile Meijer, showing the Taller Amsterdam, an artists' collective, rehearsing before their performance at the Centre Pompidou, Paris; in 'Avenue' December 1979.

Sélection d'un reportage par Mareille Ruskauff et Emile Meijer, qui montre le Taller Amsterdam, une collectivité d'artistes, en répétition avant leur spectacle au Centre Pompidou, Paris; dans 'Avenue' décembre 1979.

Die Bilder für die Reportage ('Transparente Gesellschaft') von Marielle Ruskauff und Emile Meijer zeigen die 'Taller Amsterdam', ein Künstler-Kollektiv, bei Proben für ihre Vorstellung im Centre Pompidou, Paris; 'Avenue' Dezember 1979.

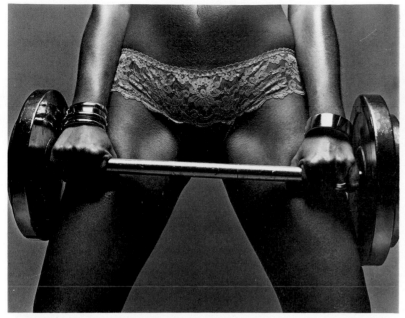 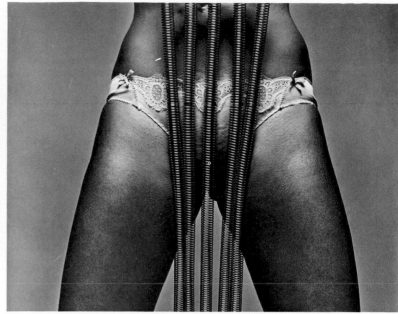

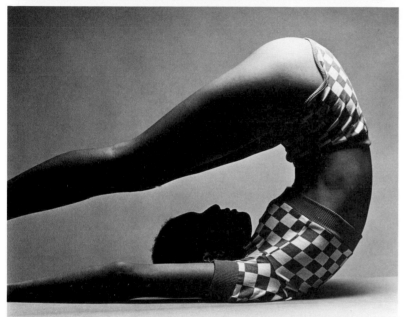 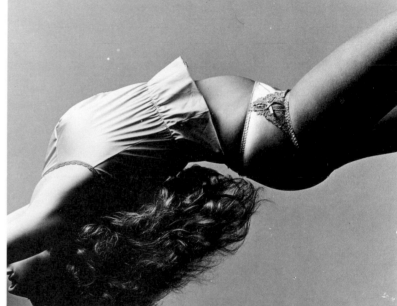

Photographer · Photographe · Fotograph · JAN HENDERIK
Designer · Maquettiste · Gestalter · HANS VAN BLOMMESTEIN
Art Directors · Directeurs Artistiques · DICK DE MOEI/H H VESTERS
Publishing Company · Editeur · Verleger · DE GEILLUSTREERDE PERS B.V.

Four double-page spreads from a fashion feature, 'De kleinste Mode' (The smallest fashion) by Marie-Louise Terwindt; black and white, in 'Avenue' December 1979.

Quatre double pages en noir et blanc extraites d'un reportage de mode, 'La petite mode' par Marie-Louise Terwindt; parues dans 'Avenue' décembre 1979.

Vier Doppelseiten zum Mode-Bericht 'Die kleinste Mode' von Marie-Louise Terwindt; schwarz-weiss, in 'Avenue' Dezember 1979.

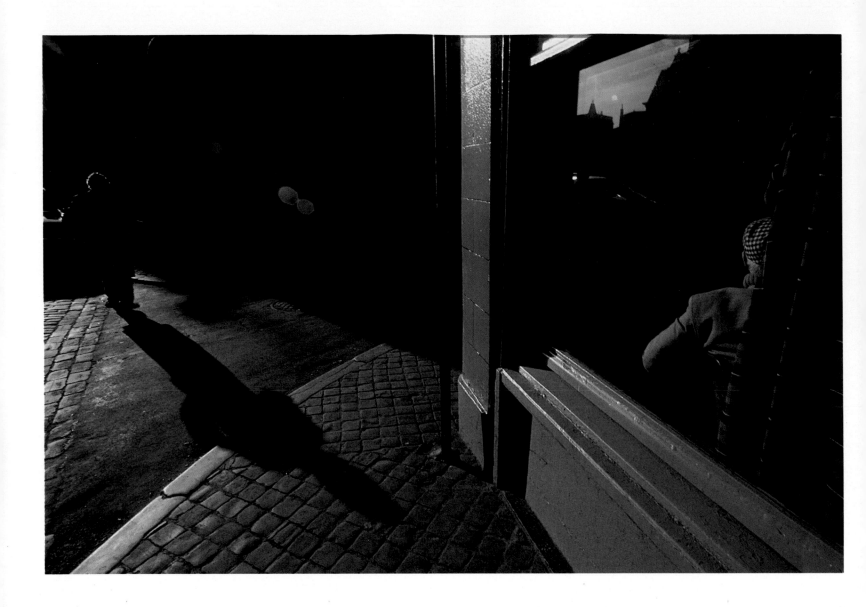

Photographer · Photographe · Fotograph · WILFRIED BAUER
Designer · Maquettiste · Gestalter · MAX LENGWENUS
Art Director · Directeur Artistique · ROLF GILLHAUSEN
Publishing Company · Editeur · Verleger · GRUNER & JAHR AG & CO

Selected from the feature 'Das kleine Kino im Kopf' (The movie in the mind) by Jürgen Kesting, in which passages from Georges Simenon's books were matched with true life locations. When Simenon saw these photographs, taken in Holland, Belgium and Northern France, he recognised scenes from both his books and his childhood. In 'Stern' November 1980.

Sélectionnées du reportage 'Le petit cinéma dans la tête' qui traite l'entreprise du photographe de trouver de vrais endroits pour illustrer des passages des livres de Georges Simenon. Lorsque Simenon a vu ces photographies, qui ont été prises en Hollande, au Belgique et au Nord de la France, il a reconnu des scènes de ses livres aussi bien que de son enfance. Dans 'Stern' novembre 1980.

Ausgewählt aus der Reportage 'Das kleine Kino im Kopf' von Jürgen Kesting, in der Passagen aus den Büchern von Georges Simenon den wirklichen Lokalitäten gegenübergestellt wurden. Als Simenon diese Bilder aus Holland, Belgien und Nord-Frankreich sah, erinnerte er sich an Szenen aus seinen Büchern und seiner Kindheit. Im 'Stern' November 1980.

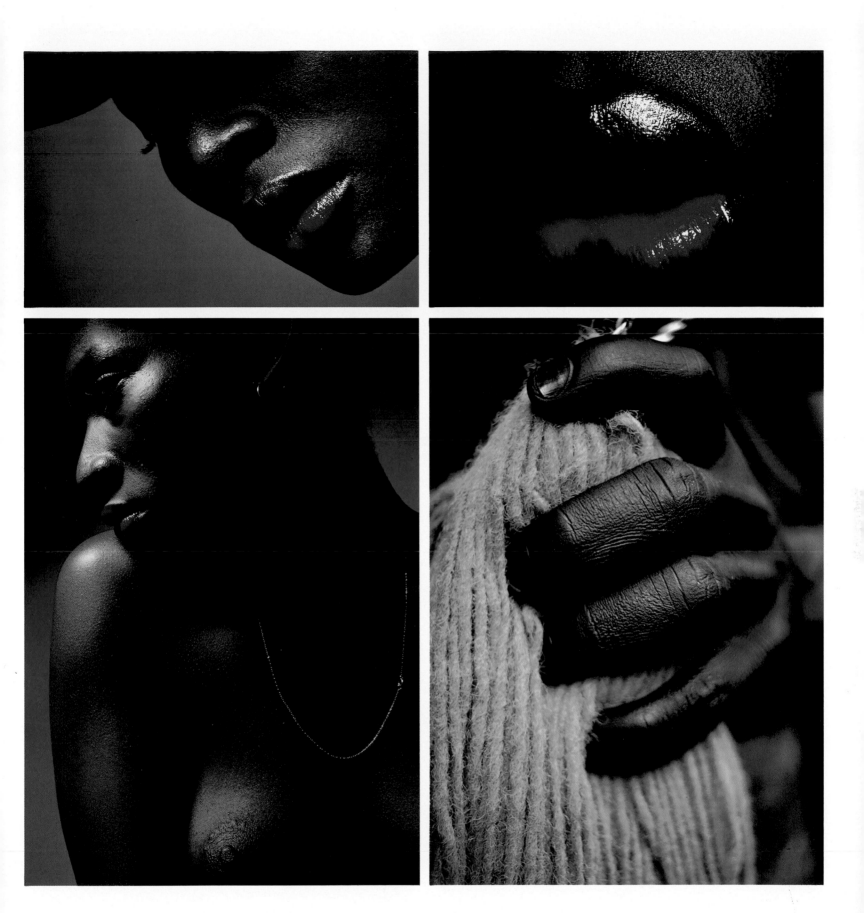

Photographer · Photographe · Fotograph · JOHN CLARIDGE
Art Director · Directeur Artistique · MAURICE CORIAT
Publishing Company · Editeur · Verleger · PUBLICNESS

Selected from an article by Michel Maingois on John Claridge and his work, in 'Zoom'.

Sélectionnées d'un article par Michel Maingois sur John Claridge et son travail, dans 'Zoom'.

Ausgewählt aus einem Artikel von Michel Maingois über John Claridge und sein Werk, in 'Zoom'.

Photographer · Photographe · Fotograph · JOHN CLARIDGE
Art Director · Directeur Artistique · JOEL LAROCHE
Publishing Company · Editeur · Verleger · PUBLICNESS

Taken on location in San Francisco and published in 'Zoom', 1981.

Prise sur place à San Francisco et publiée dans 'Zoom', 1981.

Aufgenommen in San Francisco und veröffentlicht in 'Zoom', 1981.

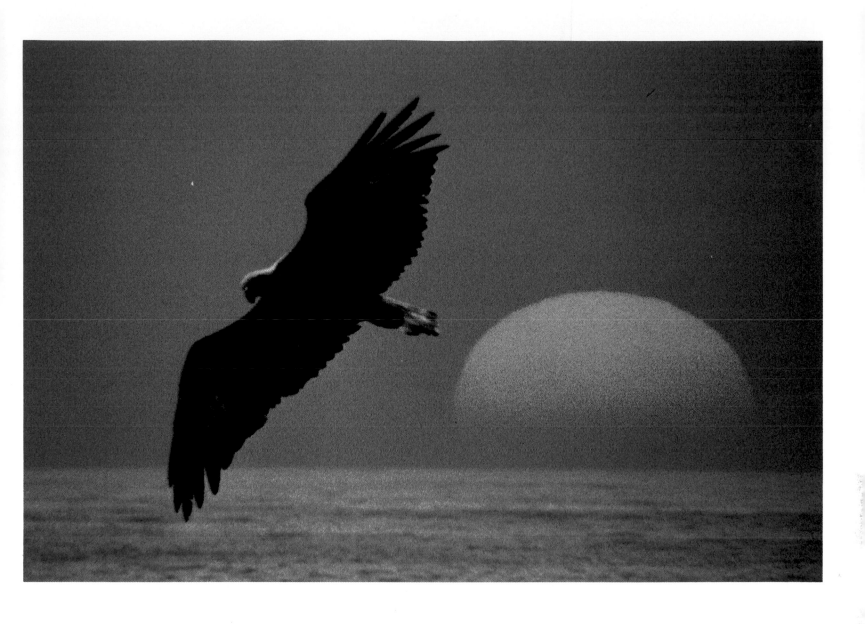

Photographer · Photographe · Fotograph · JOHN CLARIDGE
Art Director · Directeur Artistique · JOEL LAROCHE
Publishing Company · Editeur · Verleger · PUBLICNESS

Taken on location in Sri Lanka and published in 'Zoom', March 1981.

Prise sur place en Sri Lanka et publiée dans 'Zoom', mars 1981.

Aufgenommen in Sri Lanka und veröffentlicht in 'Zoom', März 1981.

BOOKS

This section includes work commissioned for book jackets, paperback covers, and all
types of photographically illustrated books.

LIVRES

Photographies pour des jaquettes de livres reliés, des couvertures de livres de poche, et toutes sortes
de livres illustrés, romans ou autres.

BÜCHER

Photographie für Schutzumschläge, Paperback-Umschläge und Bücher aller Art,
Romane und Sachbücher.

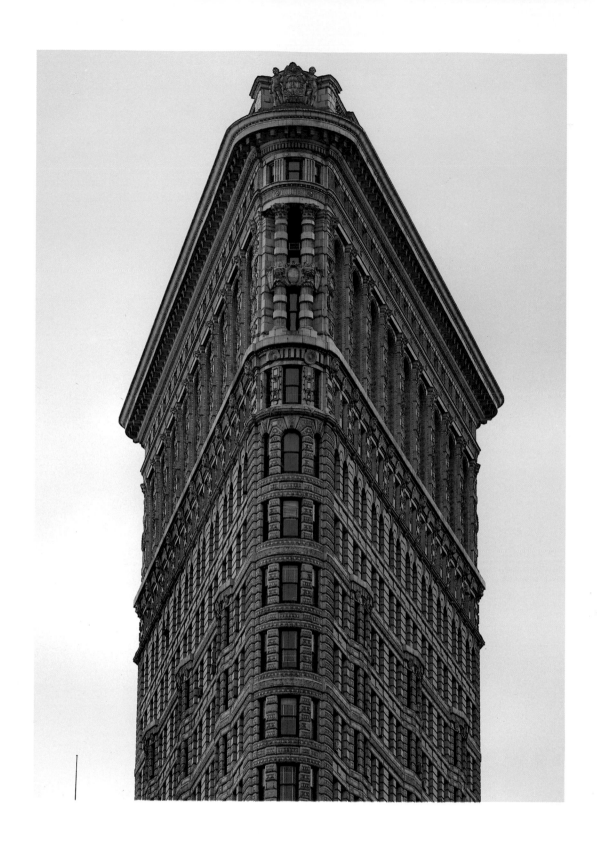

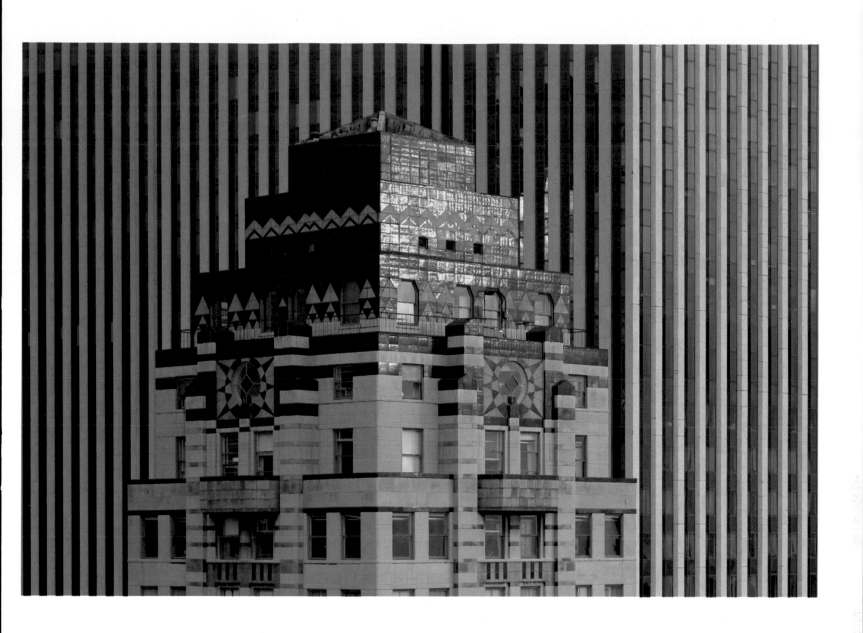

106, 107, 108, 109, 110

Photographer · Photographe · Fotograph · REINHART WOLF
Art Director · Directeur Artistique · VILIM VASATA
Publishing Company · Editeur · Verleger · GRUNER & JAHR AG & CO.

Photographs from Reinhart Wolf's book 'New York' published in 1980; respectively: Flatiron Building, Fuller Building, Empire State Building, Chrysler Building (detail).

Photographies du livre 'New York' de Reinhart Wolf publié en 1980; respectivement: Flatiron Building, Fuller Building, Empire State Building, Chrysler Building (détail).

Photos aus dem Buch 'New York' von Reinhart Wolf. veröffentlicht 1980; der Reihe nach: Flatiron Building, Fuller Building, Empire State Building, Chrysler Building (detail).

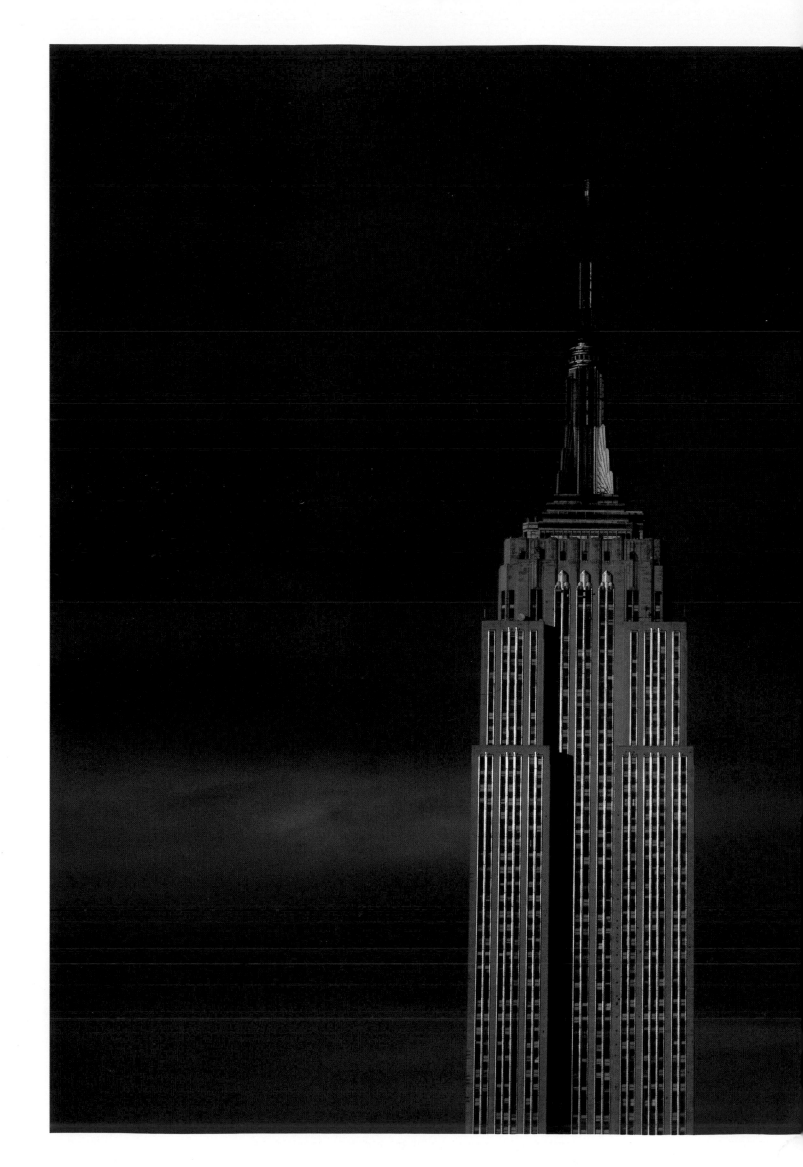

Photographer · Photographe · Fotograph · FRANCO FONTANA
Designer · Maquettiste · Gestalter · JUDE HARRIS
Art Director · Directeur Artistique · ALAN FLETCHER
Design Group · Equipe de Graphistes · Design Gruppe · PENTAGRAM
Client · Auftraggeber · THE COMMERCIAL BANK OF KUWAIT

Selection from 'Landscapes', a book of twenty landscape studies of Kuwait, published in 1980.

Sélection du livre 'Paysages': vingt études de paysages au Koweit, publié en 1980.

Auswahl von 20 Landschaftstudien in Kuweit aus dem Buch 'Landschaften', erschienen 1980.

112, 113

Photographer · Photographe · Fotograph · PETER MACKERTICH
Designer · Maquettiste · Gestalter · ROY WALKER
Art Director · Directeur Artistique · TONY MACKERTICH
Publishing Company · Editeur · Verleger · MATHEWS MILLER & DUNBAR

Selection from the book 'Façade', a decade of British and American commercial architecture, by Peter and Tony Mackertich, published in 1976.

Une sélection du livre 'Façade', l'architecture commerciale britannique et américaine pendant une période de dix ans par Peter et Tony Mackertich, publié en 1976.

Auswahl aus dem Buch 'Facade', ein Jahrzehnt englischer und amerikanischer Gebrauchsarchitektur von Peter und Tony Mackertich, erschienen 1976.

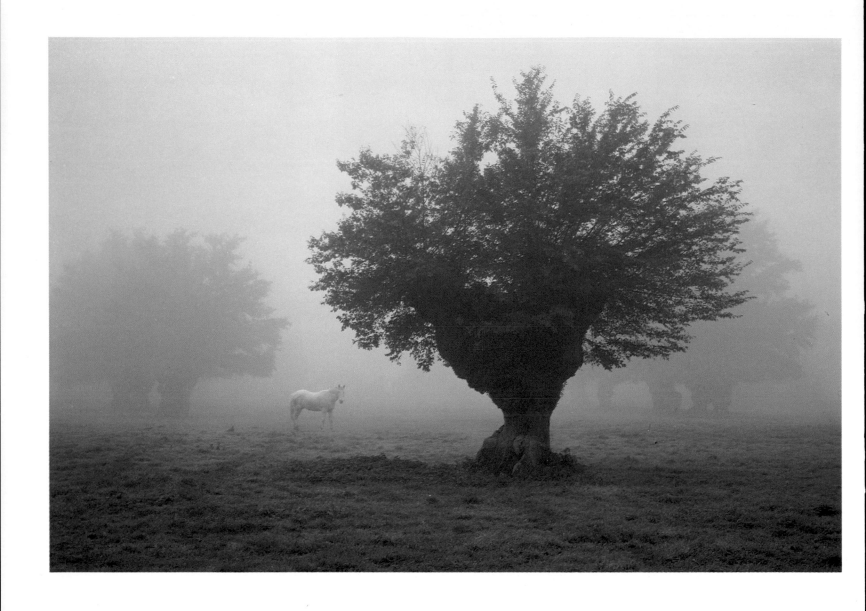

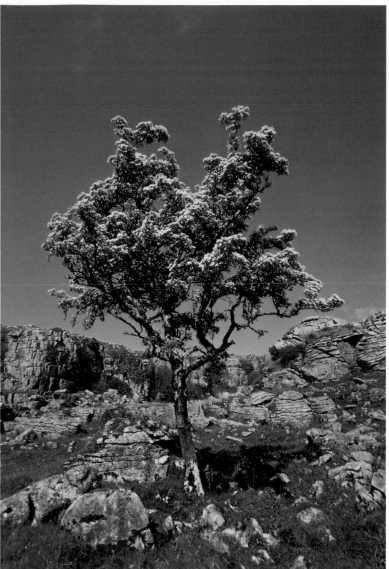

114, 115

Photographer · Photographe · Fotograph · TONY EVANS
Designer · Maquettiste · Gestalter · ROGER WALKER
Publishing Company · Editeur · Verleger · HUTCHINSONS GENERAL BOOKS LIMITED

Selection from the book 'The Flowering of Britain' by Sélection du livre 'La Grande Bretagne en fleurs' Auswahl aus dem Buch 'Die Blumen von England',
Richard Mabey, published in October 1980. par Richard Mabey, publié en octobre 1980. von Richard Mabey, erschienen Oktober 1980.

Photographer · Photographe · Fotograph · ROGER PHILLIPS
Designer · Maquettiste · Gestalter · ROGER PHILLIPS

Selection from the book 'Grasses, Ferns, Mosses & Lichens of Great Britain and Ireland' by Roger Phillips, published in 1980.

Sélection du livre 'Les graminées, les fougères, les muscinées et les lichens de la Grande Bretagne et de l'Irelande' par Roger Phillips, publié en 1980.

Auswahl aus dem Buch 'Gräser, Farne, Moos und Flechten in England und Irland' von Roger Phillips, erschienen 1980.

Photographer · Photographe · Fotograph · DENIS WAUGH
Art Director · Directeur Artistique · CLIVE CROOK
Publishing Company · Editeur · Verleger · MACDONALD & COMPANY PUBLISHERS LIMITED

Taken in Snowdonia and used for the cover of 'The Sunday Times Book of the Countryside', 1980.

Prise dans la Snowdonia et employée comme couverture de 'The Sunday Times Book of the Countryside', 1980.

Aufgenommen in Snowdonia und erschienen auf dem Titel des Buches 'The Sunday Times Book of the Countryside', 1980.

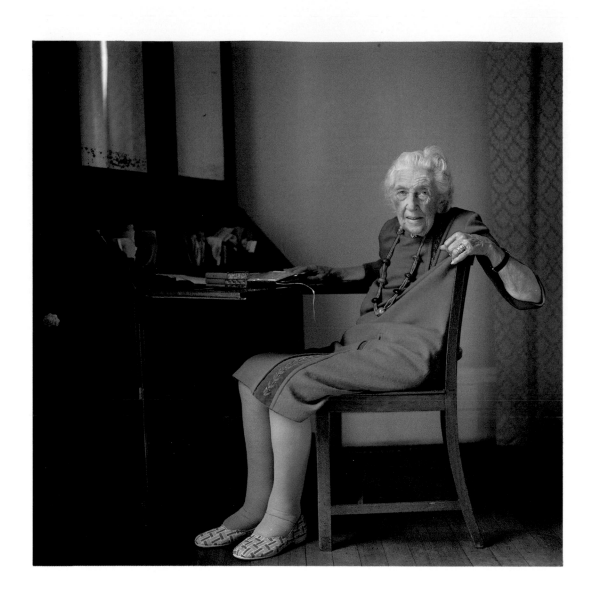

Photographer · Photographe · Fotograph · SNOWDON

Art Director · Directeur Artistique · MICHAEL RAND

Publishing Company · Editeur · Verleger · TIMES NEWSPAPERS LIMITED

Portrait of Agatha Christie aged 84 at her home in Berkshire in 'The Sunday Times Magazine'. 3 November 1974.

Portrait de Agatha Christie agée de 84 ans chez elle dans le Berkshire dans 'The Sunday Times Magazine'. 3 novembre 1974.

Portrait von Agatha Christie im Alter von 84 Jahren in ihrem Haus in Berkshire, in 'The Sunday Times Magazine'. 3. November 1974.

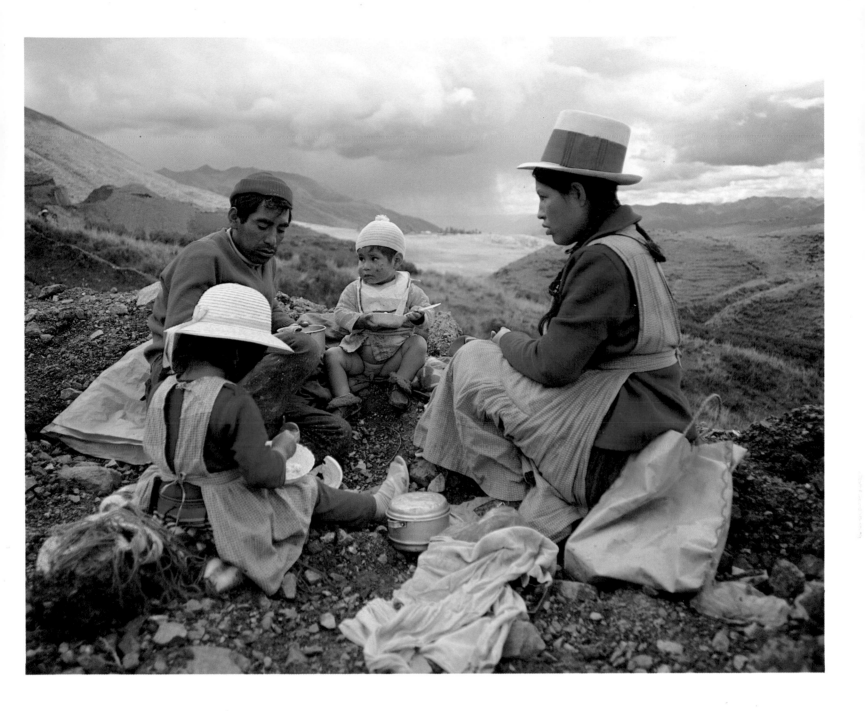

Photographer · Photographe · Fotograph · SNOWDON
Art Director · Directeur Artistique · MICHAEL RAND
Publishing Company · Editeur · Verleger · TIMES NEWSPAPERS LIMITED

Picnic at Cusco, Peru for the article 'Peru, The Problems of Staying Alive' by Norman Lewis, in 'The Sunday Times Magazine', 12 November 1972.

Pique-nique à Cusco, Le Pérou, pour l'article 'Le Pérou, les problèmes de survivre' par Norman Lewis, dans 'The Sunday Times Magazine', 12 novembre 1972.

Picknick in Cusco, Peru, für den Artikel 'Peru, die Probleme des Überlebens' von Norman Lewis, in 'The Sunday Times Magazine', 12. November 1972.

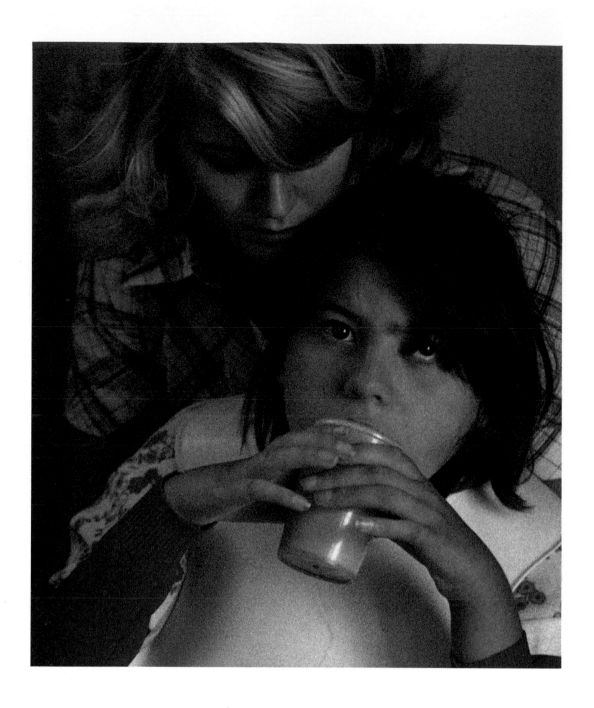

Photographer · Photographe · Fotograph · SNOWDON
Art Director · Directeur Artistique · MICHAEL RAND
Publishing Company · Editeur · Verleger · TIMES NEWSPAPERS LIMITED

'Love and Affection-A new future for the mentally handicapped', cover of 'The Sunday Times Magazine', March 1977.

'Amour et tendresse-un nouvel avenir pour les handicappés mentaux, couverture de 'The Sunday Times Magazine', mars 1977.

'Liebe und Zuneigung-eine neue Zukunft für Geisteskranke', Titelseite für 'The Sunday Times Magazine', März 1977.

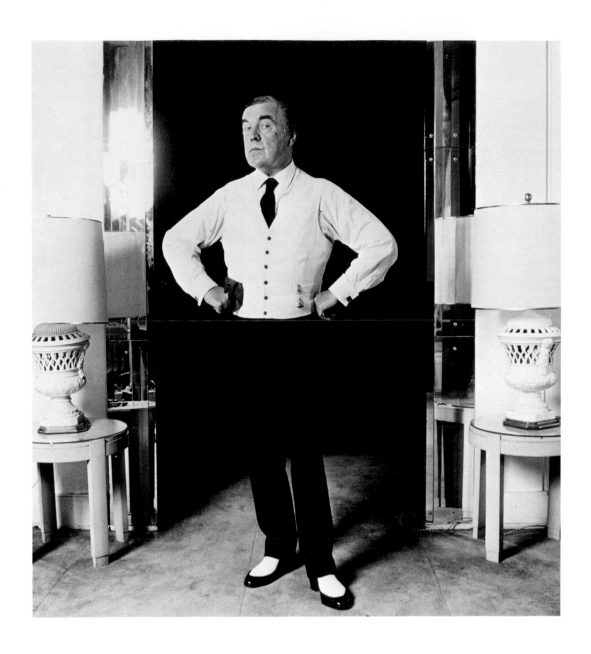

Photographer · Photographe · Fotograph · SNOWDON
Art Director Directeur Artistique MICHAEL RAND
Publishing Company · Editeur · Verleger · TIMES NEWSPAPERS LIMITED

Portrait of Sir Norman Hartnell, couturier, in his Mayfair salon, for the article 'The Pearly King' by Francis Wyndham, in 'The Sunday Times Magazine', 22 September 1968.

Portrait de Sir Norman Hartnell, couturier, dans son salon à Mayfair, Londres, pour l'article 'Le Roi des perles' par Francis Wyndham, dans 'The Sunday Times Magazine', 22 septembre 1968.

Portrait von Sir Norman Hartnell, Modeschöpfer, in seinem Salon in Mayfair, London, für den Artikel 'Der Perlen-König' von Francis Wyndham, in 'The Sunday Times Magazine', 22. September 1968.

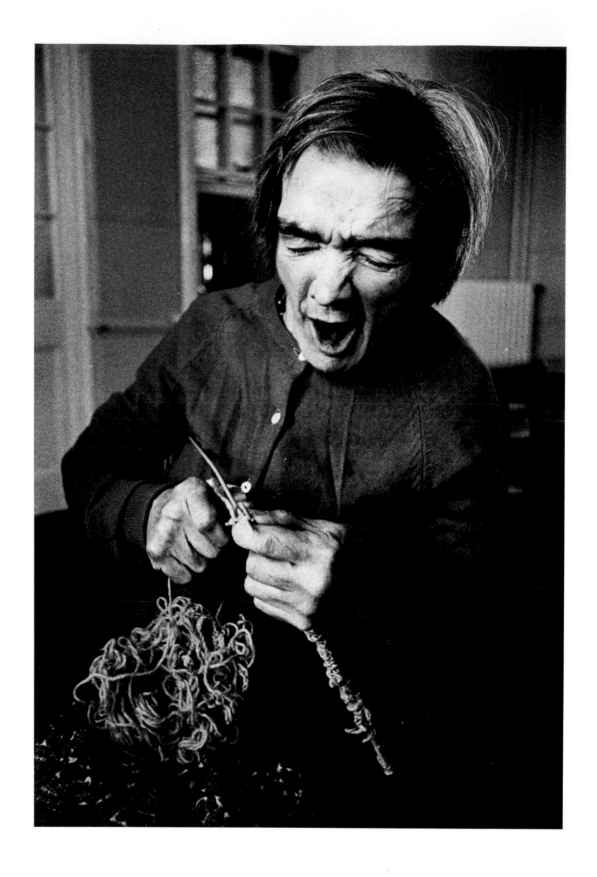

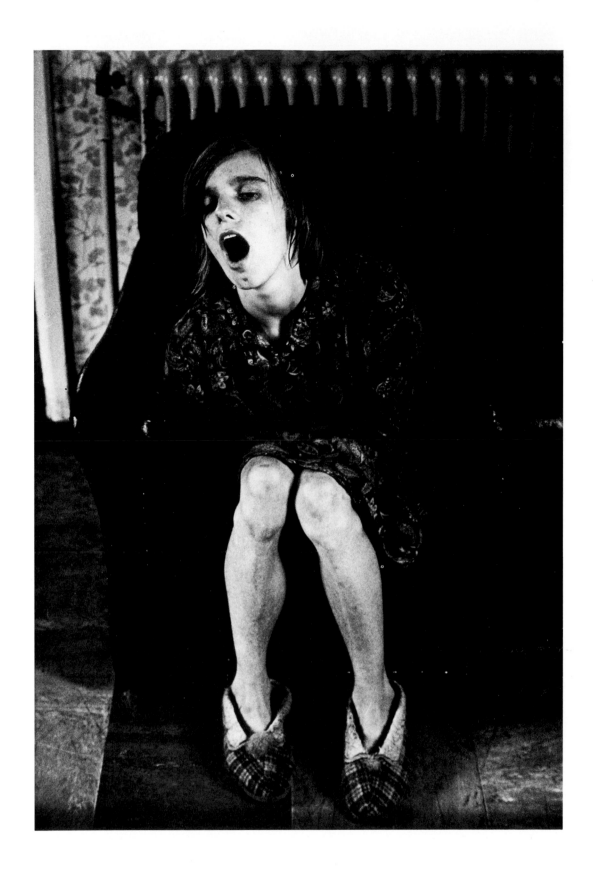

122, 123, 124, 125

Photographer · Photographe · Fotograph · SNOWDON
Art Director · Directeur Artistique · MICHAEL RAND
Publishing Company · Editeur · Verleger · TIMES NEWSPAPERS LIMITED

Patients in English mental hospitals for a report by D. A. N. Jones 'Mental Hospitals, a Suitable Cause for Conscience,' in 'The Sunday Times Magazine,' 29 September 1968.

Malades dans des asiles d'aliénés anglais pour un reportage par D. A. N. Jones, 'Des Asiles d'aliénés, un cas pertinent de conscience,' dans 'The Sunday Times Magazine,' 29 septembre 1968.

Patienten in englischen Irrenanstalten, für eine Reportage von D. A. N. Jones, 'Irrenanstalten, ein echter Grund für Gewissensbisse,' in 'The Sunday Times Magazine,' 29. September 1968.

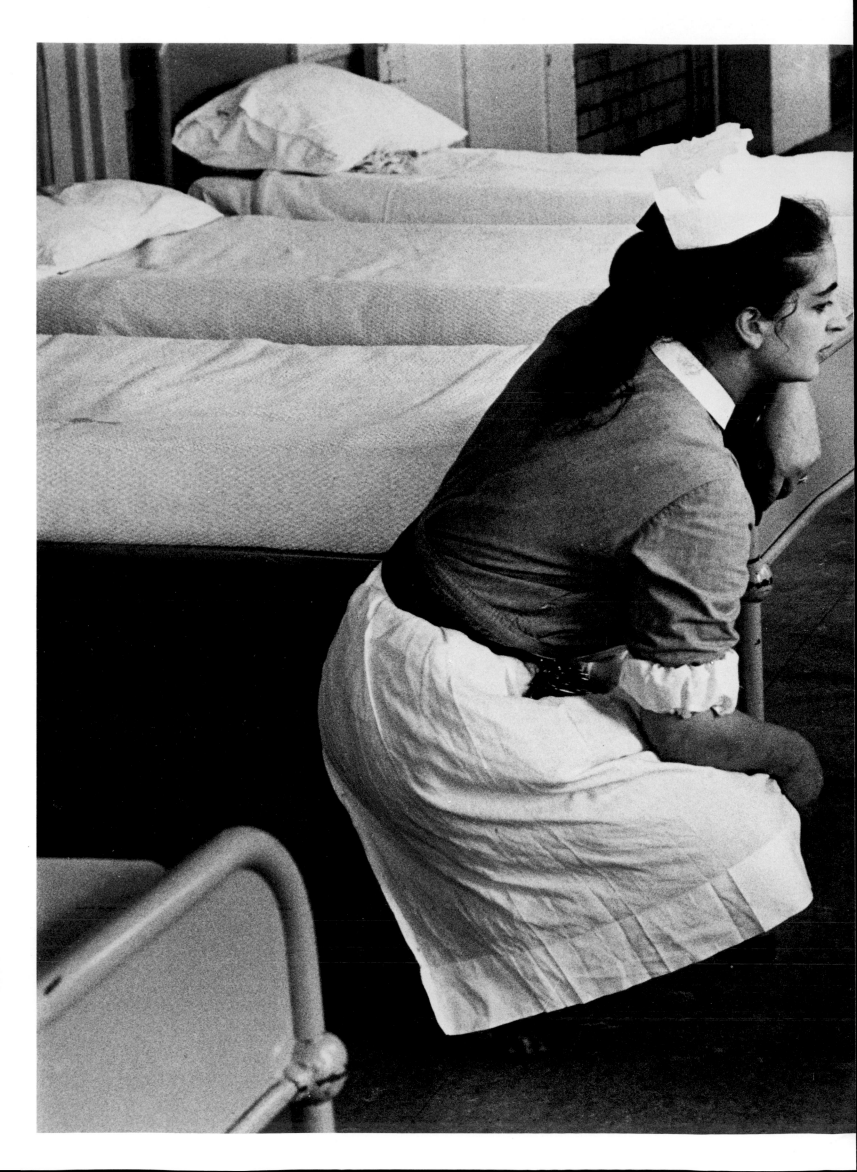

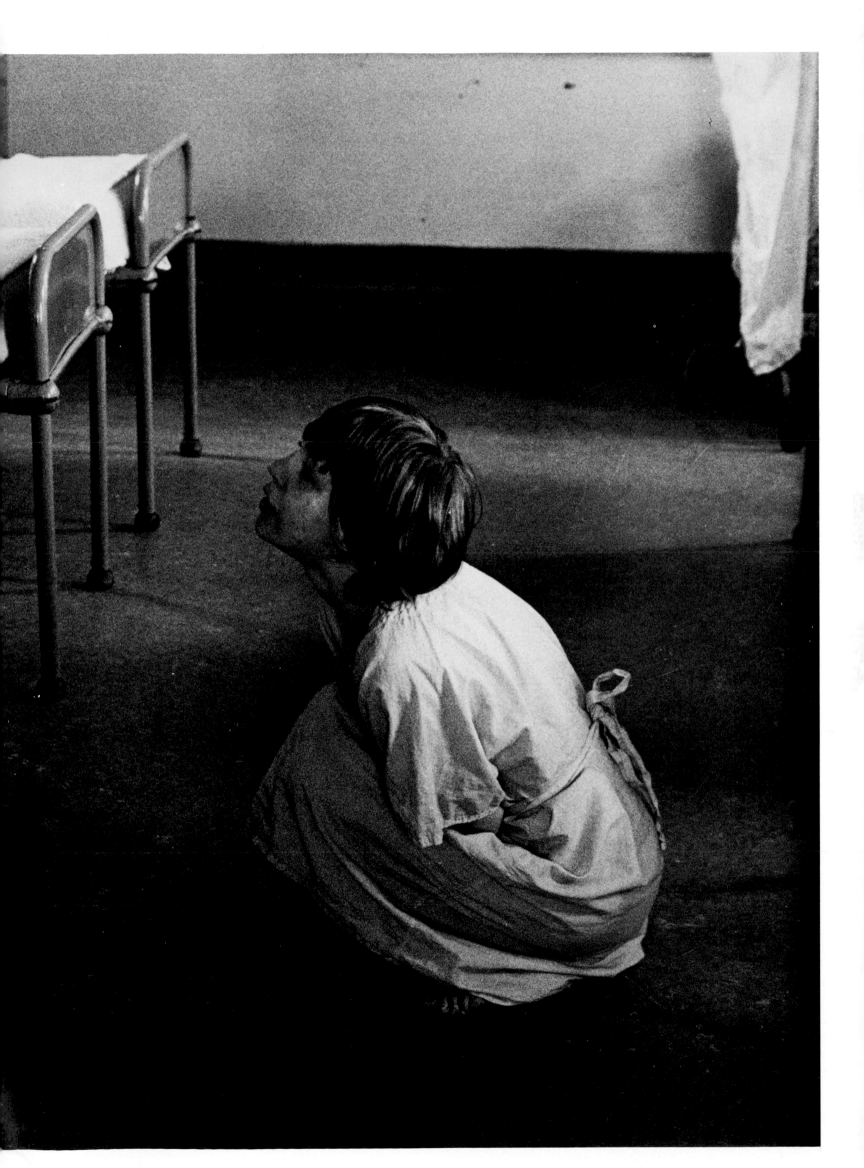

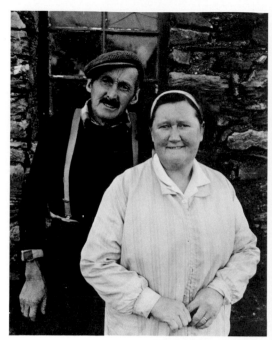
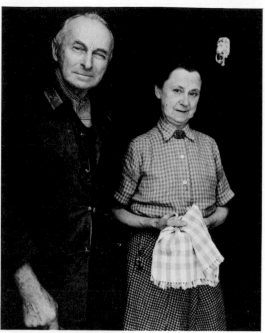

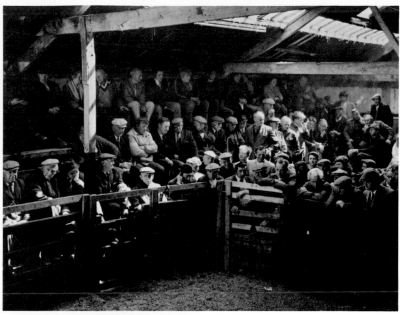

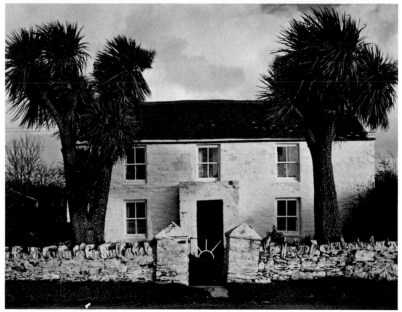

126, 127

Photographer · Photographe · Fotograph · CHRIS KILLIP
Designer · Maquettiste · Gestalter · ROLAND SCHENK
Art Director · Directeur Artistique · ROLAND SCHENK
Publishing Company · Editeur · Verleger · THE ARTS COUNCIL OF GREAT BRITAIN

Taken on location between 1969-72 for the book 'Isle of Man-A Book about the Manx' by Chris Killip, published in 1980.

Prises sur place entre 1969-72 pour le livre 'Isle of Man-Un livre sur les gens' par Chris Killip, publié en 1980.

Aufgenommen zwischen 1969-72 für das Buch 'Die Isle of Man-Ein Buch über deren Einwohner' von Chris Killip, erschienen 1980.

ADVERTISING & POSTERS

This section includes work commissioned for posters, prints and advertisements for consumer magazines.

PUBLICITÉ ET AFFICHES

Cette section comprend des travaux commandés pour des affiches, des illustrations et de la publicité pour les magazines de consommateurs.

WERBUNG UND PLAKATE

Dieser Abschnitt umfasst Auftragsarbeiten für Plakate, Drucksachen und Anzeigen für Verbraucherzeitschriften.

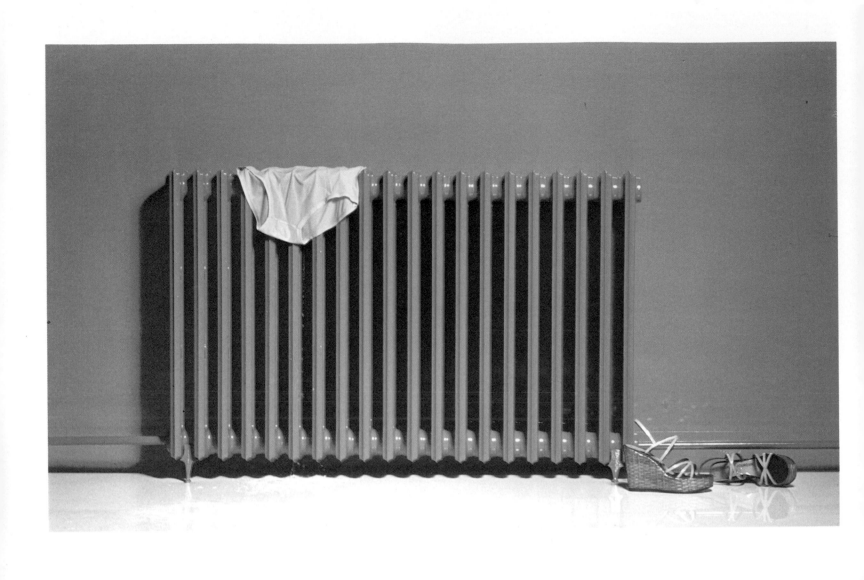

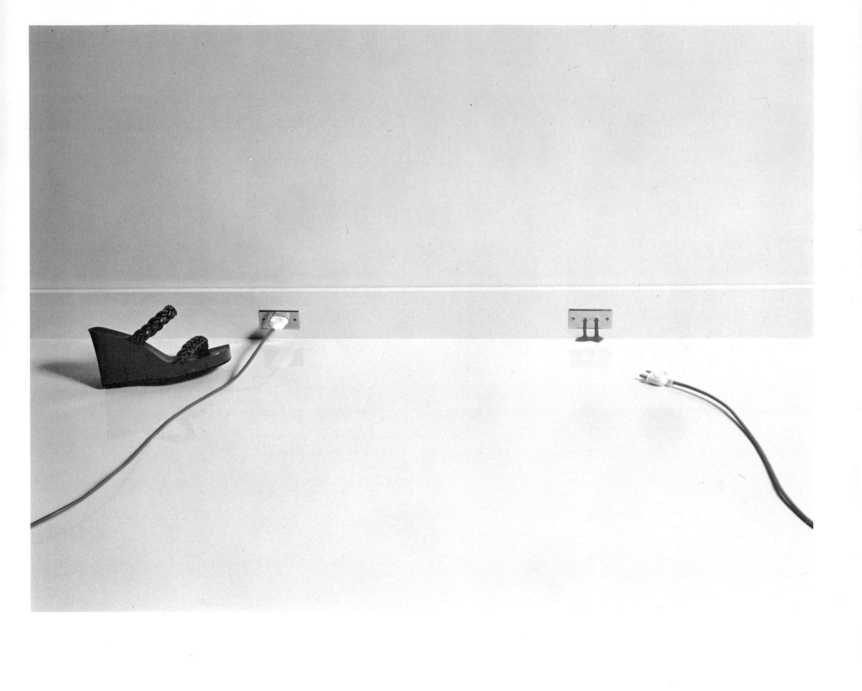

130, 131, 132, 133, 134, 135, 136

Photographer · Photographe · Fotograph · GUY BOURDIN
Designer · Maquettiste · Gestalter · GUY BOURDIN
Art Director · Directeur Artistique · GERARD TAVENAS
Client · Auftraggeber · CHARLES JOURDAN

A selection of advertisements for Charles Jourdan shoes, published in various magazines throughout the world.

Une sélection de photo-publicitaires pour des chaussures de Charles Jourdan, publiées dans de diverses revues partout dans le monde.

Verschiedene Anzeigen für Charles Jourdan Schuhe, weltweit in verschiedenen Zeitschriften veröffentlicht.

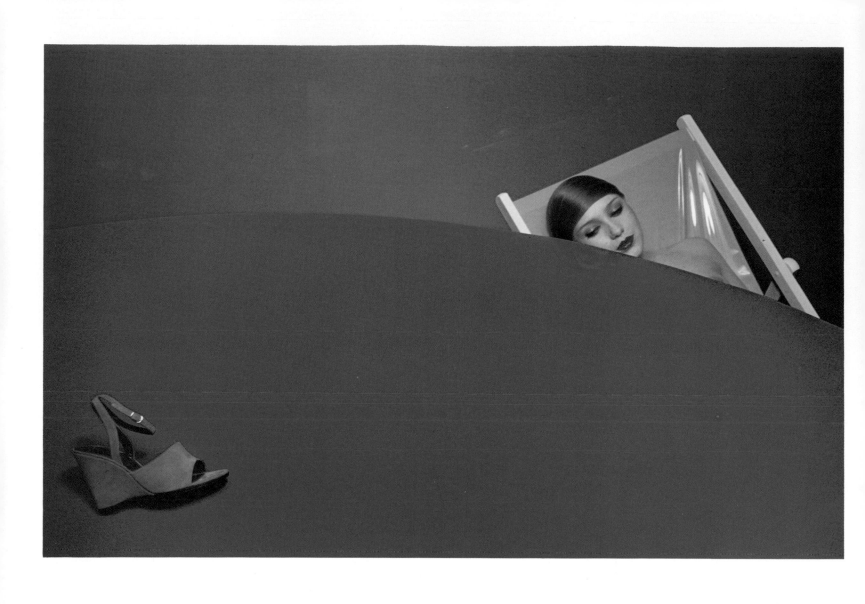

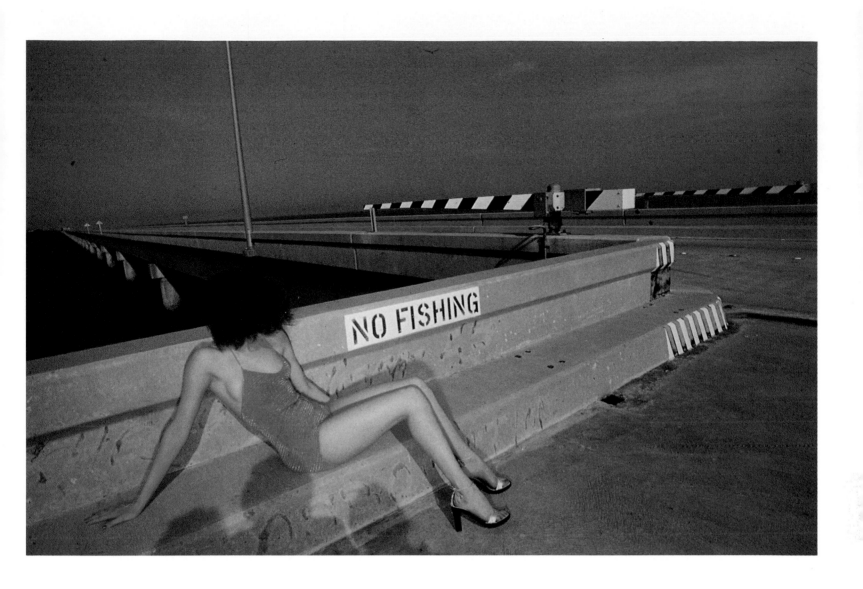

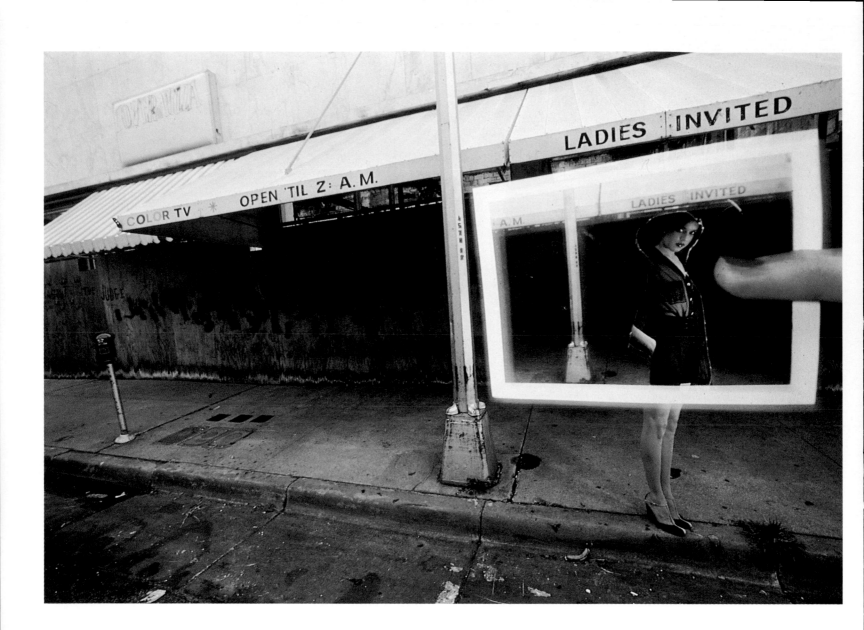

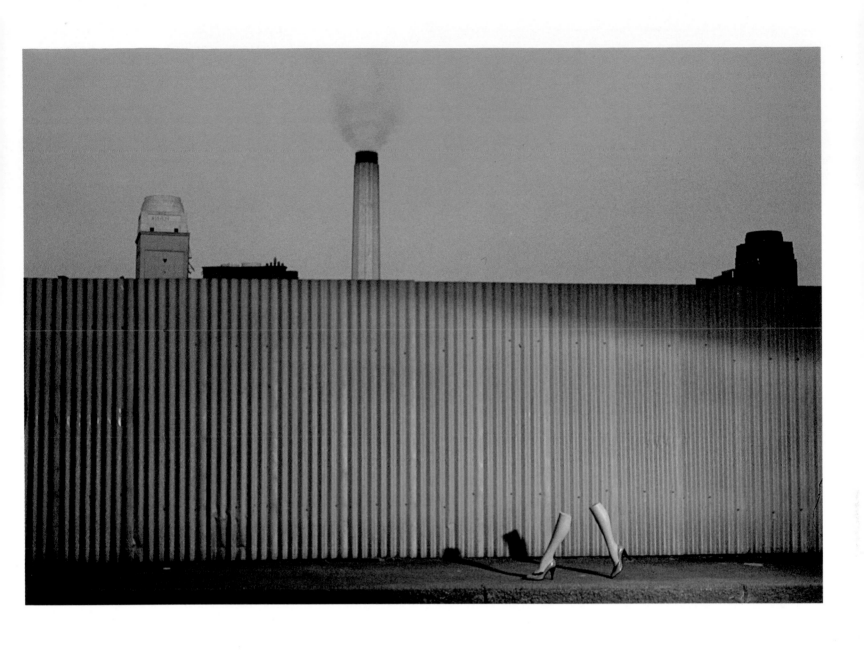

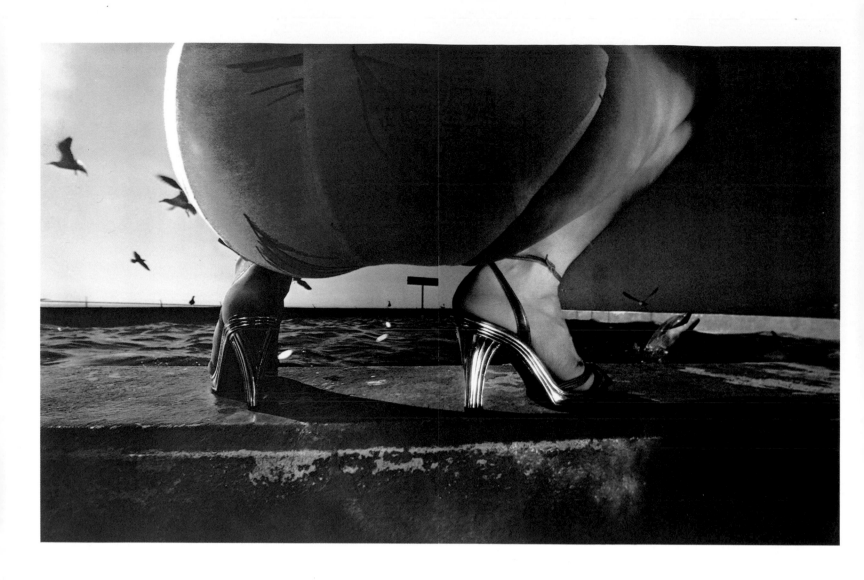

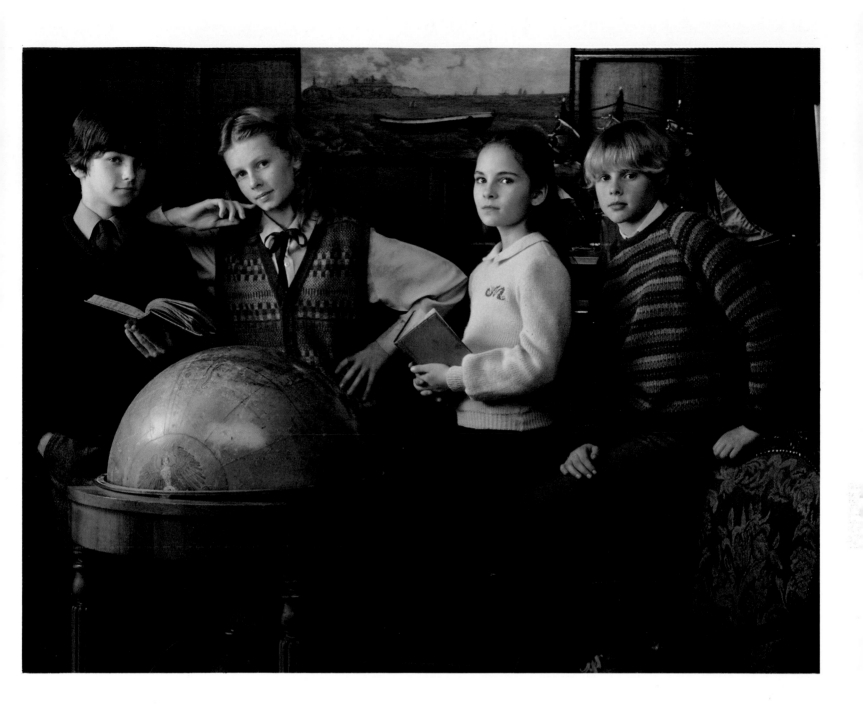

Photographer · Photographe · Fotograph · MICHAEL JOSEPH
Art Director · Directeur Artistique · BEATRICE PATRAT
Advertising Agency · Agence de Publicité · Werbeagentur · RSCG FERTON/BILLIÈRE
Client · Auftraggeber · TRICOTS MARÈSE

Advertisement for children's knitwear which appeared in various magazines in France.

Une publicité pour les tricots d'enfants parue dans plusieurs revues en France.

Anzeige für Kinder-Stricksachen, erschienen in verschiedenen französischen Zeitschriften.

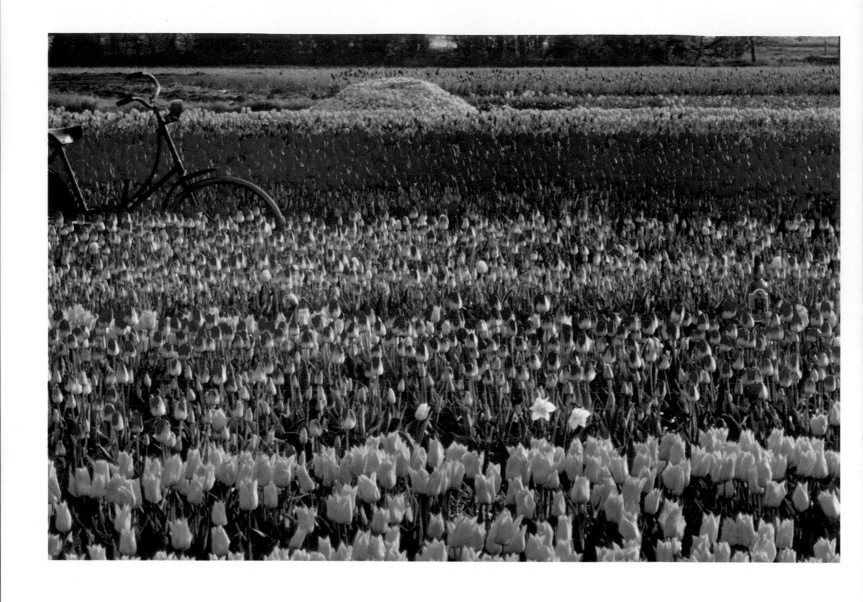

Photographer · Photographe · Fotograph · ELLIOTT ERWITT
Art Director · Directeur Artistique · NIGEL ROSE
Advertising Agency · Agence de Publicité · Werbeagentur · COLLETT DICKENSON PEARCE & PARTNERS LIMITED
Copywriter · Rédacteur · Texter · JOHN SALMON
Client · Auftraggeber · INTERNATIONAL DISTILLERS & VINTERS LIMITED

Advertisement for J & B Whiskey with headline 'J & B Rare, can be found', which appeared as a double-page spread in several British magazines.

Une publicité pour J & B Whiskey avec la légende 'J & B Rare, on peut le trouver', parue en double page dans plusieurs revues en Grande Bretagne.

Anzeige für J & B Whiskey mit dem Titel 'J & B Rare, man, kann inn finden', in verschiedenen Zeitschriften als Doppelseite erschienen.

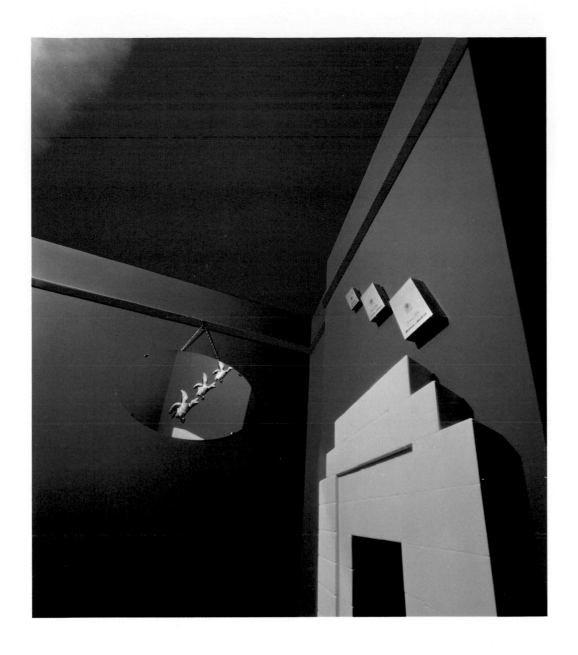

Photographer · Photographe · Fotograph · ADRIAN FLOWERS
Designer · Maquettiste · Gestalter · GRAHAM WATSON
Art Director · Directeur Artistique · GRAHAM WATSON
Advertising Agency · Agence de Publicité · Werbeagentur · COLLETT DICKENSON PEARCE & PARTNERS LIMITED
Client · Auftraggeber · GALLAHER LIMITED

Advertisement for Benson & Hedges cigarettes, which appeared both as a poster and in selected magazines.

Une publicité pour les cigarettes de Benson & Hedges, parue dans plusieurs revues et aussi comme une affiche.

Anzeige für Benson & Hedges Zigaretten, erschienen in verschiedenen Zeitschriften und als Plakat.

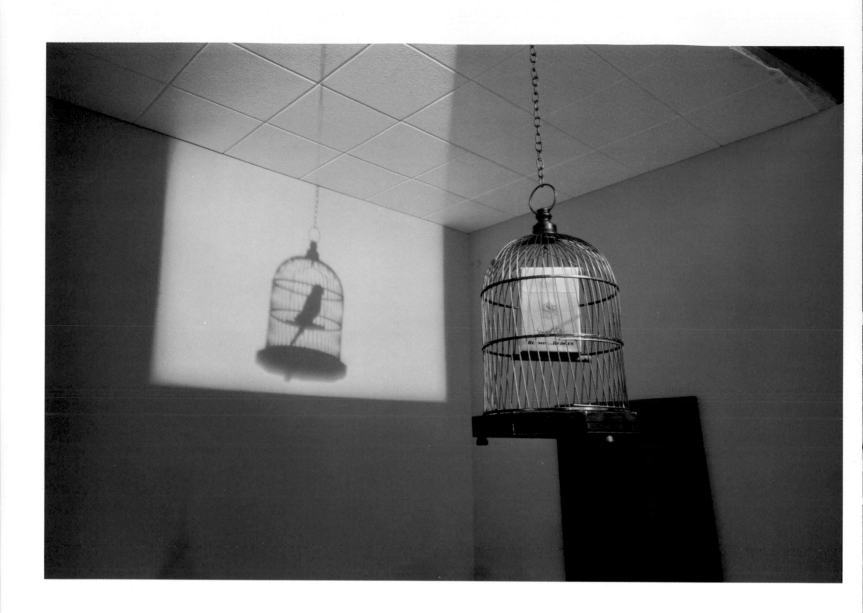

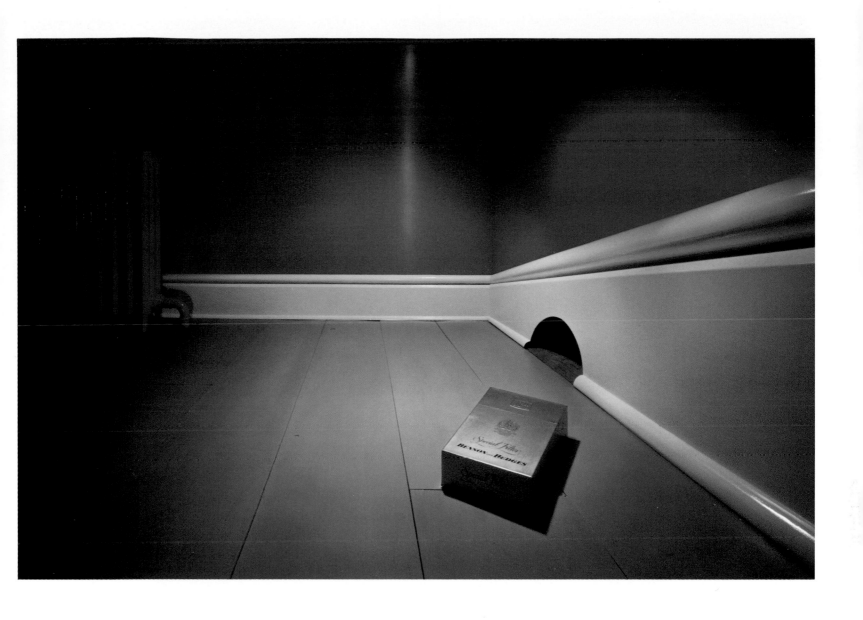

Photographer · Photographe · Fotograph · DUFFY
Designer · Maquettiste · Gestalter · MIKE COZENS
Art Director · Directeur Artistique · ALAN WALDIE
Advertising Agency · Agence de Publicité · Werbeagentur · COLLETT DICKENSON PEARCE & PARTNERS LIMITED
Client · Auftraggeber · GALLAHER LIMITED

Advertisement for Benson & Hedges cigarettes, which appeared both as a poster and in selected magazines.	Une publicité pour les cigarettes de Benson & Hedges, parue dans plusieurs revues et aussi comme une affiche.	Anzeige für Benson & Hedges Zigaretten, erschienen in verschiedenen Zeitschriften und als Plakat.

Photographer · Photographe · Fotograph · ROLPH GOBITS
Designer · Maquettiste · Gestalter · UWE DUVENDACK
Art Director · Directeur Artistique · MALCOLM GASKIN
Advertising Agency · Agence de Publicité · Werbeagentur · TBWA LIMITED
Copywriter · Rédacteur · Texter · NEIL PATTERSON
Client · Auftraggeber · CIGA HOTELS

Advertisement with headline 'To be sure of a seat on the first flight to the moon, talk to the concierge at the Excelsior, Rome;' double-page spread which appeared in magazines in Great Britain, France and Germany.

Une publicité avec le titre 'Pour être certain d'une place sur le premier vol pour la lune, adressez-vous au concierge de l'Excelsior, Rome;' une double page parue dans des revues en Grande Bretagne, en France et en Allemagne.

Anzeige mit dem Titel: 'Wenn Sie sich einen Platz auf dem ersten Flug zum Mond sichern wollen, sprechen Sie mit dem Portier vom Excelsior, Rom;' Doppelseite, erschienen in verschiedenen Zeitschriften in England, Frankreich und Deutschland.

Photographer · Photographe · Fotograph · ROLPH GOBITS
Designer · Maquettiste · Gestalter · UWE DUVENDACK
Art Director · Directeur Artistique · MALCOLM GASKIN
Advertising Agency · Agence de Publicité · Werbeagentur · TBWA LIMITED
Copywriter · Rédacteur · Texter · NEIL PATTERSON
Client · Auftraggeber · GIGA HOTELS

Advertisement with headline 'Only a bird gets a better view of Florence than a guest at the Excelsior,' showing three views of the skyline of Florence taken from the Hotel Excelsior's roof terrace. Published in magazines in Great Britain, France and Germany.

Une publicité avec le titre 'Un oiseau est le seul d'avoir une meilleure vue de Florence qu'un client de l'Excelsior', elle montre trois vues de profil de Florence prises de la terrasse sur le toit de l'Hotel Excelsior; publiée dans des revues en Grande Bretagne, en France et en Allemagne.

Anzeige mit dem Titel 'Nur ein Vogel hat einen besseren Blick auf Florenz, als ein Gast im Excelsior,' drei Stadtansichten, aufgenommen von der Dachterrasse des Excelsior Hotels. Veröffentlicht in englischen, französischen und deutschen Zeitschriften.

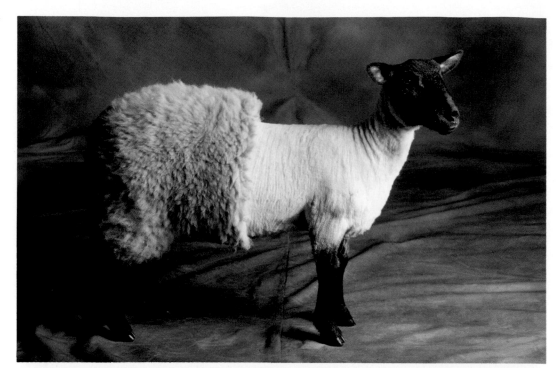

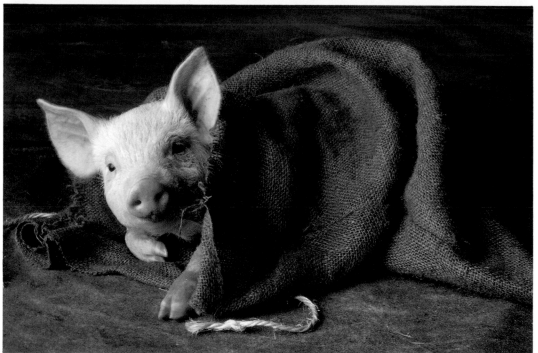

Photographer · Photographe · Fotograph · STAK
Art Director · Directeur Artistique · MIKE PRESTON
Advertising Agency · Agence de Publicité · Werbeagentur · J WALTER THOMPSON COMPANY LIMITED
Copywriter · Rédacteur · Texter · RICHARD SLOGGETT

Series of advertisements, using unsedated animals, which appeared in 'Farmer's Weekly'.

Série de publicités figurant des animaux vivants non-drogués, parues dans 'Farmer's Weekly'.

Anzeigen-Serie über den Umgang mit unruhigen Tieren, in 'Farmer's Weekly'.

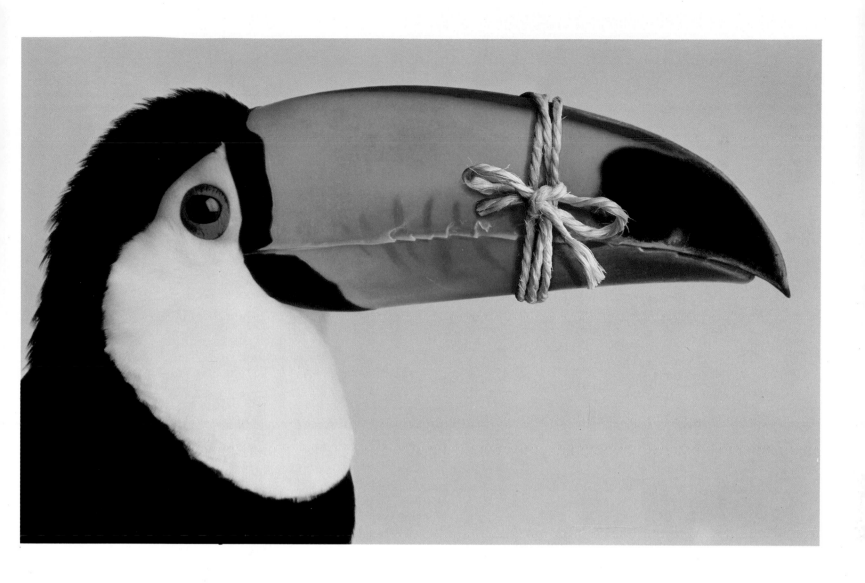

Photographer · Photographe · Fotograph · STAK
Art Director · Directeur Artistique · JILL O'MEARA
Advertising Agency · Agence de Publicité · Werbeagentur · J WALTER THOMPSON COMPANY LIMITED
Copywriter · Rédacteur · Texter · PAUL FISHLOCK
Client · Auftraggeber · ARTHUR GUINNESS SON & COMPANY (PARK ROYAL) LIMITED

| Poster with the slogan, 'Enjoy a quiet Guinness at home'. | Affiche-publicitaire avec le slogan 'Dégustez un Guinness tranquille chez vous'. | Plakat mit dem Titel 'Geniessen Sie Guinness in Ruhe zu Hause'. |

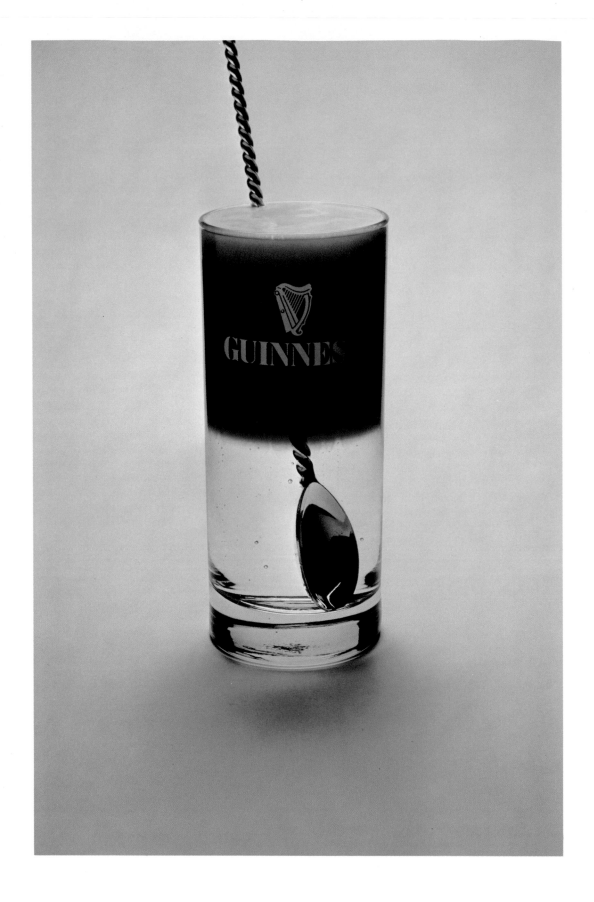

Photographer · Photographe · Fotograph · STAK
Art Director · Directeur Artistique · SIMON KENTISH
Advertising Agency · Agence de Publicité · Werbeagentur · J WALTER THOMPSON COMPANY LIMITED
Copywriter · Rédacteur · Texter · NICK FORDHAM
Client · Auftraggeber · ARTHUR GUINNESS SON & COMPANY (PARK ROYAL) LIMITED

Advertisement for Guinness with the slogan 'We'll meet you half way,' which appeared in 'Harpers & Queen' and 'Vogue', 1980.

Une publicité pour le Guinness avec le slogan 'Nous viendrons a votre rencontre', parue dans les revues 'Harpers & Queen' et 'Vogue', 1980.

Anzeige für Guinness mit dem Titel 'Wir kommen Ihnen entgegen', erschienen in 'Harpers & Queen' und 'Vogue' 1980.

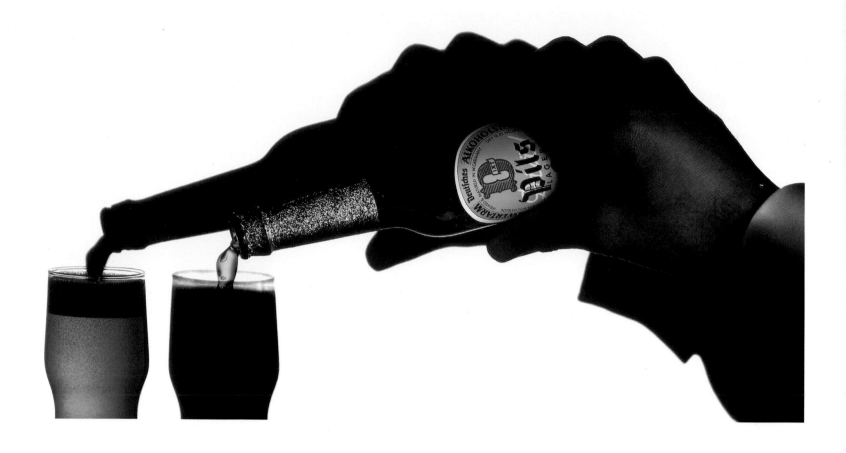

Photographer · Photographe · Fotograph · GRAHAM FORD
Art Director · Directeur Artistique · BOB MILLER
Advertising Agency · Agence de Publicité · Werbeagentur · BUTLER DENNIS GARLAND & PARTNERS LIMITED
Copywriter · Rédacteur · Texter · TERRY LOVELOCK
Client · Auftraggeber · WATNEY MANN & TRUMAN BREWERS

Poster advertising Pils from Holsten with caption 'Pour out the odd bottle', 1980.

Une affiche-publicitaire pour Pils de Holsten avec la légende 'Versez-vous un original de temps en temps', 1980.

Werbeplakat für Pils der Holsten-Brauerei mit dem Text 'Gönnen Sie sich ab und zu eine Flasche', 1980.

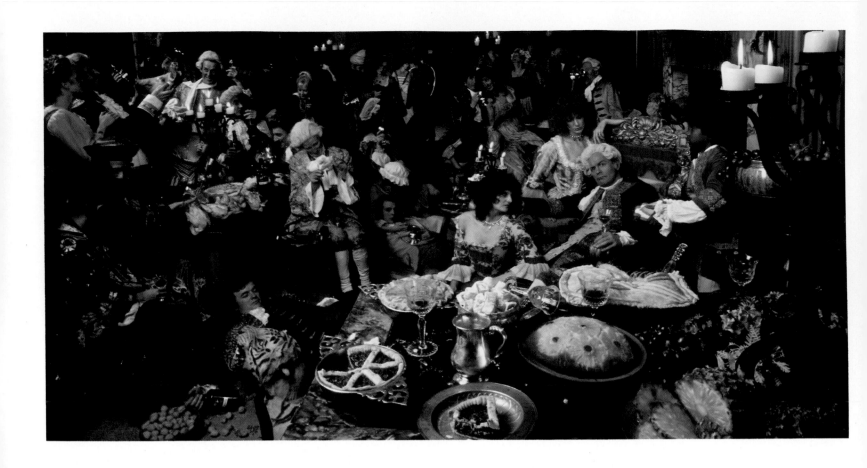

Photographer · Photographe · Fotograph · MICHAEL JOSEPH
Art Director · Directeur Artistique · FRANCO MORETTI
Advertising Agency · Agence de Publicité · Werbeagentur · McCANN ERICKSON ITALIANA
Client · Auftraggeber · MARTINI & ROSSI

Advertisement for Offley Port Wine with caption 'On the evening of the 23 April 1737 William Offley began to realise that he would never manage to drink all the port that he produced – so he began to sell it', which appeared in various magazines in Italy.

Une publicité pour Offley Port Wine avec la légende 'Le soir du 23 avril 1737 William Offley commença à penser qu'il ne serait jamais arrivé à boire tout le porto qu'il produisait, donc il commença à le vendre', parue dans plusieurs revues en Italie.

Anzeige für Offley Portwein mit dem Text 'Am Abend des 23. April 1737 wurde es William Offley klar, daß er seinen selbstgemachten Portwein niemals alleine austrinken kann. Folglich begann er, ihn zu verkaufen', erschienen in verschiedenen italienischen Zeitschriften.

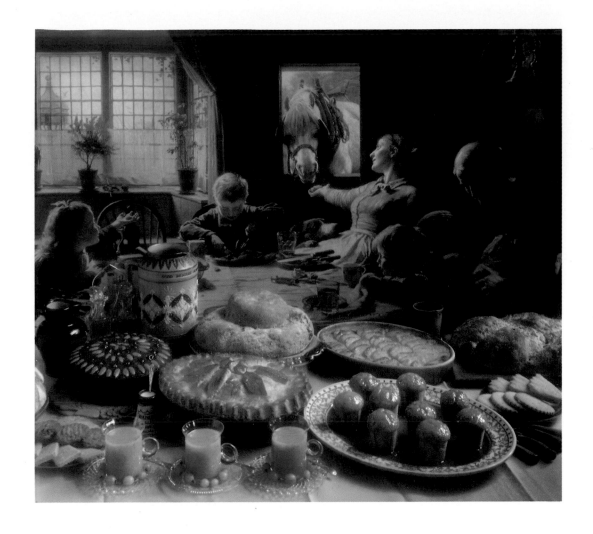

Photographer · Photographe · Fotograph · TESSA TRAEGER
Art Director · Directeur Artistique · JONATHAN ABBOTT
Copywriter · Rédacteur · Texter · JONATHAN ABBOTT
Client · Auftraggeber · ICTC

Advertisement for 'La Grande Famille Magimix' (Family Size Magimix); still life against background of painting by F·G Cotman, 'One of the family'. Published in 'Vogue' and 'House and Garden'.

Une publicité pour 'La Grande Famille Magimix;' une nature morte avec au fond un tableau de F·G Cotman, 'Un de la famille;' publiée dans 'Vogue' et 'House and Garden'.

Anzeige für 'La Grand Famille Magimix' (Die große Familie Magimix); Stilleben vor dem Bild von F G Cotman, 'One of the Family'. Veröffentlicht in 'Vogue' und 'House and Garden'.

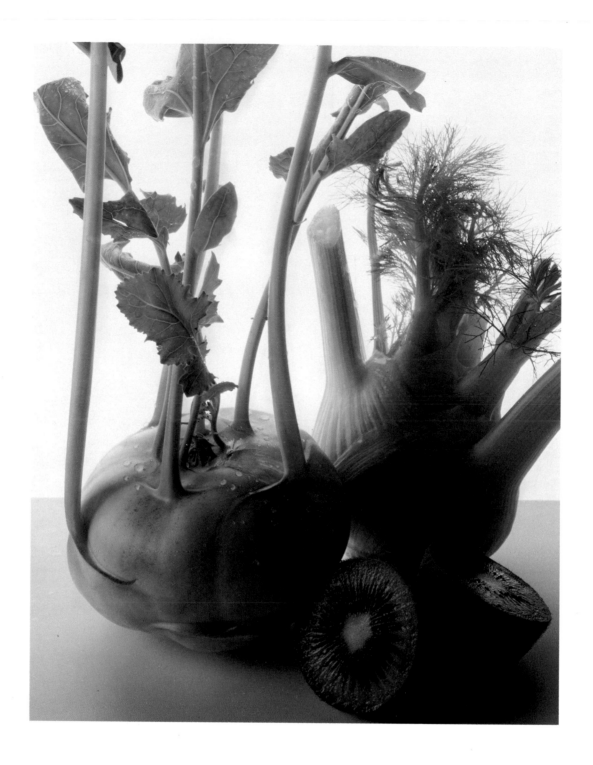

Photographer · Photographe · Fotograph · STEVE CAVALIER
Art Director · Directeur Artistique · RON BROWN
Advertising Agency · Agence de Publicité · Werbeagentur · ABBOTT MEAD VICKERS/SMS LIMITED
Copywriter · Rédacteur · Texter · DAVID ABBOTT
Client · Auftraggeber · J SAINSBURY LIMITED

Advertisement with headline 'Have Sainsbury's discovered three new avocados?' which appeared in several women's magazines in Britain.

·Une publicité avec le titre 'Sainsbury's, ont-ils découvert trois nouveaux avocats?' parue dans plusieurs revues de femmes en Grande Bretagne.

Anzeige mit dem Titel 'Hat Sainsbury's drei neue Avocados entdeckt?' erschienen in verschiedenen Frauen-Zeitschriften.

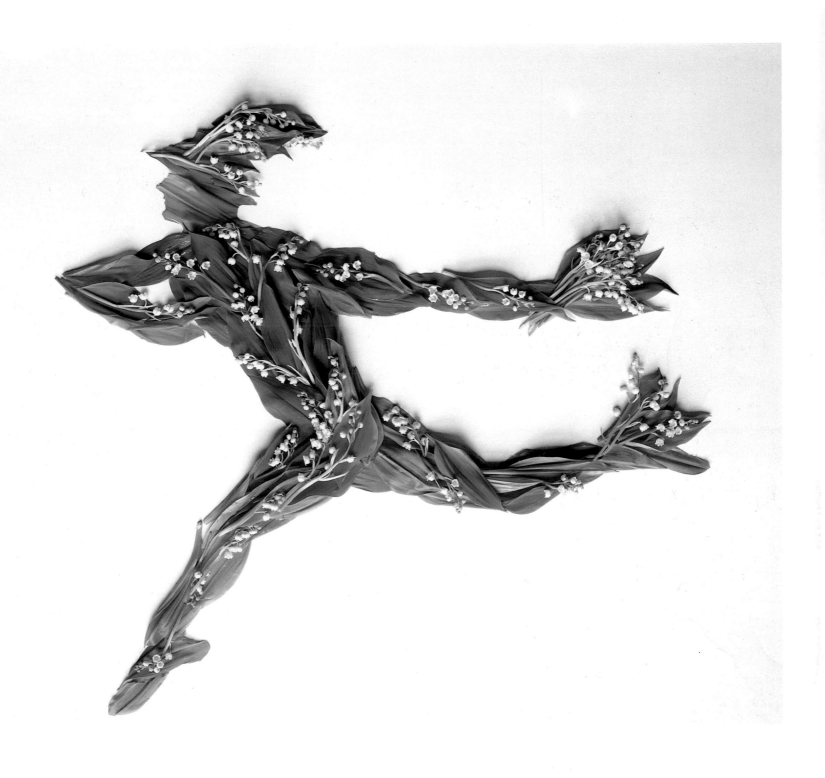

Photographer · Photographe · Fotograph · TESSA TRAEGER
Designer · Maquettiste · Gestalter · TESSA TRAEGER
Art Director · Directeur Artistique · GERARD MONOD
Advertising Agency · Agence de Publicité · Werbeagentur · TBWA (FRANCE)
Client · Auftraggeber · INTERFLORA (FRANCE)

Poster with flowers arranged in the shape of the Interflora logo, to advertise May Day in France when lilies of the valley are traditionally given.

Affiche-publicitaire: le muguet est arrangé dans la forme du logo d'Interflora pour la fête du premier mai.

Plakat für 'Interflora' zum 1. Mai, an dem aus alter Tradition Maiglöckchen verschenkt werden.

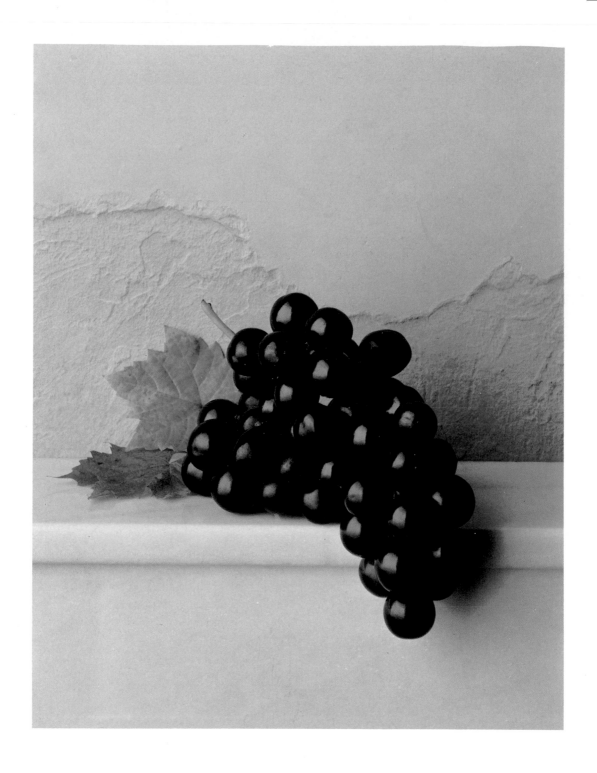

Photographer · Photographe · Fotograph · STAK
Art Director · Directeur Artistique · JOHN SCOTT
Advertising Agency · Agence de Publicité · Werbeagentur · HAVAS CONSEIL
Copywriter · Rédacteur · Texter · JEAN-LOUIS BLANC
Client · Auftraggeber · RHÔNE-POULENC

Advertisement for Rovral, a fungicide, with caption 'Rhône-Poulenc. The skin specialist', which appeared in 'Time' 1980.

Une publicité pour Rovral, un fongicide, avec la légende 'Rhône-Poulenc; Les spécialistes de la peau' qui a paru dans 'Time' 1980.

Anzeige für Rovral, ein Fungizid, mit dem Titel 'Rhône-Poulenc. Der Haut-Specialist', erschienen im 'Time' 1980.

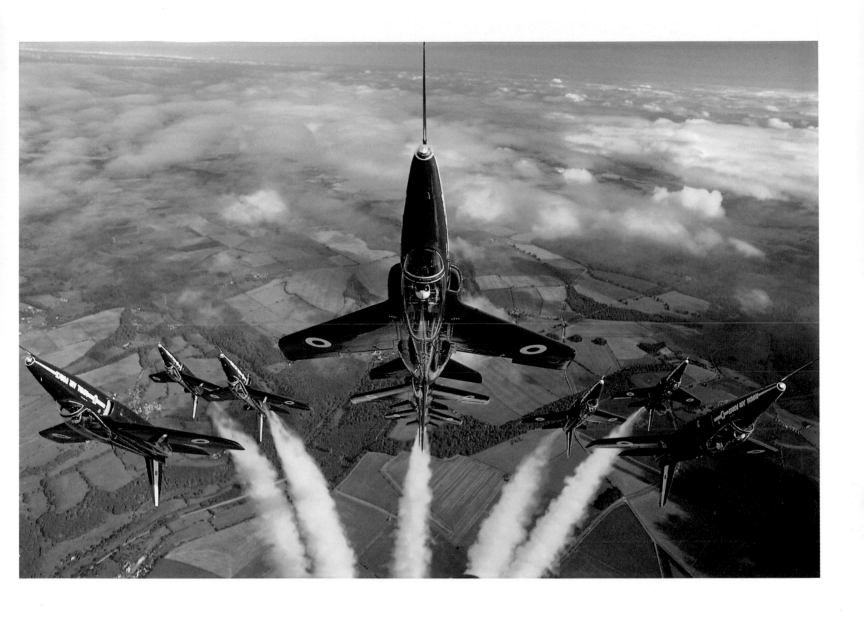

Photographer · Photographe · Fotograph · RICHARD COOKE
Art Director · Directeur Artistique · RICHARD COOKE
Client · Auftraggeber · THE ROYAL AIR FORCE 'RED ARROWS' DISPLAY TEAM

Poster showing The Red Arrows' Gnat aircraft coming up to the top of the loop in 'Apollo' formation. The photographer was in the lead plane, flown by the team leader at a height of approximately 1000 feet and 10 feet away from the following plane.

Une affiche qui montre l'avion Gnat des Red Arrows arrivant au sommet de la boucle en formation 'Apollo'. Le photographe était dans l'avion en tête piloté par le chef de l'équipe à une hauteur de 300 mètres approximatif et une distance de 3 mètres entre lui et l'avion suivant.

Das Plakat zeigt 'The Red Arrow Gnat'-Flugzeuge auf dem Höhepunkt einer Schleife in 'Apollo-Formation'. Der Fotograph saß in der Leitmaschine, die vom Team-Chef in ungefähr 300 Metern Höhe und drei Metern Abstand zur nächsten Maschine gehalten wurde.

Photographer · Photographe · Fotograph · MAX FORSYTHE
Art Director · Directeur Artistique · GARY DENHAM
Advertising Agency · Agence de Publicité · Werbeagentur · MARSTELLER LIMITED
Copywriter · Rédacteur · Texter · MICHAEL DENNETT
Client · Auftraggeber · MERCEDES BENZ

Advertisement with headline 'The Only Indulgence We Allow Ourselves', in 'The Sunday Times Magazine'.

Une publicité avec le titre 'La seule indulgence qu'on se permet', parue dans 'The Sunday Times Magazine'.

Anzeige mit dem Titel 'Die einzige Nachgiebigkeit, die wir uns erlauben', in 'The Sunday Times Magazine'.

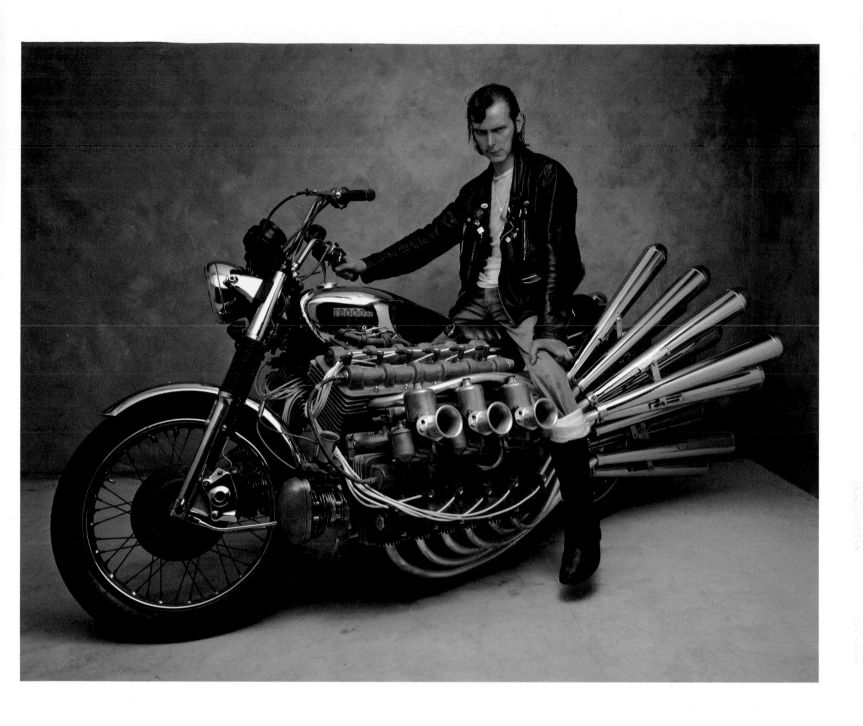

Photographer · Photographe · Fotograph · JOHN LONDEI
Model Maker · Maquettiste · Modellbauer · RUPERT ASHMORE
Art Director · Directeur Artistique · FERGUS FLEMING
Advertising Agency · Agence de Publicité · Werbeagentur · SAATCHI & SAATCHI LIMITED
Copywriter · Rédacteur · Texter · JOHN TURNBULL
Client · Auftraggeber · DUNLOP LIMITED

Advertisement featuring a specially made motorcycle, with the heading 'Is your engine overtaking your tyres?', in 'Motor Cycle News' October 1980.

Cette photographie représente une motocyclette construite spécialement pour la publicité laquelle porte la légende 'Est-ce que votre moteur dépasse vos pneus?', parue dans 'Motor Cycle News' octobre 1980.

Anzeige für ein Spezial-Motorrad mit der Überschrift 'Überfordert ihr Motor ihre Reifen?', in 'Motor Cycle News' Oktober 1980.

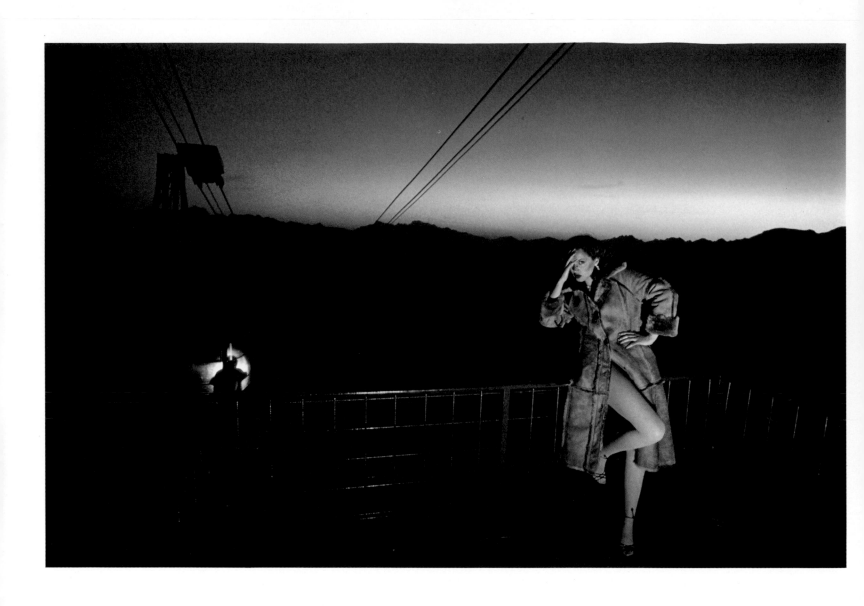

Photographer · Photographe · Fotograph · GRAHAM HUGHES
Art Director · Directeur Artistique · TONY MURANKA
Advertising Agency · Agence de Publicité · Werbeagentur · CHERRY HEDGER & SEYMOUR LIMITED
Copywriter · Rédacteur · Texter · GEOFFREY SEYMOUR
Client · Auftraggeber · MORLANDS

Advertisement for Morlands coats with caption 'When a Luxury Becomes a Necessity', taken on location in Switzerland; in the 'Sunday Telegraph' and 'Scottish Observer'.

Une publicité pour les manteaux de Morlands avec la légende 'Quand un luxe devient une nécessité', prise sur place en Suisse; parue dans le 'Sunday Telegraph' et le 'Scottish Observer'.

Werbung für Morlands Mäntel mit der Bildunterschrift 'Wenn Luxus zur Notwendigkeit wird', photografiert in der Schweiz; im 'Sunday Telegraph' und 'Scottish Observer'.

 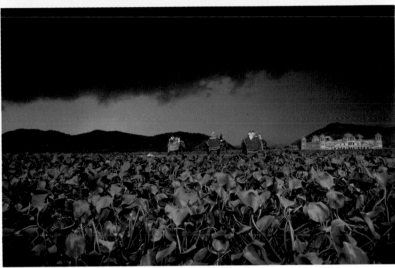

Photographer · Photographe · Fotograph · JOHN CLARIDGE
Art Director · Directeur Artistique · a,d GRAHAM CORNTHWAITE; b,c JONATHAN HALL
Advertising Agency · Agence de Publicité · Werbeagentur · CHERRY HEDGER SEYMOUR LIMITED
Copywriter · Rédacteur · Texter · a,d GEOFFREY SEYMOUR; b,c ANDREW CRACKNELL
Client · Auftraggeber · INDIAN TOURIST BOARD

Series of advertisements taken on location in India, which appeared in 'The Sunday Times', 'The Observer' and 'The Sunday Telegraph' magazines.

Série de publicités prises sur place aux Indes qui ont parues dans les suppléments du 'Sunday Times', du 'Observer' et du 'Sunday Telegraph'.

Anzeigen-Serie, aufgenommen in Indien, erschienen in 'The Sunday Times', 'The Observer' und 'The Sunday Telegraph'.

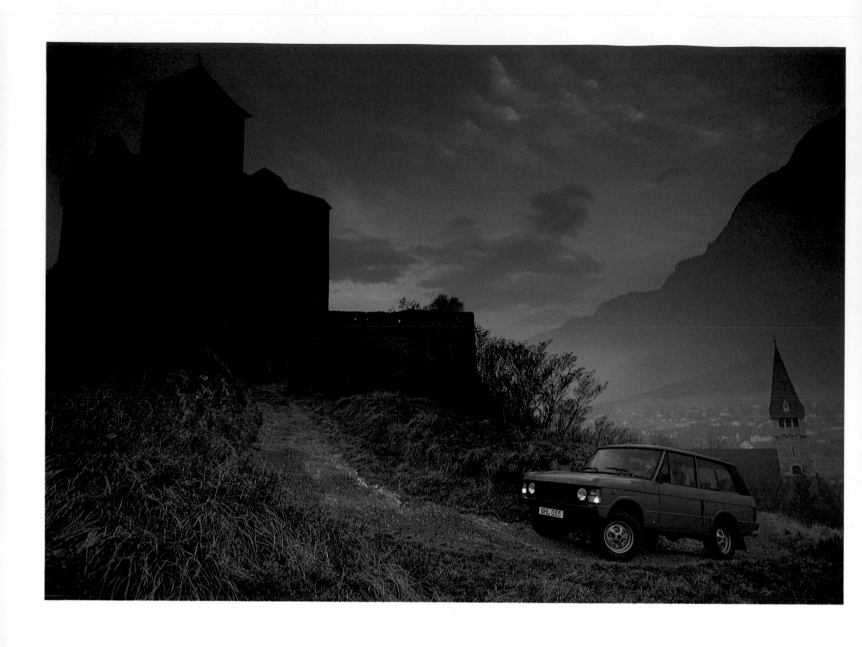

Photographer · Photographe · Fotograph · JOHN CLARIDGE
Art Director · Dirécteur Artistique · BRIAN MORROW
Advertising Agency · Agence de Publicité · Werbeagentur · TBWA LIMITED
Copywriter · Rédacteur · Texter · KEN MULLEN
Client · Auftraggeber · BL LIMITED LAND ROVER LIMITED

Advertisement for Range Rover with headline 'It's great to have friends in high places', which appeared in 'Country Life' and 'The Sunday Times Magazine', 1980.

Une publicité pour Range Rover avec le titre 'C'est chouette d'avoir des amis haut placés', parue dans 'Country Life' et 'The Sunday Times Magazine', 1980.

Anzeige für Range Rover mit der Überschrift 'Es ist toll, Freunde an hochgelegenen Plätzen zu haben', erschienen in 'Country Life' und 'The Sunday Times Magazine', 1980.

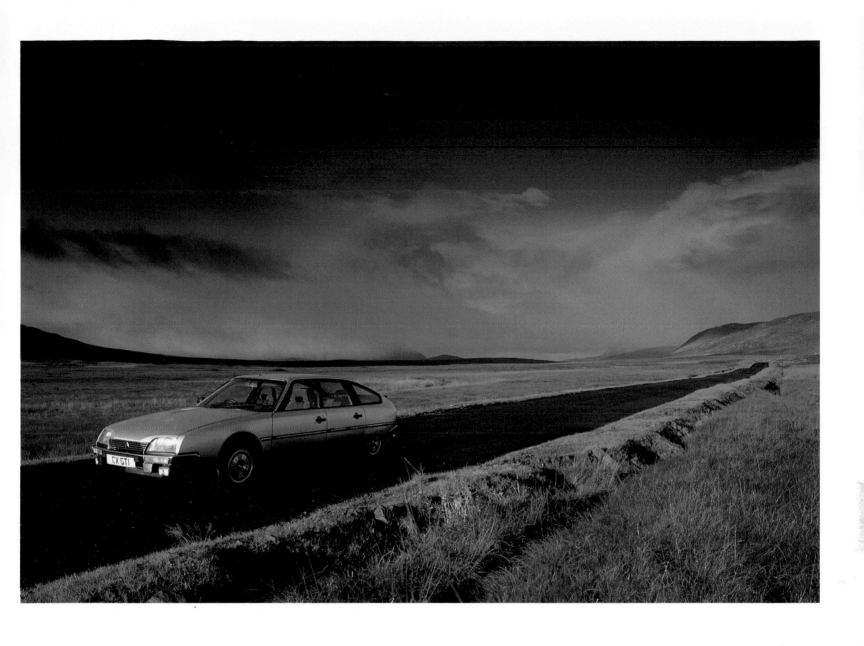

159

Photographer · Photographe · Fotograph · JOHN CLARIDGE
Designer · Maquettiste · Gestalter · VERNON OAKLEY
Art Director · Directeur Artistique · RICHARD OXBERRY
Advertising Agency · Agence de Publicité · Werbeagentur · VERNON OAKLEY DESIGN LIMITED
Client · Auftraggeber · CITRÖEN CARS LIMITED

Taken on location in Scotland for the Citroën brochure, 1981.

Prise sur place en Ecosse pour le prospectus de Citroën, 1981.

Photographiert in Schottland für einen Citroen-Prospekt, 1981.

DESIGN

This section includes work commissioned for calendars, diaries, direct mail announcements, greetings cards, packaging, promotional booklets, promotional mailings, record sleeves, stationery, technical and industrial catalogues.

DESIGN

Cette section comprend des travaux commandés pour des calendriers, des agendas, des lettres circulaires, des cartes de voeux, des emballages, des livrets de promotion par poste, des pochettes de disques, de la papeterie, des catalogues techniques et industriels.

GEBRAUCHSGRAPHIK

Dieser Abschnitt umfasst Arbeiten für Agenden, Kalender, Werbesendungen, Grusskarten, Verpackungsartikel, Prospekte, Schallplattenhüllen, Briefköpfe, technische und Industriekataloge.

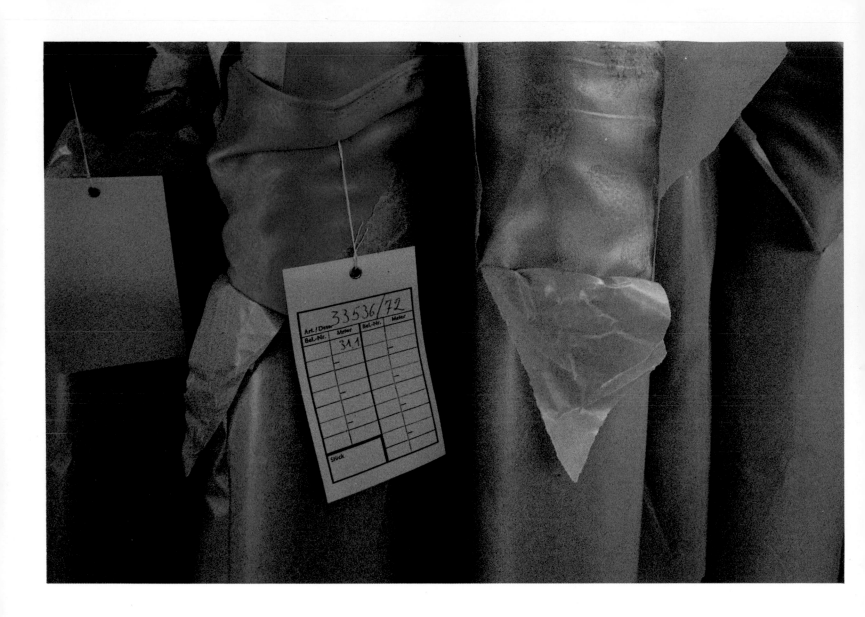

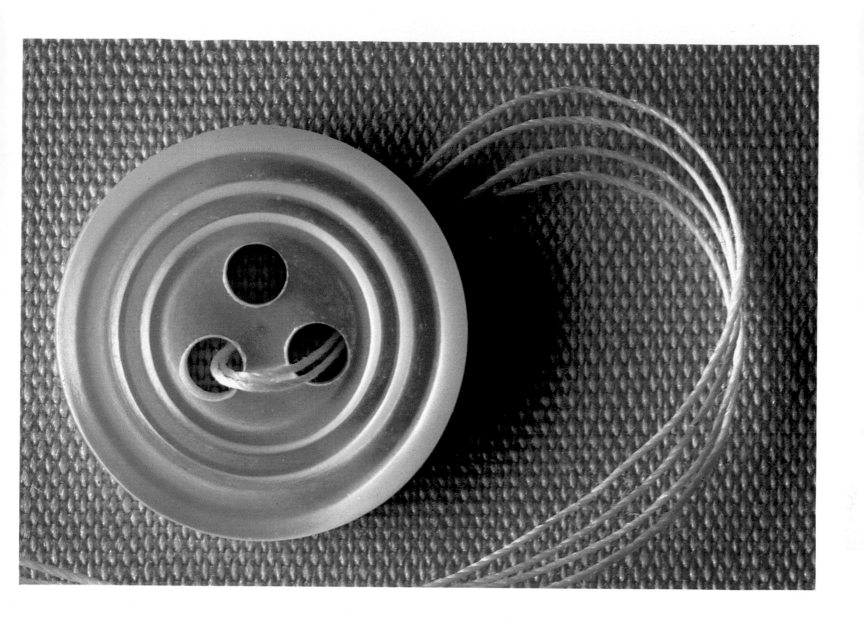

Photographer · Photographe · Fotograph · ALAN GINSBURG
Art Director · Directeur Artistique · FEICO DERCHOW
Advertising Agency · Agence de Publicité · Werbeagentur · EILER & RIEMEL

| Series of photographs which appeared in the brochure of the fashion house Van Laack. | Série de photographies parue dans le prospectus de la maison de couture Van Laack. | Eine Reihe von Photos für eine Broschüre des Modehauses Van Laack. |

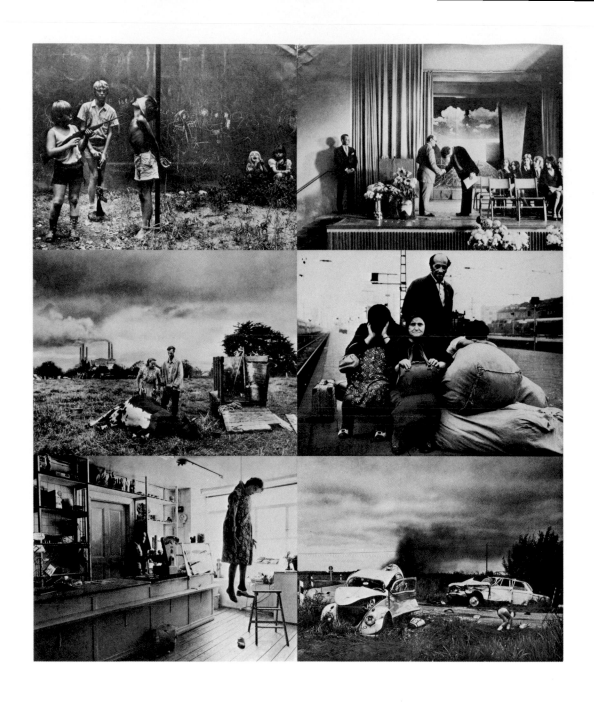

Photographer · Photographe · Fotograph · BEN OYNE
Designer · Maquettiste · Gestalter · BEN OYNE

Self-promotion poster dealing with the themes of destruction and disaster.

Affiche auto-promotionelle qui traite des thèmes de la destruction et du désastre.

Das Plakat mit Eigenwerbung behandelt de Themen Zerstörung und Katastrophen.

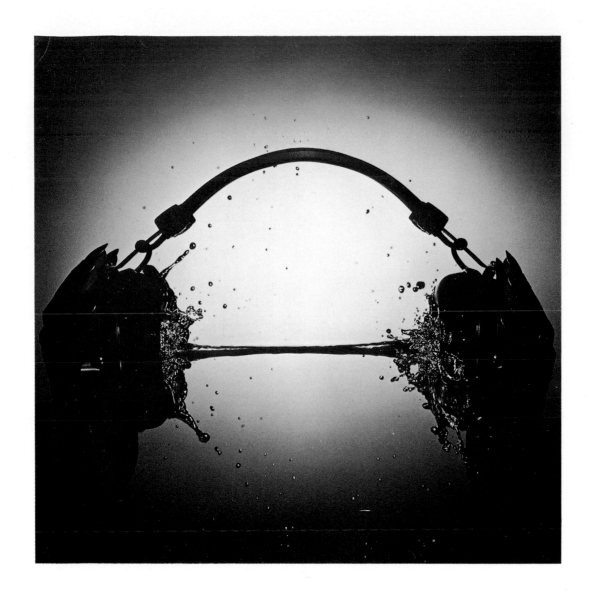

Photographer · Photographe · Fotograph · PHIL JUDE
Art Director · Directeur Artistique · JOHN PASCHE
Client · Auftraggeber · GULL RECORDS

Record sleeve for 'Illusion', an album by Isotope. | Pochette pour l'album 'Illusion' enregistré par le groupe Isotope. | Umschlag für das Album 'Illusion' von der Gruppe Isotope.

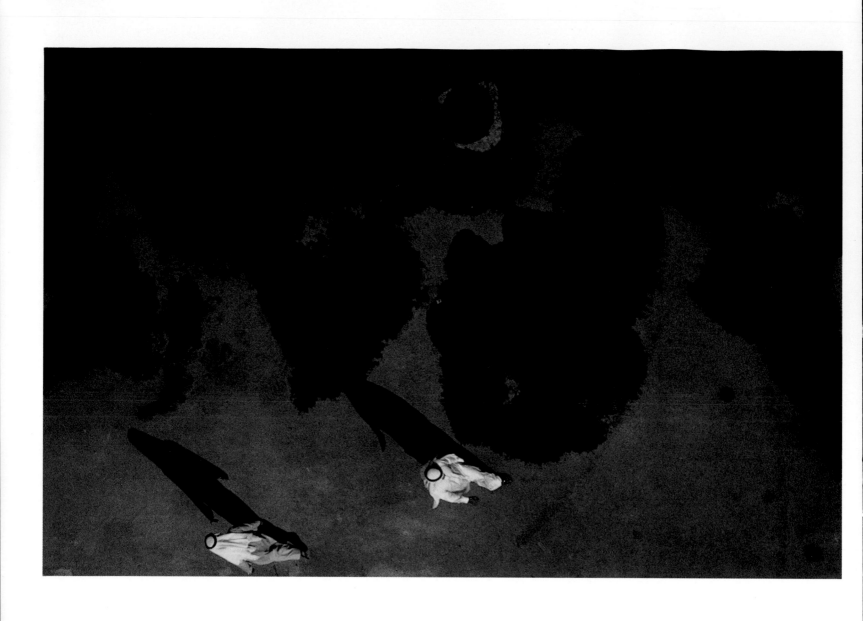

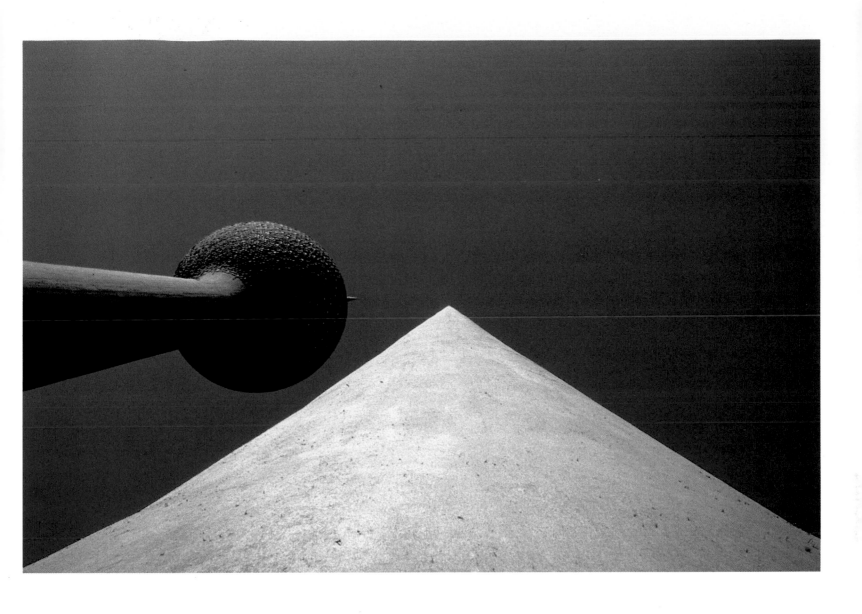

Photographer · Photographe · Fotograph · FRANCO FONTANA
Art Director · Directeur Artistique · ALAN FLETCHER
Design Group · Equipe de Graphistes · Design Gruppe · PENTAGRAM
Client · Auftraggeber · COMMERCIAL BANK OF KUWAIT

Pages from the 1980 Commercial Bank of Kuwait calendar showing Al Wafra and Kuwait City.

Des feuilles sélectionnées du calendrier de 1980 de la Banque Commerciale de Koweit qui montrent Al Wafra et la ville de Koweit.

Blätter aus dem Kalender der Commercial Bank von Kuweit von 1980, mit Aufnahmen von Al Wafra und Kuweit-Stadt.

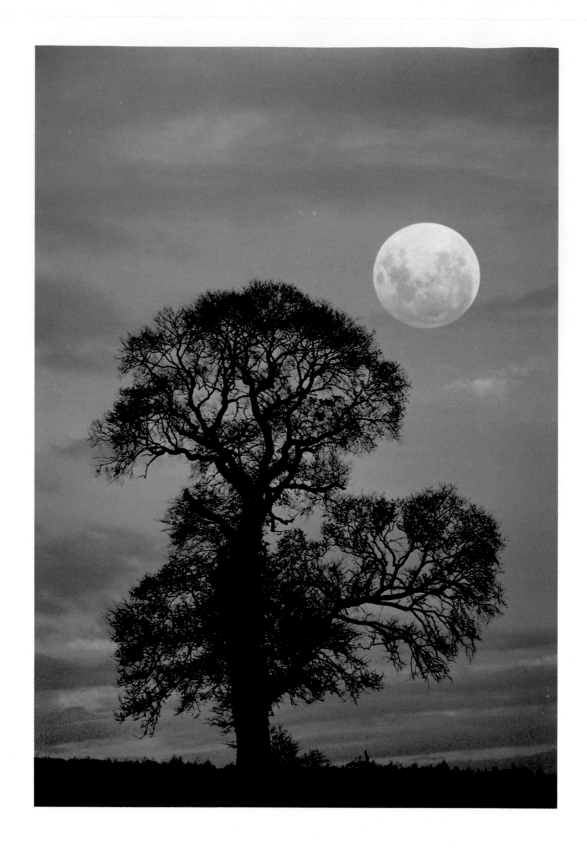

Photographer · Photographe · Fotograph · TONY EVANS
Art Director · Directeur Artistique · JOHN GORHAM

'English Elm', self-promotion for the Tony Evans
Picture Library.

'L'orme anglais', affiche auto-publicitaire pour la
Tony Evans Picture library.

'Englische Ulme', Plakat für die Eigenwerbung der
Tony Evans Picture Library.

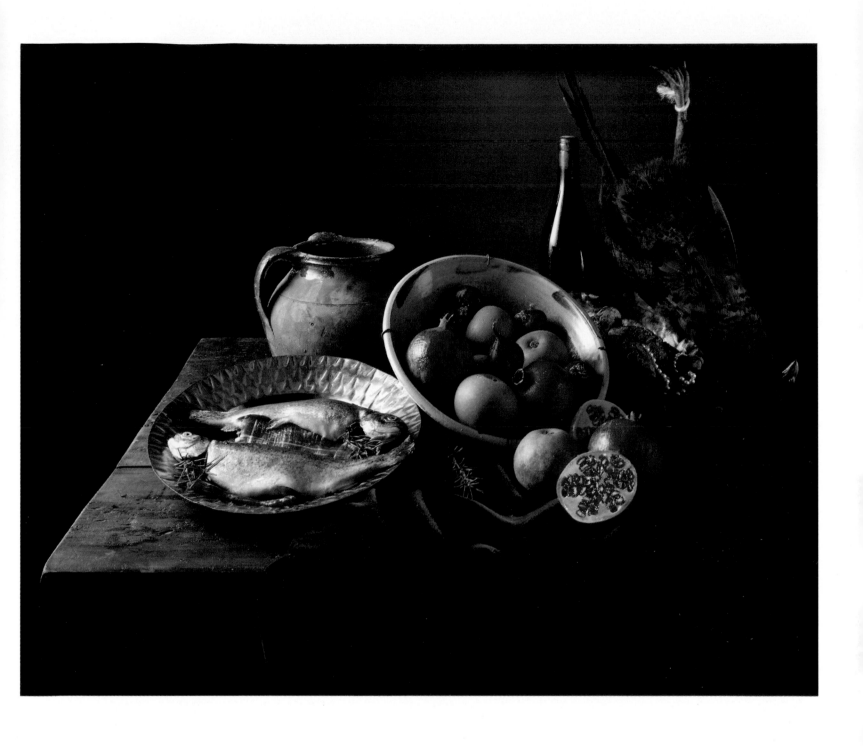

Photographer · Photographe · Fotograph · ROBERT GOLDEN

Design Group · Equipe de Graphistes · Design Gruppe · CARROLL & DEMPSEY

Still life used as self-promotion poster. Nature morte; affiche auto-promotionelle. Stilleben; Plakat für die Eigenwerbung.

UNPUBLISHED

This section consists of commissioned but not published photography, personal work produced by professional photographers, and the work of students.

OEUVRES NON PUBLIEES

Cette section comprend des travaux personnels de professionnels et d'étudiants, et des photographies commandées mais non publiées.

UNVERÖFFENTLICHTE ARBEITEN

Dieser Teil zeigt in Auftrag gegebene, aber nicht veröffentlichte Photos; Privataufnahmen von Berufs-Photographen und Arbeiten von Studenten.

Photographer · Photographe · Fotograph · JIM ARNOULD

Unpublished photograph of The Brynffynon pub in South Wales.

Photographie non publiée du Brynffynon pub au Pays de Galles du Sud.

Unveröffentlichtes Photo des Brynffynon Pubs in Süd Walis.

Photographer · Photographe · Fotograph · ANDREW STEVENS
Designer · Maquettiste · Gestalter · HELEN FOX

Unpublished photograph for use as a direct mailer to advertising agencies.

Une photographie non publiée qui servira comme une publicité à envoyer par la poste aux agences publicitaires.

Unveröffentlichte Aufnahme, als Einführung bei Werbeagenturen eingesetzt.

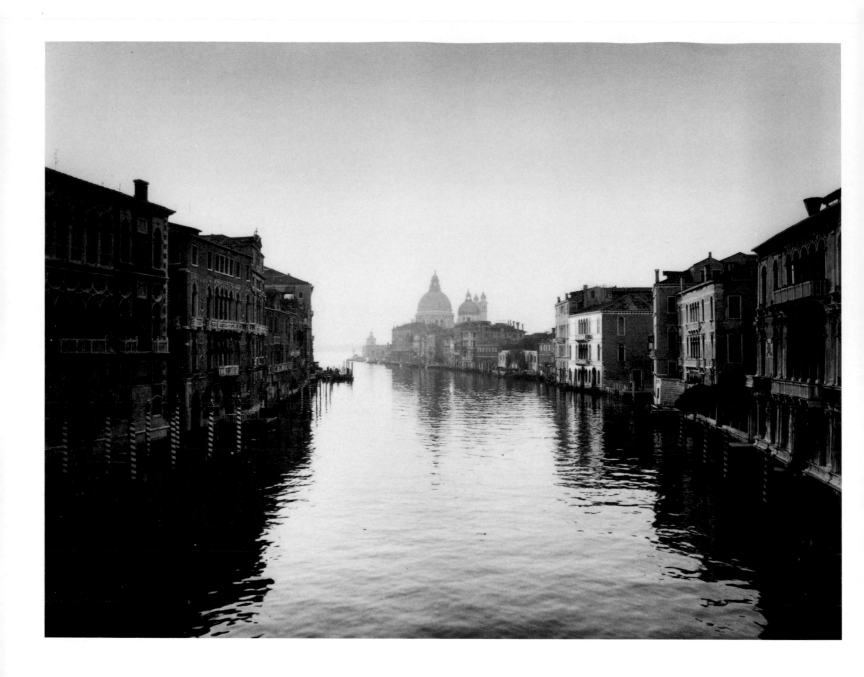

Photographer · Photographe · Fotograph · BRUCE BROWN

Unpublished experimental work taken on location in Venice.

Photographie expérimentale non publiée et prise sur place à Venise.

Unveröffentlichte, experimentelle Arbeit, aufgenommen in Venedig.

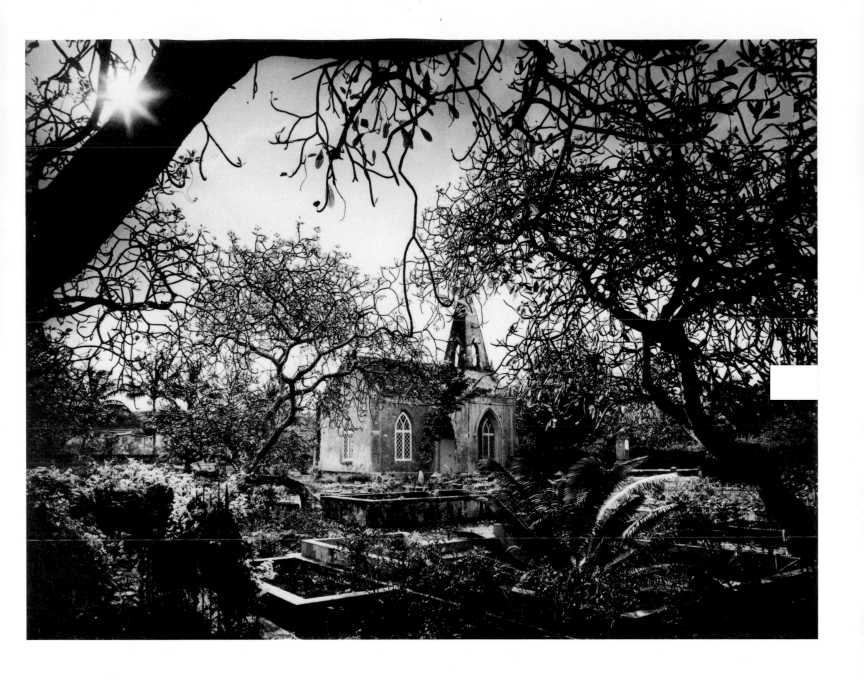

179, 180, 181

Photographer · Photographe · Fotograph · BRUCE BROWN

Unpublished experimental work taken on location in New Zealand.

Des photographies expérimentales non publiées et prises sur place à la Nouvelle-Zélande.

Unveröffentlichte, experimentelle Arbeit, aufgenommen in Neuseeland.

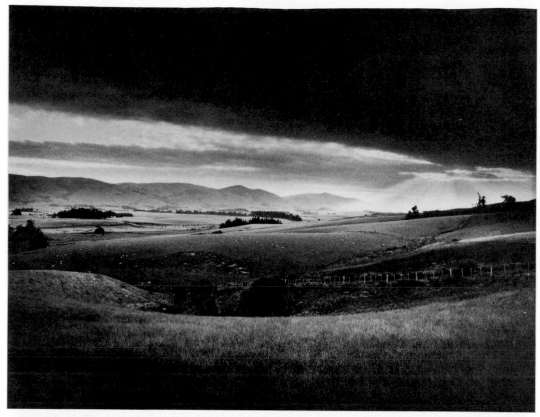

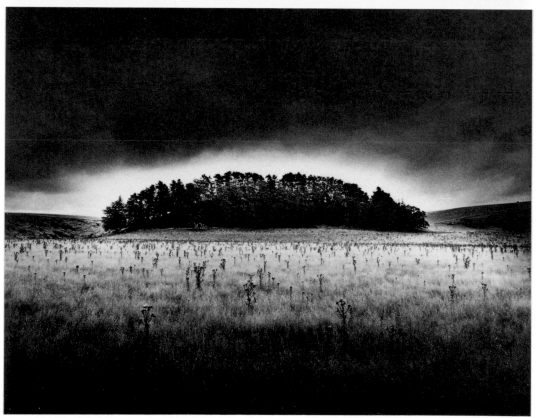

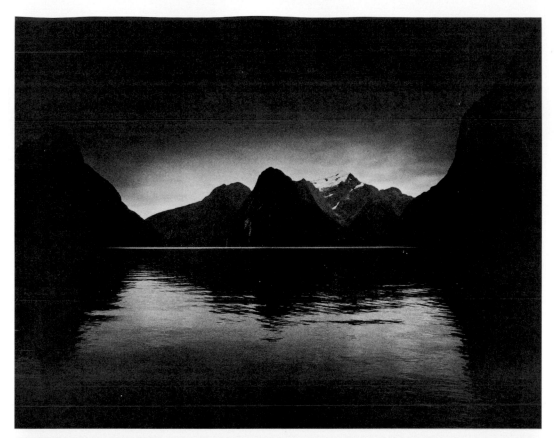

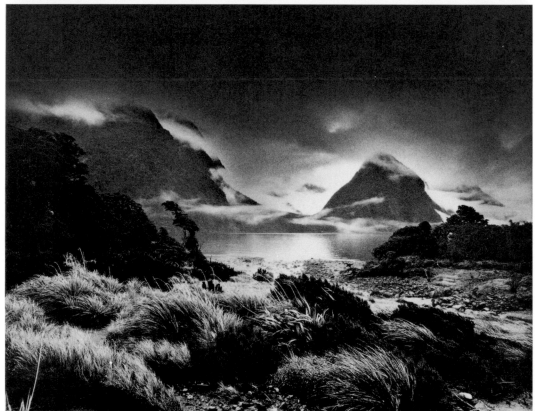

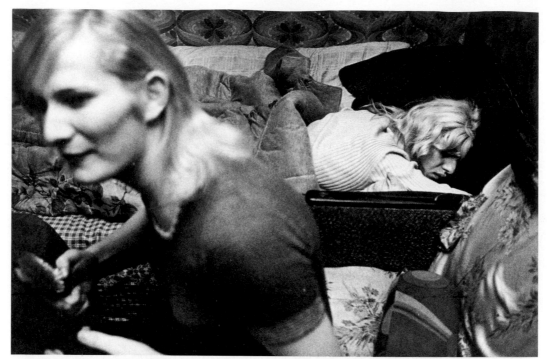

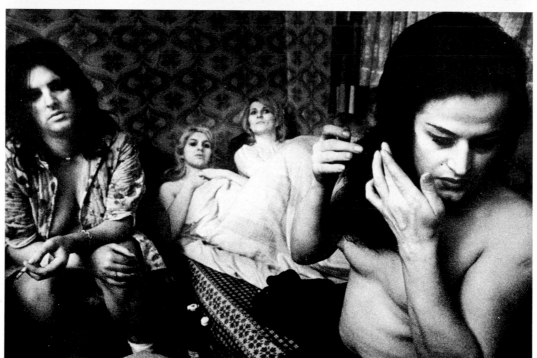

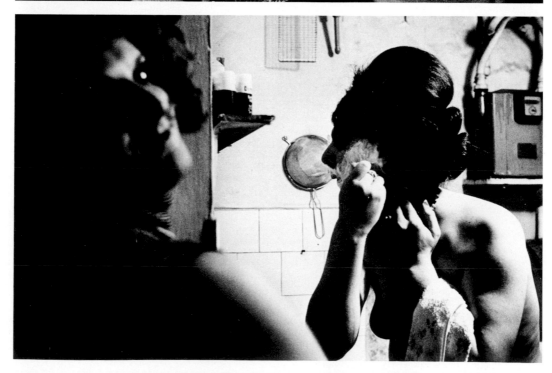

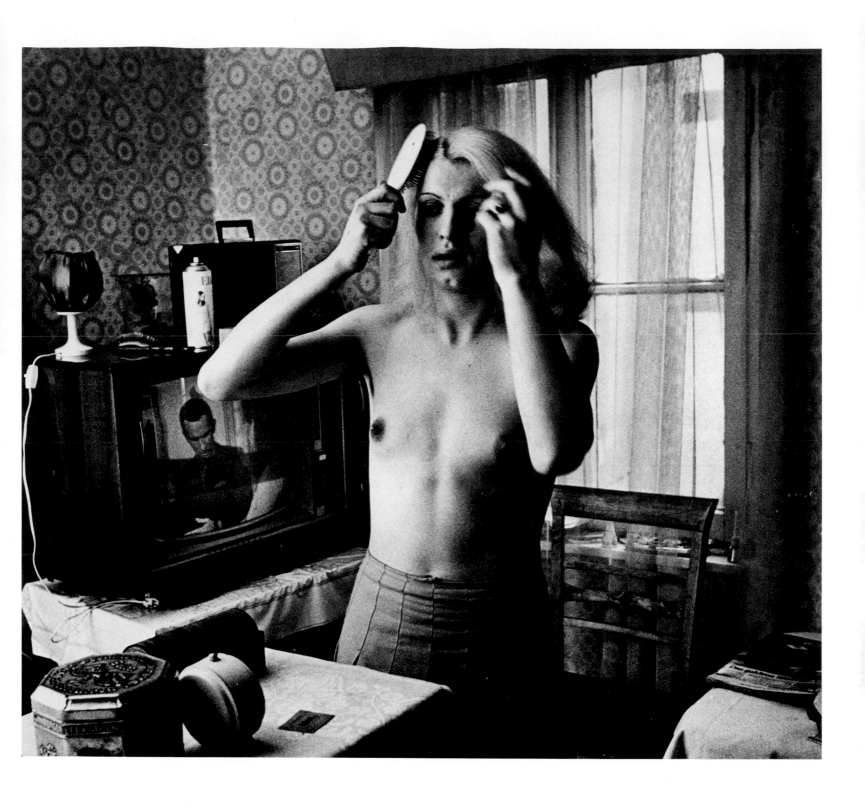

Photographer · Photographe · Fotograph · ANDREJ REISER

Series of unpublished photographs of people in the St Pauli surburb of Hamburg, for a projected book, 'Wenn ich genug hab', hau ich ab' (When I've had enough, I get out).

Une série de photographies non publiées des gens de la banlieue St Pauli, Hamburg, prises pour un livre en projet 'Quand j'en ai marre, je me barre'.

Unveröffentlichte Photo-Serie von Menschen im Stadtteil St. Pauli, Hamburg, für das geplante Buch 'Wenn ich genug hab', hau ich ab'. ·

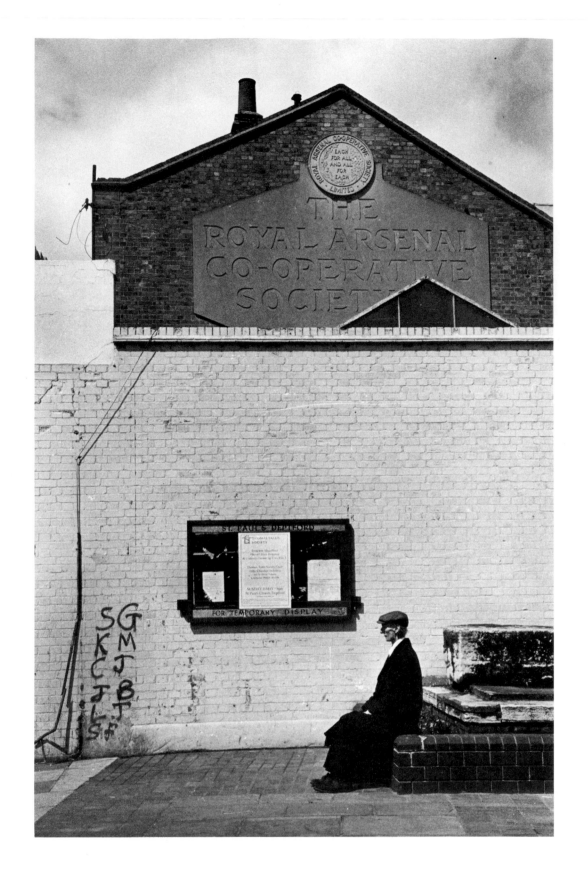

Photographer · Photographe · Fotograph · CHRIS SCHWARZ

Photograph from a series showing isolation and deprivation in South East London, commissioned by The Combination at The Albany Community Centre for a small exhibition portraying the area.

Photographie d'une série qui montre l'isolement et la privation dans le sud-est de Londres, commandée par The Combination au centre récréatif, The Albany pour une petite exposition au sujet de ce quartier.

Photo aus einer Serie über Isolation und Entbehrung im Süd-Osten von London, gedacht als kleines Portrait dieses Stadtteils, von The Combination at The Albany.

Photographer · Photographe · Fotograph · DANIEL FURON

Unpublished photograph taken on location in Morocco.

Photographie non publiée prise sur place au Maroc.

Unveröffentlichtes Photo aufgenommen in Marokko.

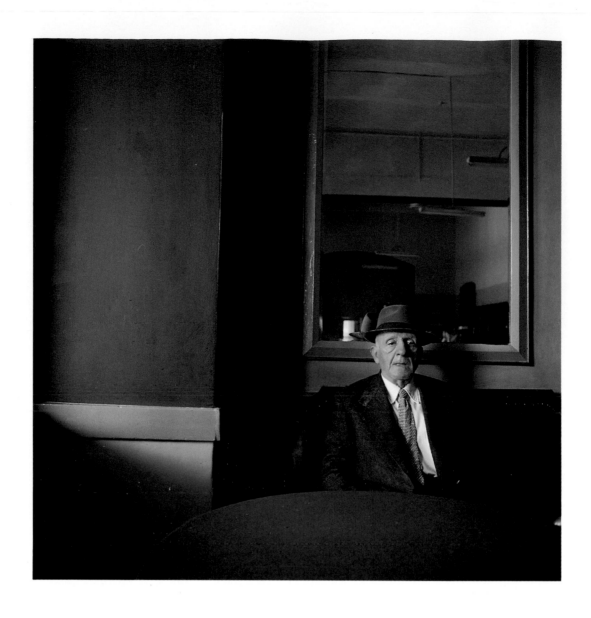

Photographer · Photographe · Fotograph · ROLPH GOBITS

Unpublished photograph taken on location in Greece for an article on small villages near the Greek/Albanian border.

Photographie non publiée prise sur place en Grèce pour un article au sujet des petits villages près de la frontière grèque-albanaise.

Unveröffentlichte Aufnahme aus Griechenland für eine geplante Geschichte über kleine Ortschaften an der griechisch-albanischen Grenze.

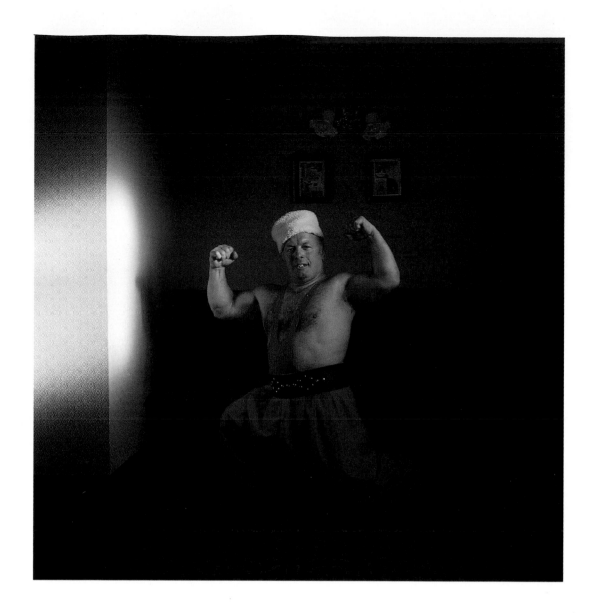

Photographer · Photographe · Fotograph · ROLPH GOBITS

'Strongman', unpublished photograph for a book project on travelling entertainers.

'L'homme de force', photographie non publiée, prise pour un livre en projet au sujet des comédiens ambulants.

'Strongman', unveröffentlichtes Photo für ein Buch über Wander-Theater.

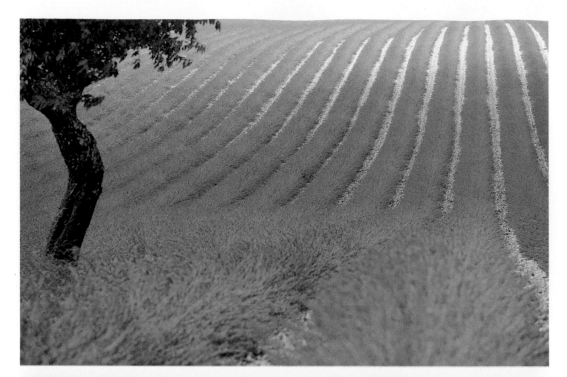

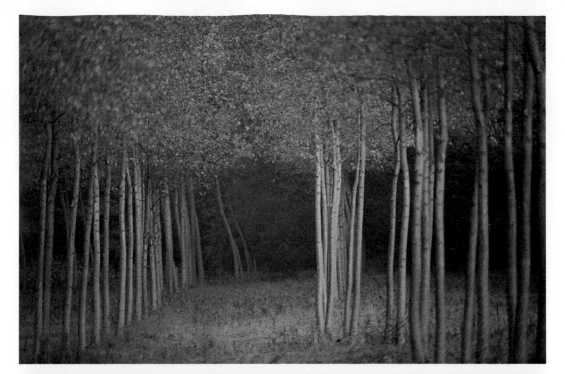

188, 189, 190, 191

Photographer · Photographe · Fotograph · ANDRÉ MARTIN

Unpublished work taken on location in France.　　Photographies non publiées prises sur place en　　Unveröffentlichte Arbeit, aufgenommen in
France.　　Frankreich.

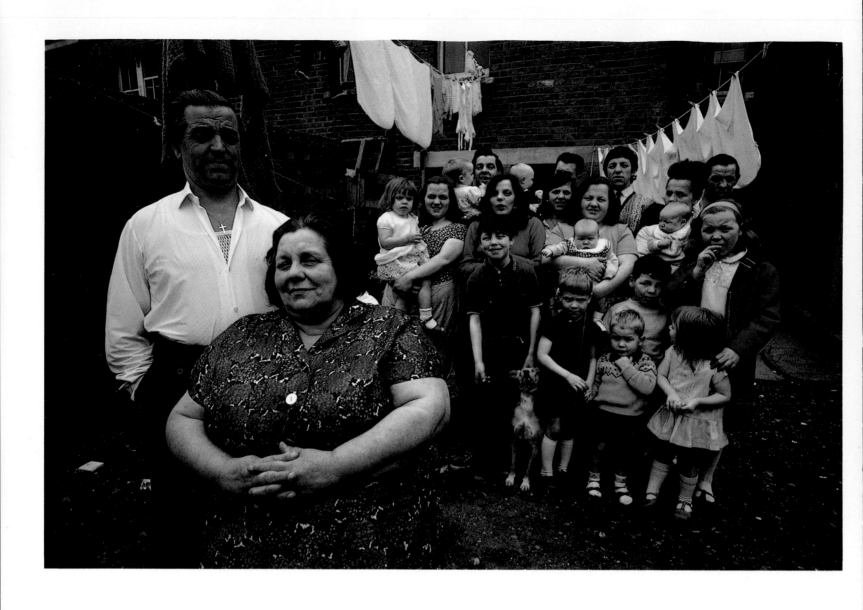

Photographer · Photographe · Fotograph · GRAHAM FINLAYSON

Unpublished photograph taken on location in London for a proposed feature on large families.

Photographie non publiée prise sur place à Londres pour un reportage proposé au sujet des familles nombreuses.

Unveröffentlichtes Photo, aufgenommen in London, für eine geplante Reportage über große Familien.

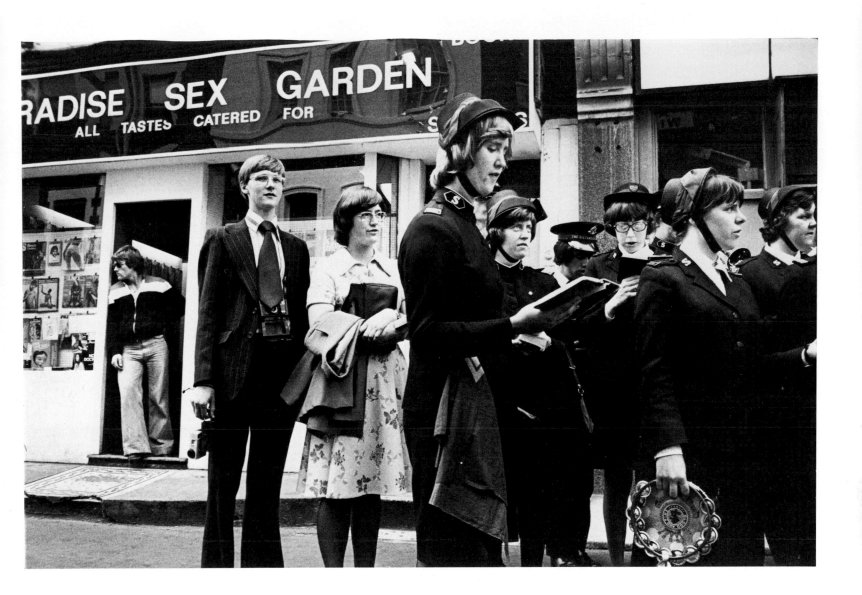

Photographer · Photographe · Fotograph · JIM ARNOULD

Photograph taken on location for an exhibition on Soho, London.

Photographie prise sur place pour une exposition sur le quartier de Soho, Londres.

Photo für eine Londoner Soho Austellung.

INDEX

PIET VAN LEEUWEN 85
Hagestraat 18
Haarlem
The Netherlands

CHEYCO LEIDMANN 94
11 rue de Square Carpeaux
75018 Paris
France

JOHN LONDEI 155
28-29 Great Sutton Street
London EC1
England

PETER MACKERTICH 112-113
25 St Pancras Way
London NW1
England

GUIDO MANGOLD 46
Ginsterweg 7
8012 Ottobrunn
West Germany

ANDRÉ MARTIN 188-191
c/o European Photography
12 Carlton House Terrace
London SW1
England

DON MCCULLIN 30-31
c/o European Photography
12 Carlton House Terrace
London SW1
England

ALAIN MINGAM 21
c/o Gamma
Frank Spooner Pictures
City Golf Club Building
Bride Lane
Fleet Street
London EC4
England

BOUDEWIJN NEUTEBOOM 98
Sloterweg 996
Amsterdam
The Netherlands

HELMUT NEWTON 43
c/o Art Directions
34 Quai Henri IV
75004 Paris
France

BEN OYNE 164
Alsterdorfer Str 19
2000 Hamburg 60
West Germany

ROGER PHILLIPS 116
15a Eccleston Square
London SW1
England

PETER RAUTER 174-175
1 Rossetti Studios
Flood Street
London SW3
England

ANDREJ REISER 182-183
Isestrasse 17
2 Hamburg 13
West Germany

TADANORI SAITO 32-33
c/o European Photography
12 Carlton House Terrace
London SW1
England

RED SAUNDERS 65, 83
41 Great Windmill Street
London W1
England

PHIL SAYER 50, 70-71
19 Thicket Road
London SE20
England

WALTER SCHMIR 88-91
c/o European Photography
12 Carlton House Terrace
London SW1
England

CHRIS SCHWARZ 184
91a Moray Road
London N4
England

IVARS SILIS 51
PO Box 151
3920 Julianehaab
Greenland

SNOWDON 45, 63, 118-125
c/o European Photography
12 Carlton House Terrace
London SW1
England

STAK 144-146, 152
10 Bourdon Street
London W1
England

WOLFGANG STAIGER 49
Lazarettestr 6
4300 Essen 1
West Germany

ANDREW STEVENS 177
26 Mayfield Gardens
Edinburgh EH9
Scotland

PETER THOMANN 44
c/o European Photography
12 Carlton House Terrace
London SW1
England

TESSA TRAEGER 149, 151
7 Rossetti Studios
72 Flood Street
London SW3
England

JAY ULLAL 24
c/o Stern
Gruner & Jahr AG & Company
Warburgstr 50
2000 Hamburg 36
West Germany

ROBERT VAVRA 52-55
c/o Schuler-Verlagsgesellschaft
Munich
West Germany

DENIS WAUGH 37-39, 66, 117
5 Hillier Road
London SW11
England

MIKE WELLS 60
c/o European Photography
12 Carlton House Terrace
London SW1
England

ARNAUD DE WILDENBERG 62
c/o European Photography
12 Carlton House Terrace
London SW1
England

REINHART WOLF 106-110
c/o Stern
Gruner & Jahr AG & Company
Warburgstr 50
2000 Hamburg 36
West Germany